LOST DUNDEE

*

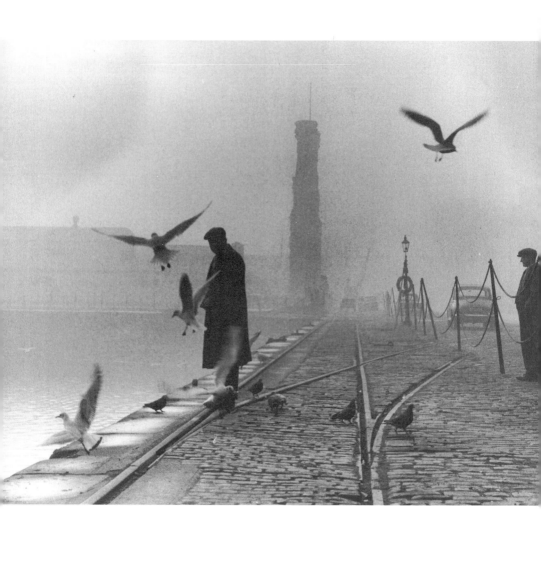

LOST DUNDEE

DUNDEE'S LOST ARCHITECTURAL HERITAGE

*

*Charles McKean and Patricia Whatley
with Kenneth Baxter*

BIRLINN

✳

First published in 2008 by
Birlinn Limited
West Newington House
10 Newington Road
Edinburgh
EH9 1QS

www.birlinn.co.uk

ISBN: 978 1 84158 562 8 (hardback)
ISBN: 978 1 84158 815 5 (paperback)

British Library Cataloguing-in-Publication Data
A catalogue record for this book is available from the British Library

Designed by Mark Blackadder

Typeset in Scotch Roman at Birlinn

Printed and bound by MPG Books Limited, Cornwall

CONTENTS

Acknowledgements vii

General Introduction ix

PART ONE
SEAPORT 1500–1820
Introduction 1
The Architectural Heritage 12

PART TWO
JUTEOPOLIS 1820–1900
Introduction 80
The Architectural Heritage 93

PART THREE
UNIVERSITY CITY 1900–2008
Introduction 159
The Architectural Heritage 181

Further Reading 229

Image Acknowledgements 235

Index 236

ACKNOWLEDGEMENTS

*

We owe a great debt to so many people that we are dividing them up into categories.

First, for historical knowledge (which we cannot acknowledge in the usual manner through footnotes), a particular debt is owed to authors of chapters in the Dundee Project volumes, namely David Barrie, Karen Cullen, Elizabeth Foyster, Bob Harris, Alan Macdonald, Andrew McKillop, Louise Miskell, Derek Patrick, Claire Swan, Malcolm Archibald, Christopher Whatley and Mary Young. We are also hugely grateful to Kenneth Baxter, who carried out much of the picture research and contributed to the caption writing. We also owe thanks to Dennis Collins, Innes Duffus, Iain Flett, Stuart Mee, Denis Naulty, Hamish Robertson, John Robertson, Jerry Wright and Stuart Walker, and we owe much to the various authors of the Abertay Historical Society publications.

For visual information and permission to use their illustrations, we are hugely indebted first to Anne Swadel and Brian McLaughlin, DC Thomson Ltd for permission to reproduce from their outstanding photographic archive. We are then immeasurably indebted to David Kett and the staff of Dundee Central Libraries, and to Dundee City Council, for their permission to reproduce the drawings from the Charles Lawson collection, and from 'Photopolis'. We are equally indebted to Clara Young and Dundee Museums and Art Galleries for permission to reproduce drawings from the David Small collection. We are particularly grateful to Professor David Walker for being able to use his splendid sketches of the jute palaces. Other illustrations derive from the Royal Commission on the Ancient and Historical Monuments of Scotland, the RIAS, the University of Dundee Archives, Charles McKean and from a private collection. Sources for all the images used are detailed on p. 235.

For help, collaboration and support we owe much to Richard Cullen, Neil Grieve, Craig McGeochie, Adam Swan, Clara Young, Ruth Neave and all the staff of Dundee University Archives.

The authors gratefully acknowledge the invaluable assistance of Michael Bolik, Archive Services, University of Dundee, in identifying, scanning and organising the images used in this book and for preparing the index. We are also grateful to Dr Gary Smith for proof-reading the final text.

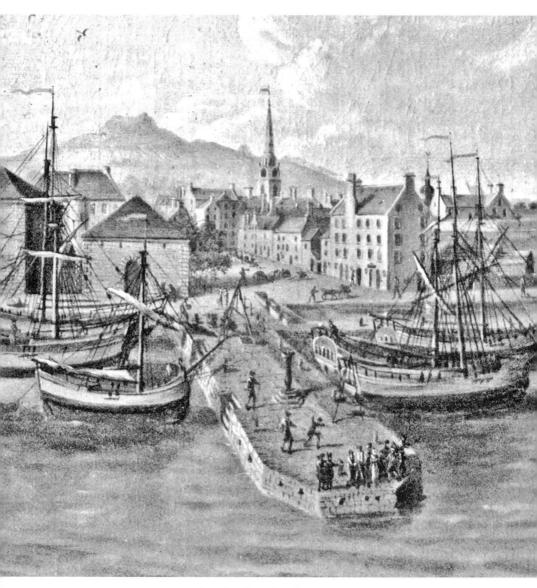

Dundee: the point of arrival in 1780.

GENERAL INTRODUCTION

This book is primarily concerned, not with how Dundee lost some of its architectural heritage, so much as how the great seaport of Dundee lost its identity and its memory. The fact that, save for the tower of St Mary's, only one of the impressive civic buildings that adorned its streets during either the Renaissance or the Georgian period survives is loss enough. However, the emphasis in this volume is upon the town as a whole, and the streets, lanes, closes, alleys, wynds and entries, the buildings and courts that made up the bulk of the burgh's character – before they were all surgically removed in the town's new craving for modernity, in a four-part clearance plan beginning in 1871 and lasting for over 100 years.

Since Dundee was the only town in Scotland to evolve in the way it did – that is to say, whose physical form and social patterns were primarily those of a seaport – it is impossible to characterise it by comparison with other Scottish burghs. It is not at all the same thing as a town with a harbour, such as Aberdeen. The burgh recorded in old drawings felt dense, dynamic and powerful because it was so tightly compressed between two small hills – the Corbie Hill and the Windmill Hill, which lay immediately behind the market place and the Overgate – and the sea. It developed, therefore, in a long, linear manner, with its market place at the centre. It is almost impossible to conceive of that town now, since both the hills were quarried away in the nineteenth century. To the north, all is now flat, as space leaches away in the characterless and confusing former Meadows and Ward lands; whereas to the south, the sea has been distanced by over half a mile of reclaimed foreshore. So, unlike all other Scots towns, one of Dundee's primary losses has been its original topography and setting.

Insofar as we recognise towns by the image we have of them – Edinburgh being symbolised either by the Old Town ridge or the neo-classical Valhalla of Calton Hill, Aberdeen by Union Street and Glasgow by the cathedral or George Square – Dundee is again unusual. For there is no nationally recognised image of the burgh. The only way that artists felt they could capture the character of this long, linear port, with its backdrop of hills obscuring any

civic skyline it might build, was to take the view from out in the Tay estuary or, more immediately, from the East Head breakwater. Given that it was a port, the harbour and its shipping in the foreground were deemed perfectly adequate to symbolise it. As a consequence, there was almost nothing until 1822 to represent Dundee comparable to the depictions of Glasgow's Trongate, Aberdeen's Castlegate or Edinburgh's High Street. Proud of its gracious market place though it was, Dundee invariably presented itself to the outside world through its harbour, its shipping and its shore.

As a seaport, nonetheless, Dundee rose to be the second burgh in Scotland after Edinburgh (judged by tax revenue) by the fifteenth century, and remained as such until the later seventeenth century. Its mother church of Our Blessed Virgin Mary was rebuilt upon the grandest scale to become the largest parish church in Scotland, with the most (48) altars and chaplainries, and the tallest tower – originally capped by a crown steeple. Its merchant venturers (as they styled themselves) developed extensive trading connections with Europe (see the introduction to Part One: Seaport 1500–1820), and lived in considerable style in impressive town houses with painted galleries. When they desired peace and reflection (the evidence being that they were very literate), they retreated to rural villas a short ride away; and these villas had a form unique to Dundee and its hinterland – distinctly Baltic in their long, low proportions, yet decorated with stair towers and turrets in the Scottish manner, and constructed of Scots stone rather than Baltic timber.

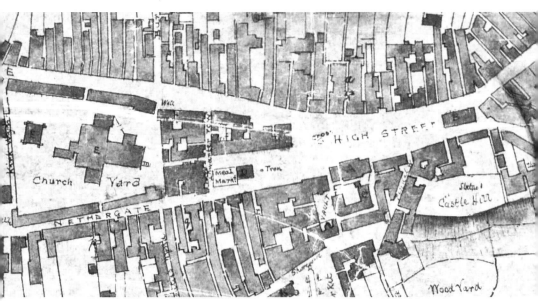

The High Street.

Although parallels with other Scots burghs are difficult, comparisons with ports such as Danzig, Lübeck and Hamburg – with which Dundee customarily traded – are less so, even though Dundee was significantly smaller than they were and enjoyed far less patronage. Its town plan, for example, is very similar to that of Lübeck. Lübeck's curving great street, which winds along a ridge – narrowing then widening for town hall or church – closely parallels that of Dundee. As in Dundee, its passages curve down to the harbour to cope with the slope and also to control the wind. A port's industries and activities are focused upon processing, producing and distributing what is imported or exported. By the later eighteenth century, Dundee fitted that model like a glove; the size and scale of its industries of glass-making, shoemaking, sugar-refining, coloured-thread making and manufacture of osnaburgs (cheap brown cloth) were entirely geared to its seaborne trade.

It is rather more difficult to establish a port's state of mind. That Dundonians were as proud as any other urban Scots – if not more so – is without doubt. Between 1550 and 1640, when invaders held off, Renaissance Dundee was a place of both conspicuous consumption and ostentation. When its citizens rebuilt their tolbooth in 1560 after it had been burnt by the English, it was by all accounts the most splendid in the country – a turreted and spired building faced with the fine ashlar taken from the Greyfriars and roofed with sturdy timbers removed from Lindores Abbey. Then again, when the tolbooth finally expired in 1730, its replacement was designed by Scotland's finest architect, William Adam. Once again, it was by far the finest and most modern civic building in Scotland.

Nonetheless, there was a practical bent to the way that the town evolved, and that was most evident down on the Shore. Here were civic monuments of a type and scale less typical in Scotland: the new arcaded packhouse (later called Provost Pierson's Mansion), built c. 1560 at the end of the newly reclaimed New Shore, was identifiable by its round corner turrets so typical of great buildings of that period. It was like a mercantile château. The town's arsenal at the other end of the New Shore was converted from the old windmill. Splendid though it was, the packhouse came to be insufficient to cope with the town's growing trade, so in 1644 the town constructed the much more extensive Packhouse Square, a very large courtyard or series of courtyards of storage buildings, one and a half storeys of which still survive beneath later construction. Just over a hundred years later they were replaced by the imposing late baroque packhouse facing the harbour front, designed by William Robertson in 1756. Dundee also had an elaborate civic sundial down on the pier to monitor loading and unloading. The merchant venturers

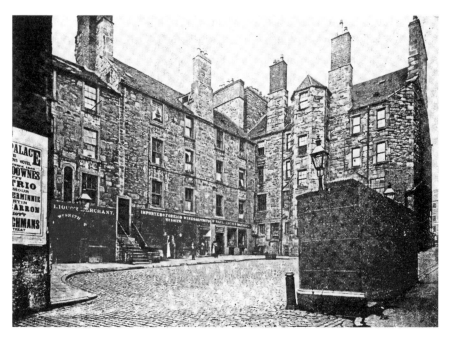

The Vault.

met and traded in the Exchange, otherwise known as the Lime Tree Walk, which ran between the sundial on the pier and the foot of the town, flanked by packhouses and inns. These were signals of Dundee's distinctive identity as a port.

On the sloping ground between the top of the shore and the market place, Dundonians used a convenient redundant graveyard to create a civic space behind the tolbooth. Called the Vault, here congregated the grammar school, the guard house and the weighhouse. It was not a service space like Edinburgh's Grassmarket, since the town house of the Laird of Strathmartine was here, and its west flank was arcaded (always a sign of a superior location), but its principal function in Dundee's civic life is not clear.

Regarding its shore as an asset, Dundee serially reclaimed land for building. In 1500, the shore was on the line of what became Fish Street (roughly at the apex of Whitehall Crescent), but then a 'new shore' was reclaimed in front of it and built upon. That presaged a habit typical of the port of reclaiming more and more of the shore, first for shipbuilding, then – particularly in the later eighteenth century – for woodyards and harbour improvement; in the nineteenth century for extensive new docks and railways, and finally in the twentieth century for roadways and parking. That process has separated the port from its sea.

Whatever else a port has to do, it must protect and enhance its harbour, without which it has no trade. In Dundee's case, that proved to be a considerable burden upon a small burgh. First, the growing part of the town that developed down at shore-level was vulnerable to the great storms that swept up the Tay. Several times – most notably in 1667 and 1755 – the harbour and its circumjacent buildings were damaged or destroyed. The tidal wave of 1755 caused the ground level of the shore lands to be raised considerably– in some cases by a storey and a half – to prevent it happening again. Given the burgh's limited resources and absence of outside patronage, that would have been difficult enough to pay for; but its problems were greatly exacerbated by the behaviour of the River Tay itself. The Tay has the largest outflow of any river in the United Kingdom, and the sheer mass of water pressing against the west breakwater required repeated repairs. But the flow also brought silt, and daily the harbour would fill up with it. Consequently, the Council had to find money to pay for clever solutions to this problem. Over three centuries it appealed virtually every 20 years to the Convention of Royal Burghs for funds to tackle repairs. Simply deepening it was fruitless, since the harbour filled up again. The first solution tried was to construct a 'tidal basin' on part of the former site of Packhouse Square, which filled at each high tide and was then released at agreed intervals to assist workmen digging away at the sandbanks in the harbour, to sluice the water out. It was not hugely effective. Then, the architect John Adam and the engineer John Smeaton proposed filling the land upstream of the west bulwark, and putting sluicing channels beneath it so that the waters of the Tay could be used to scour the harbour continuously. These remained in place until the creation of the first wet docks in the early nineteenth century. So preoccupied were Dundonians with their harbour that it comes as little surprise, therefore, that they regarded it as important a theatre for civic embellishment as the High Street.

The way that Scottish urban society is normally analysed also militates against a reasonable perception of the nature of the port of Dundee. When trying to establish the cultural level of a town, the proportion of its population who are professionals ranks highest. However, the definition of 'professional' has been restricted to those with a liberal university education; and in those terms, Dundee did not rank very high – albeit higher than Glasgow in 1841. However, if the term 'professional' were to include members of a single discipline, exercising roles of responsibility for which they had had a specific education, that definition would certainly extend to shipmasters (ship's captains), who are currently classified as 'commercial'. (One wonders what Jane Austen would have made of that.) In 1821, Dundee's shipmasters

represented the single largest identifiable group in the town, and had they been included amongst the professionals, Dundee's cultural position vis à vis other Scots burghs would seem very different.

Perhaps as a consequence of their peripatetic lifestyle, ship's captains do not appear to have shared the same attitudes towards consumption as the rest of the middling sort in Scotland in the later eighteenth century. Although relatively wealthy (rarely as rich, however, as the Baltic merchants), their apartments do not appear to have been particularly ostentatious, although they did contain plenty of sea chests, glasses, decanters and alcohol. In particular, they do not appear to have been very keen to move from such apartments into the proposed terraced houses of Castle and Tay Streets, the type of home which was becoming the norm for the middling sort in other towns. We do not know very much about them, because they have not yet been studied in detail. Equally, we have a very slight perception of life in the maritime quarter, what businesses were created there, and how it coped with the flow of sailors and ships' crews as they passed through. It was signal proof, however, of the continuing importance of the port, its shipowners and shipmasters, that it was the poor condition of the harbour and the lack of a Council strategy to deal with it, that caused parliament to move control of the harbour from the Council to a new trust, on which the maritime interest was thoroughly represented.

Even the understanding that Dundee had an identifiable maritime quarter is a recent phenomenon, there being no mention of it either in the McManus Museum or in Discovery Point. It is partly the result of the discovery of the sketchbooks of Charles Lawson in Dundee Central Library. Lawson was a jobbing artist in mid nineteenth-century Dundee, whose sketchbooks contain 644 sketches of buildings, closes and interiors. Many of them are serial sketches of the same location, moving from initial outline to a final presentation drawing ready for publication. From notations on the sketches, it is clear that there was a process of selection and approval by somebody else, and the name 'A. C. Lamb' appears on a few. The probability is that Lamb commissioned Lawson to record Dundee just prior to its demolition under the 1871 City Improvement Act, and that the intention was that his finished sketches would be published. But none of them were. Perhaps Lawson's finished drawings were less sophisticated than Lamb desired. Be that as it may, the artist David Small arrived in Dundee fresh from sketching ancient Glasgow. He prepared a selection of about 100 fine wash drawings of Dundee which Lamb did indeed use in his majestic work, *Dundee: Its Quaint and Historic Buildings* (now in the Macmanus Galleries). Most, if not all, of

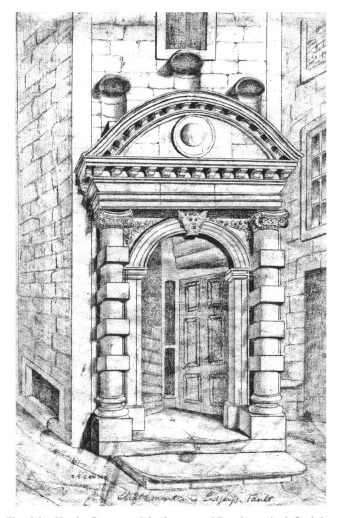

Sketch by Charles Lawson of the doorway of Strathmartine's Lodging.

Small's drawings had been worked up from Lawson's sketches. Small may not even have visited the sites, for there is something neutral – almost abstract and decontextualised – about several of them.

Lawson certainly had visited the sites. He sketched attics and cellars, staircases, hinges, windows and roof-beams promiscuously, alongside recording armorial panels, Gothic doorways, loggias, closes, townhouses, roofscapes, courts, wynds and underground passages. The extent of his collection is wondrous. He must have been in those houses just prior to their demolition, since almost all of them have been stripped of people, furniture and decoration. What makes the collection supremely valuable, however, are his depictions

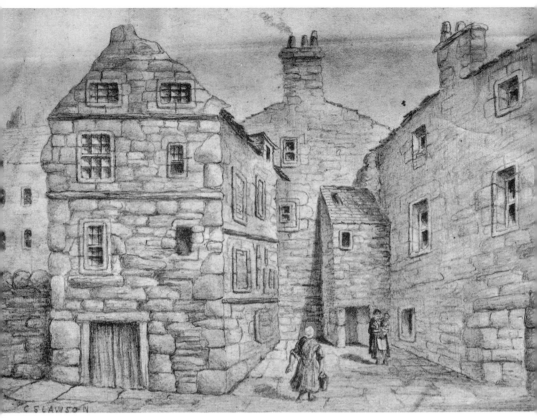

Kay's Close.

of interiors of houses; they show the sheer richness of their panelling, plaster-work, buffets, Renaissance fireplaces, Adam fireplaces, scrolls, cherubs and closets. It is in the view from a finely panelled, shuttered and plastered draw-ing room in Bradford's, Butcher Row, overlooking the masts in the harbour, that one can finally sense the atmosphere of Georgian Dundee as a port. It is from his depiction of the tight court in Kay's Close, the changes of level in Scott's Close and the astonishing concentration and huddle of roofscapes in Keys Close – so different from what he recorded in other parts of the town – that we can begin to appreciate the maritime quarter as having a distinc-tive form and way of life.

When concepts of improvement and modernisation began to infect Scotland in the eighteenth century, Dundee improved itself (it was ahead in the widening and straightening of streets, removing old-fashioned timber galleries from the tenements facing the main street), but it never modernised itself by building a grid-iron new suburb on which to locate its new civic

monuments. Indeed, some may find it difficult to take the notion of 'classical Dundee' seriously until they appreciate the extent of Georgian rebuilding that is recorded in this volume. Moreover, Dundee's classical buildings were erected in the softer Scottish provincial classicism of the period pre-1800, whereas the architecture now assumed to represent Scottish classical is from the later neo-classical period – which was altogether crisper and more hard-edged. So Dundee's classical buildings have never really received adequate recognition. But what the town built by way of a new Town House, pack-house, Trades Hall, infirmary, lunatic asylum and two churches – to say nothing of a completely reformatted western entrance into the town, dotted with small classical villas – was far from inconsiderable. Since only a single church of this period, St Andrews, survives, Georgian Dundee has slipped from the memory as conclusively as the Renaissance port.

The memory of the burgh has been profoundly affected, for buildings provide an anchor for both memory and history. When you lose the building, not only do you lose memory, but its replacement can overwhelm any residual recollection of its predecessor. Thus, pre-1800 Dundee was perceived either as an early example of the urban misery typical of the later Victorian period, or as an insignificant working-class community – a proletarian mill town. Take Sinclair Gauldie, for example, quoted in *Dundee: An Illustrated Introduction*: 'The eighteenth century burgh never experienced that expansion of a civilised middle class which ensured the success of Edinburgh's New Town.' Its 'civilised middle class' did expand, but they opted *not* to build a new town. But the story of Dundee, according to the same author, had become one where it was but 'a modest burgh with a fairly typical eighteenth-century social stratification, whose "tone" was set by the lifestyles of merchants and artisans and became within a matter of decades an industrial city with an overwhelmingly proletarian population'. In short, Dundee was an insignificant and rather downmarket Georgian burgh, which became a proletarian mill town.

Gauldie was a highly knowledgeable and intelligent playwright and architect. His perception, therefore, demonstrates the extent to which the mythological history of Dundee – the Dundee of *Witch's Blood*, by William Blain – had taken hold. However, it would have been more exact to say that Dundee was 'a highly significant and prosperous seaport that became a dynamic and prosperous industrial city, only declining with the decline of jute'. The implications are hugely divergent.

The next myth was the characterisation of industrial Dundee as Juteopolis. Jute became the dominant import of the town only in 1858, and Baxter

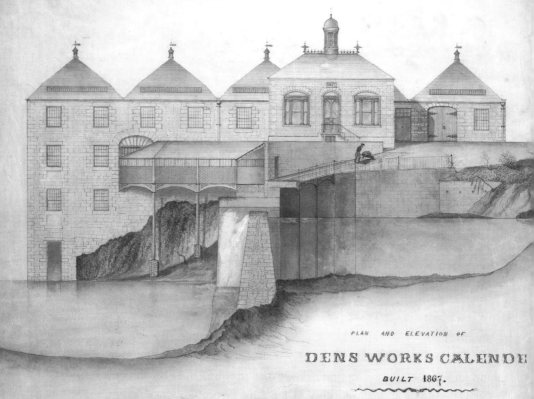

PLAN AND ELEVATION OF

DENS WORKS CALENDER

BUILT 1867.

SCALE

Brothers, for example, never moved their great linen complex of the Dens over to jute. In the first half of the nineteenth century, Dundee was the linen centre of the United Kingdom; but, as Part Two: Juteopolis 1820–1900, explains, it had also become a centre of railways, engineering and the associated industries. Its expanding docks coped not just with the whaling fleet, the later herring fleet, and with an enormous increase in shipbuilding, but also with the gigantic clippers that travelled directly from Dundee to Calcutta and other Indian ports. An industrial town grew up in its wake. To the Victorians, factory smokestacks represented business and progress, and those arriving at Dundee by sea would have seen the ancient port surrounded by 200 of them. Small-scale industry and warehousing had filled up the gardens in the old town, but large-scale industry lay in a thick swathe around the fringes which, from a combination of the steep slopes on which they were built, and the lack of any strategic planning, were (and are) characterised by cul-de-sacs. The industrial zone that encircled Dundee became impenetrable, and that became the primary characteristic of Juteopolis.

So why did Dundee's politicians allow this to happen? Other towns and cities managed to regulate even the fiercest of nineteenth century industrial growth quite satisfactorily. The answer probably lies earlier, in the bitter dispute between merchants and the Council over the condition of the harbour in the later eighteenth century – a Council which, for virtually 40 years, had excluded the Baltic traders from its membership. When asked by a parliamentary committee in 1817 about the composition of Dundee's Council under Provost Alexander Riddoch, 'Riga Bob' Jobson, a Baltic flax merchant, had replied that 'nobody respectable' was on the Council. In the eyes of the town's entrepreneurs, the Council's reputation for business had been permanently damaged by the Riddoch era, and it could not be trusted with any but the most basic powers. So, when the Council attempted to introduce a municipal water supply to the town 20 years later, it was ruinously opposed by the town's entrepreneurs.

Thus, when it came to town planning, the Council was struck by a strange gormlessness. Before 1871, the planning of the town comprised a litany of half-completed concepts and unfulfilled ideas; and, in striking contrast to Glasgow, the leaders of the town's industries remained aloof. Plans – good plans – were drawn up, but the Council failed to implement or enforce them. There was nothing, therefore, to prevent industrialists large and small from occupying whatever land they could purchase, and developing it as they pleased. The urban opportunity of the Meadow lands (see p. 10), provided

Opposite: Dens Calender Works. This is the calender building where the jute products were given their final finish by compression and smoothing.

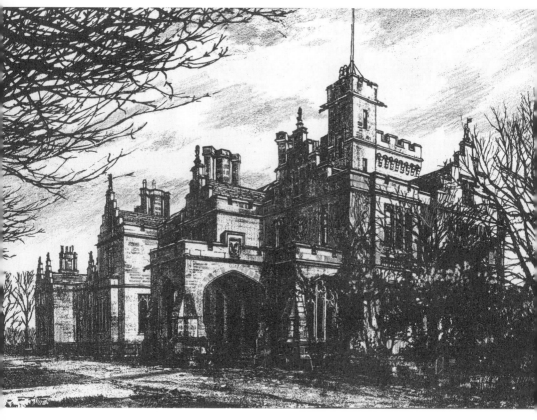

Castleroy, one of the 'Jute Palaces' built by wealthy industrialists, drawn by David Walker in 1958.

perhaps the most striking example of available land in the right place being squandered. Land that should have been developed as the showcase of a modern city evolved as a confusing hodgepodge of mixed uses – high-status monuments such as the High School surrounded by warehouses and wood-yards, with a little railway being towed down the middle. This was deeply embarrassing. Whilst the Council dithered, the town's population was inflating. Although it grew by 500 per cent between 1820 and 1890, the infrastructure of the town in 1870 remained essentially that of 1780. The position was that Dundee in 1871 comprised the largest surviving medieval town centre in Scotland, swaddled on all sides by a thick belt of largely impenetrable glowering industry, with incomers filling up whatever gaps they could find. Something would have to give.

By 1871, however, the character of the ancient seaport of the 1790s had given way to enormous dock expansion and railway lines driving across

beaches and the muddy foreshore. The reclaimed lands to the west were now occupied by railway sidings, marshalling yards and coal depots, whereas the Seagate, whose gardens had once touched the water's edge, was now over half a mile inland. The Corbie and Windmill hills had been quarried away. Shipmasters no longer inhabited the maritime quarter, and Kay's, Key's and Scott's Closes were packed with the poor instead. Fish Street was becoming increasingly well known to the police and the newspapers, for its inhabitants' habits offended the Victorian nostril. Maritime activities like shipbuilding, rope-making and even the seamen's home had mostly followed the docks downstream.

In 1868, the business acumen of the jute barons finally arrived in the Council. James Cox, chairman both of Cox Brothers (of the Camperdown works) and of the Tay Rail Bridge Undertaking, was elected that year, and two years later he was provost. The following year Dundee had appointed a burgh engineer, William Mackison, and had obtained a 'City Improvement Act' for him to work with. Small-trader indecision was being replaced by industrialist managerialism. The City Improvement Act addressed efficiency, health, sewers, trams and urban grandeur, but not the poor and destitute who inhabited the concentrations of ancient buildings that were about to be condemned.

By extending Commercial Street in the manner of Baron Haussman's Parisian boulevards through the narrows of the Murraygate and Seagate, eventually reaching Albert Square, Dundee provided itself with a ceremonial carriage entrance to the town from the railway stations and the harbour. It was more or less complete by 1880. The next phase took out the Maritime Quarter and replaced it with Whitehall Street and Crescent, which provided a stylish entrance for rail passengers to the High Street. Dundee was reluctant to use architects in determining its new grand manner, preferring Mackison's more blustering designs. This way of doing things would extend into the twentieth century, with the even grander (but unsubtle) designs of the city engineer, James Thomson, and to the twenty-first century with similarly unsympathetic replanning of the Shore. Dundonians had never been particularly sentimental, but with the appointment of Mackison they became preoccupied with the present and the future at the expense of the past. Now they had the powers to achieve 'modernity', they fell in love with it.

There was something magnificent in Thomson's proposal for 'Chicago on Tay'. He attempted to use the third phase of city improvement to create, in Dundee, a miniature version of what his acquaintance, Daniel Burnham, proposed for the Michigan shore in Chicago – the construction of a huge, new domed city hall, a concert hall, a museum, a covered market on the site of the

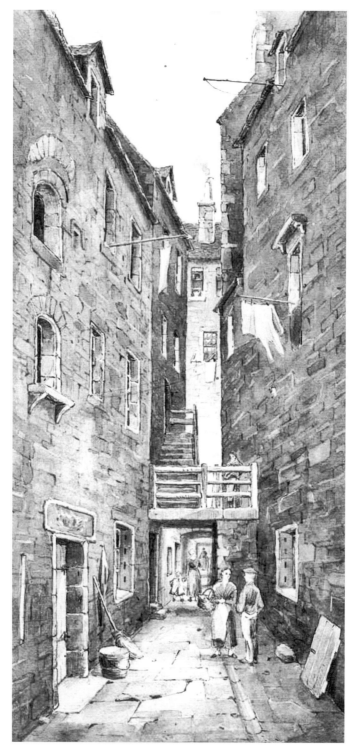

XXII

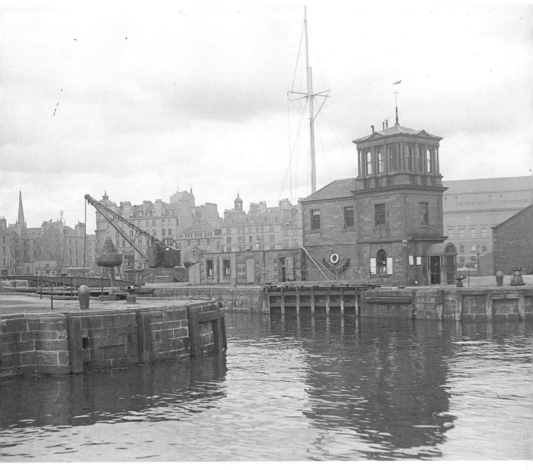

Above: Dundee Harbour and Caird Hall. Opposite: Mitchell's Close, off Seagate.

Vault; the re-orientation of Crichton Street on a beaux-arts axis focused upon statues, the *Haubtbahnhof*, or central station, that had been talked about for the previous 40 years, and an enormous reclamation of foreshore into Edwardian walks and parks. He also planned street-widening (the Queen's Hotel was identified to be pulled down, as was much of the Seagate) and the reconstruction of the Overgate. He blocked the proposal for a new city hall designed by Sir Robert Lorimer on the site of the Luckenbooths. Thomson's designs were not delicate (as may be appreciated from the Caird Hall), but the most significant aspect of his remodelling was that he found nothing in the town of sufficient value to preserve – save possibly the Town House, which he made a very half-hearted effort to save by shifting elsewhere.

Whereas the nineteenth century was preoccupied with coping with the growth of an industrial boom town, the problem for the twentieth was

entirely the opposite – coping with a town whose industry contracted fiercely and terminally, its population eventually following suit. Whereas it might be thought that the heritage would be safe once the redevelopment pressure had been removed, it did not quite work out like that. For, in its search for a post-jute existence in the 1950s, Dundee fell back on image and made up its mind to strive to become Scotland's most modern town.

Jute had begun to decline in the 1890s and, although boosted by the need for sandbags in the First World War, it continued downwards thereafter as plastics became more favoured. So, between the two world wars, Dundee was characterised principally by industrial decline and suburban growth – suburbs to the north and east, the Kingsway with its ice rink and industrial estates to the north, and the construction of the pioneering Logie housing estate in the inner north-west in 1918. The middling sort huddled in their houses in the West End, Broughty Ferry and Newport, powerless as the centre collapsed. This was the context in which the third phase of city improvement took place, namely the demolition of the Vault, Town House, Strathmartine's Lodging and associated buildings, to make way for a new City Chambers and City Square. Since one of the arguments used for the demolition was that it would increase work in the building trades at the height of the Depression, only a few voices were heard in protest – principally those of Dundee's trades, architects and the Chamber of Commerce.

Dundee did enjoy a certain amount of a leisure boom (although not comparable in extent to Glasgow's), expressed by cafés, dance halls, garages

Green's Playhouse.

and skating rinks. Most distinctive, however, was Dundee's love of cinema. The town had over 80 of them over the years (but not all at the same time), including Green's Playhouse, which was not just the second largest 'super cinema' in Europe, but unexpectedly stylish. Its façade and entrance suites had been designed by the young Montrose architect, George Fairweather, whilst working in Blackpool in the fashionable office of Joseph Emberton. He transmitted his ideas to the architect of Green's Playhouse, his uncle, John Fairweather, who had them built. In due course, all but two of Dundee's cinemas would be demolished – one converted to the Whitehall Theatre and the other rebuilt as a bingo parlour. Nonetheless, although the 1930s had done little essentially to transform either Dundee's character or its opportunities, a new pressure was beginning to emerge – that of the motor vehicle and, with it, the question of whether there should be a road bridge across the Tay.

In 1946, all British towns and cities were required to commission development plans, so that they could avoid the mismanagement of the urban fabric so evident in Victorian Dundee. These plans should have had two parts: one analysing the essential character of the town, and the other making proposals for change. Dundee's, published in 1952, provided only a token evaluation of the essential character of the city. Only twelve buildings were considered worth protecting – seven of them churches, and nothing in the Overgate – and everything else was expendable. The city centre was to be reshaped by a traffic bypass to which the road bridge, relocated from the eastern suburbs, would be connected on former docks at the very centre of town. It was a very political gesture in favour of modernism. The inner ring bypass would take out (amongst others) Long Wynd, St Enoch's Church, the West Port, the New Howff, most of lower Chapelshade and remove the eastern edge of the city. Far more damaging, however, was that the opportunity of the bypass triggered the fourth, final and largest phase of the clearance of medieval Dundee – the destruction of the vast swathe of old Dundee that had survived in and around the Overgate. It was to be replaced by the first modern shopping centre of its type of Britain. However, rather than creating a twentieth-century Dundee of which its citizens could be proud, as they had been promised, an indifferent shopping centre was constructed, which had an undistinguished life of barely 30 years. In doing so, the city destroyed not only its citizens' past, but much of their self confidence and belief in the future.

Post-industrial contraction has proved very difficult for Dundee and the process is not yet complete. However, the origins of how the city has revived so strongly since the mid-1990s lie back in the 1880s, namely the largely unobserved but enormous growth of Higher Education, led principally by

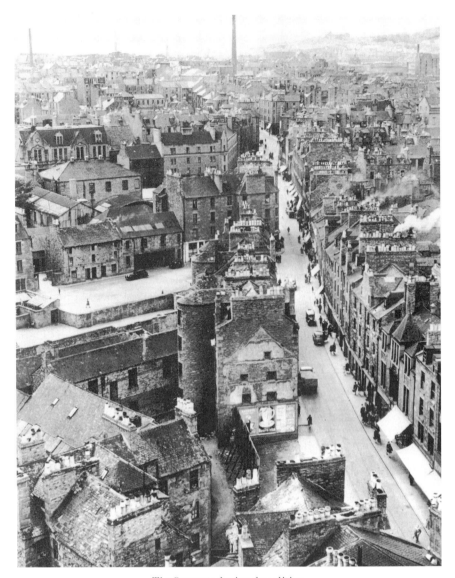

The Overgate during demolition.

Dundee and Abertay universities. Both institutions, which trace their origins back to jute funding from the Baxter family, grew to the extent that, by 1996, Dundee had attained a student/citizen ratio equivalent to that of Heidelberg – in other words, the same as Germany's oldest, and principal, university city. Dundee had become a university city – it simply had not cottoned on to it.

The universities impacted upon the town far beyond mere employment and the attraction of students (although university spin-off is now regarded

as being Dundee's new growth sector). Abertay occupied the centre of town – effectively Lower Chapelshade – and became the principal regenerative force in a part of Dundee that had been grimly affected by the closure of jute companies' head offices, and the destruction wrought by the bypass. The University of Dundee, colonising the sunny slopes of the Nethergate and Perth Road up to Hawkhill, has effectively created a new Hawkhill. However, it also bent its attention to the city itself, being deeply involved in the rescue of Gardyne's Land, and its archives amassed unmatched jute, railway and health material relating to the city's history. In 1997, its History Department initiated the three-volume 'Dundee Project'. The first volume was published as *Victorian Dundee: Myth and Realities* in 1999. The second volume, *Dundee 1500–1820: From Renaissance to Enlightenment,* will be published in 2009 and the third volume, *Dundee in the Twentieth Century,* should follow two years later. The authors of this volume have gained valuable insights and information about Dundee's past from the Project.

It is the research effort put into these volumes that should provide an adequate counterbalance to Dundee's much beloved myths – Monk's siege and massacre, jute, jam and journalism, kettle boilers, class warfare, witches, Jacobites, capitalist exploitation, and proletarian mill town – and allow us to begin to appreciate the city for what it really was. This book is intended to provide the essential visual evidence to complement that new research.

It all began with the port.

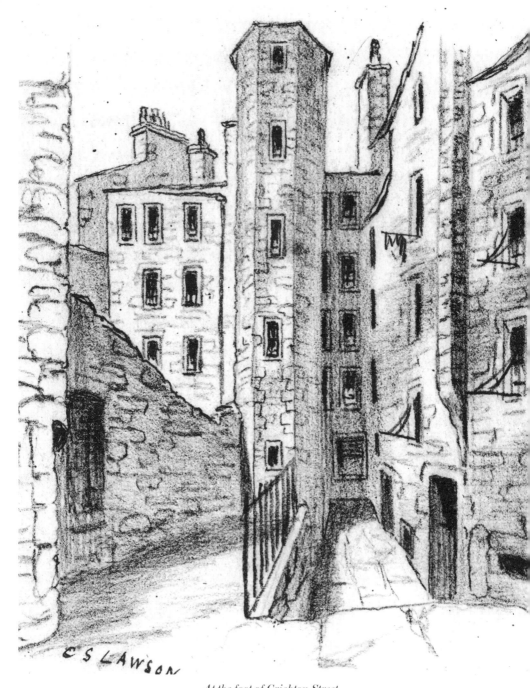

At the foot of Crichton Street.

SEAPORT 1500–1820

INTRODUCTION

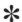

> One of the most beautiful and most populous towns of the country.
> *French army officer, Jean de Beaugé, 1547*

Renaissance Dundee is the burgh that Scotland has forgotten. Neither its mother church, St Mary's, nor its five monastic houses, nor its twelve chapels figure in the standard books on Scottish medieval or Renaissance architecture. Yet, with its 48 altars and chapels, St Mary's was the largest parish church in Scotland, with the tallest and most imposing steeple, and Dundee's Greyfriars was the largest Greyfriars establishment. Equally overlooked are its houses and civic monuments. Yet only in Edinburgh were Dundee's five-to eight-storey mammoth tenements equalled or surpassed in scale. By all accounts, the burgh's tolbooth, splendidly rebuilt in 1560, far outshone the rest in the country. Although Dundee's population was about half that of the capital, its urban footprint was about the same.

Dundee was second only to Edinburgh amongst Scottish towns in size and wealth from the beginning of the fifteenth century until c. 1673 and it built accordingly. The problem is that virtually nothing of that Renaissance town survived the nineteenth- and twentieth-century urban improvements. The consequence is that the burgh has generally been perceived as a manufacturing town – an industrial city – of the Victorian period, and thereafter as a struggling post-industrial city. Only a single example of that earlier Dundee – Gardyne's Land on the High Street – now faces a main street. The remainder, surprisingly extensive, lies unnoticed amidst the remains of 30 of its former 100 closes and wynds behind later street frontages: neglected little time-capsules of a much nobler history than most Dundonians have so far understood.

On the face of it, to have become the second city of Scotland, Dundee must have been unusually successful and enterprising, for it lacked all of the advantages enjoyed by other burghs. Urban success in medieval Europe was governed by the amount of patronage that a town enjoyed. The more that it could call on the presence of king or court, a cathedral, an archbishop or

a great magnate, to that degree would its trade, culture and crafts prosper. Likewise, being the regional market centre, the county town, the seat of justice or location of a major university, would bring comparable benefit. Dundee enjoyed not a single one of those sources of patronage. Although regional aristocrats like the Earl of Strathmore would eagerly take shares in Dundee ships, the burgh and its merchants had to depend upon their own resources and the exploitation of the city's principal asset: its port, whose extensive and sheltered anchorage or 'roads' was well-placed for trade with northern Europe and the Baltic. The élite of Dundee were neither titled grandees nor churchmen, but internationally-trading merchants known as merchant venturers, and its shipmasters (ships' captains). In its dependence upon sea-borne self-reliance Dundee, far from being an industrial town, was a great port, most similar to the Hanseatic ports of Lübeck and Danzig with which it traded regularly.

The heyday of Renaissance Dundee was probably in the 1620s. Recovering from the mean-spirited and destructive occupation by the English army in 1547–50, the burgh had rebuilt its town centre and re-roofed St Mary's nave (not repairing its damaged crown steeple – see p. 111), extended its harbour, reclaimed land for a 'New Shore', and grouped its new public buildings together – the tolbooth, the grammar school, the weighhouse, the fleshmarket and the packhouse (cargo stores) – to enhance their impact. They were all located on a new axis running between the market place, the Vault (the piazza immediately behind the tolbooth) and the harbour. The town's arsenal was converted from a nearby windmill.

During the later sixteenth century, the burgh was run by about 40 élite families – including Wedderburns, Mylnes, Hallyburtons, Allasons, Ramsays, Guthries, Scrymgeours, Fletchers and Yeamans – and income was predominantly earned from trade with Europe: export of cloth, skins and fish, and the import of luxury goods, citrus fruit (the king often sent to Dundee for his oranges), hardware, salt, wine, sugar and timber from Norway. Since these families felt more secure dealing with their own kin, they developed a pattern whereby some members of the family would live in the port of destination, others would travel on the vessels and key members of the family would remain in Dundee to run the business and participate in the burgh affairs.

David Wedderburn, merchant of the Overgate, who also owned a property in Fish Street by the New Shore, is the best documented example. He was principally a dealer in cloth, fish and skins, his salmon and his linen invariably marked with his initials, DW. His extensive family network was reinforced by enormously carefully planned marriages and alliances. His ten

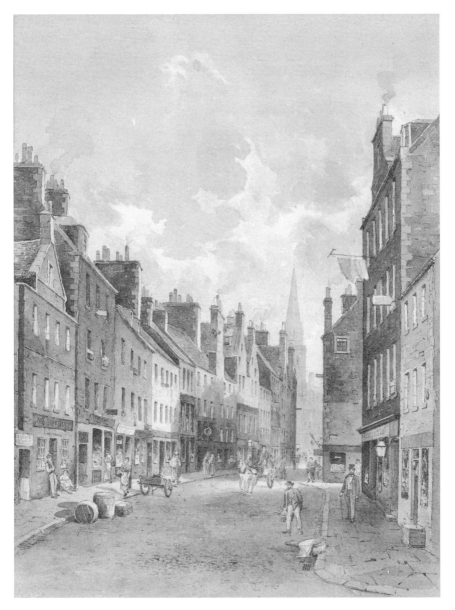

The Narrows of the Overgate.

children had three godmothers and three godfathers each, which bound the family to much of the rest of the élite of the town. Thus fortified, overseas trading was entrusted to his relatives: cousin Richard Wedderburn was an indweller in Elsinore, and brother Robert in Bordeaux. Bessie Wedderburn (cousin) was sent with one cargo to Denmark, nephew William was dispatched

to Danzig, nephew Alexander to Spain, and son-in-law James Symsone was based in Flanders. Through Symsone, David imported most of his 'dry goods' – such as plates, trenchers, lavers, salt flats, water pots, mortars and pestles, candelabra, candlesticks, velvet hangings, hats and cans of cherries. He imported whatever he could sell – olive oil, endless puncheons of white wine, claret, English cider, pepper, saffron, vinegar, Canary sugar, marmalade [murmblade] and a barrel of confections – and traded in jewellery as well as hiring out guns, pistols, muskets and swords.

Wedderburn was also a substantial banker, and a shareholder in the ships *Diamond*, *Falcon*, *William*, *Rochill*, *Lyon*, *Robert of Dundee*, *Clinkbells*, *Primrose*, *Swallow*, *Andrew*, *Providence*, *Nightingale*, *Pelican* and *The Lamb*. He was a highly cultured man. He instructed merchants to buy books for him in London and paintings in Holland and he lent out his books to his friends. On 7 November 1621 alone, he lent 21 books. His reading was predominantly cultural rather than religious, with an emphasis upon literature and history: Holinshed's *Chronicles*, Marlowe's *Dr Faustus*, Chaucer's *Ortelius*, the poems of Sir David Lindsay, Virgil and Ovid, a book of fishes in French and Drake's voyages. There is no reason to believe that Wedderburn was unusual amongst his peers. What singles him out is only the survival of his account book.

By the beginning of the seventeenth century, Dundee's merchant élite began to purchase small estates in the burgh's hinterland for use as villas – as was typical throughout Europe. These were not great estates required to provide great income, since their purchasers' principal income derived from trading in the town. These villas were small, elegant and rural, sufficiently close that the merchant could retreat from the town and soon enjoy 'blisful ease'. In 1642, for example, the Clayhills family (Baltic merchants) bought Invergowrie from Patrick Gray, making three estates held by that family, the others being Baldovie and Drumgeich. The Wedderburn dynasty held Easter Powrie, Forgan, Moonzie, Craigie and Kingennie prior to purchasing Blackness, and the Kyds held Craigie.

Dundee was the only Scottish burgh of this significance whose defining character was that of a port. Its industries derived from the processing, producing and distributing of exports and imports. A maritime quarter duly emerged down on the shore, and in the wynds and closes leading down to it, whose purpose was to service the port. It is unclear whether or not the burgh's craftsmen congregated in other distinct districts, as was customary in Europe, although shoemakers appear to have congregated in the Overgate, bucklemakers (gunsmiths) in the Wellgate and bonnetmakers in the Hilltown. The grandest of mercantile town houses probably lay in the

Overgate, as exemplified by David Hunter's great lodging (see p. 23), whereas the regional gentry and aristocrats, such as the Earl of Crawford, appear to have preferred the less dense district between the Nethergate and the sea.

The seventeenth century, however, was not kind to Dundee. As were all major Scots burghs, it was struck by plague in 1605 and again in the 1640s. Moreover, the burgh's sheer opulence and its indefensibility made it a good target for malevolence and in 1645, the Marquis of Montrose duly obliged. The town was badly damaged, and the nave of St Mary's was burned out for a second time. Although the burgh was recovering by 1648, symbolised by the Guildry's donation of the splendid sundial on the pier, it was attacked again in 1651 by General Monk's troops – generating the first of Dundee's myths.

The town, so it is alleged, was besieged for months, during which it was flattened by bombardment. It was then stormed, no quarter was given, and up to a third of its citizens were massacred – the slaughter only ceasing when Monk had observed an infant trying to suckle its dead mother. The burgh's vast wealth – which included that of other Scots burghs that had been sent to Dundee for safekeeping – were loaded with the town's records onto 50 ships in the harbour which, when sailing out into the 'roads', were all sunk by a sudden divinely inspired storm.

This story has enormous staying power; but how much is true is questionable. The burgh records do not lie beneath the Tay, but in the city archives. The harbour at that date could not take 50 ships at once. The siege lasted only over a single night, the assault beginning at first light and the contest over by 11 a.m. Quarter must have been given since many prisoners were taken to London. It is more difficult to calculate the number of those killed, but current research suggests that two companies of defending soldiers and perhaps 50 or so of the town's élite – no more than 700 in all – may have fallen. Since buildings in the Cowgate remained ruined for decades thereafter, and there is some evidence (or, rather, *was* evidence) of significant change to upper storeys in some town centre buildings, with a reduction in height, there had evidently been some damage. But on balance, Montrose's earlier attack had probably been worse.

The burgh appears to have recovered quickly, for it remained the second city of the realm (by tax revenue) for a further two decades, until it was finally overtaken in the 1670s by Glasgow, whose trade with the Americas was beginning to grow rapidly. In 1667, severe storms appear to have destroyed Dundee's entire sea front and harbour, and the burgh was still paying off the costs of rebuilding it 30 years later. By the 1680s, however, the volume of shipping had returned to the level of the 1630s, and the wealth of individuals in the

town was indicated by the significant number of Dundonians who invested generously in the disastrous scheme to establish a colony at Darien on the Panama ithsmus.

This recovery, however, was put at risk by the famine which hit Scotland between 1695 and 1699, as a result of which the town's population may have dropped by as much as 15 per cent. By 1708 Dundee was virtually bankrupt, crippled by its inherited debt and lower level of economic activity. Its merchants were beginning to refuse civic office lest they become personally liable for the town's debts. The adventurous plan by the Guildry to construct a new port for Dundee (Newport on Tay) on the Fife shore by Inverdovat (thus escaping the sweeping silt and sandbanks of the Tay) proved a costly failure. It would be wrong to suppose, however, that the state of the burgh's finances represented its merchants' circumstances. Scots burghs were generically under-endowed to carry out their principal tasks of providing for the ministry, education, order and for the state of the buildings and the public realm, and most Scots burghs were appealing to parliament claiming dire straits in the opening decade of the eighteenth century. Paradoxically, however, individual merchants and craftsmen could be doing extraordinarily well. Hence the elaborately carved timberwork and plasterwork, and the fine panelling of this period so well revealed in Charles Lawson's drawings (see p. 49).

The burgh's financial weakness would not have been helped by the overt Jacobitism of its leaders in 1715–16, particularly of its clerk, Sir Alexander Wedderburn. Dundee, whose ministers had remained Episcopalian, was the largest Scottish town to declare openly for the Old Pretender, who was awarded a formal ceremonial entry. However, even after Hanoverian order was restored, there was no witch-hunt. The burgh evidently perceived that with its economy under such threat, and lacking any significant external patronage, its best interests would be served by turning a blind eye and getting the mercantile community to pull together. There were no executions, and only a few minor and brief imprisonments, with Wedderburn only exiled to his villa at Blackness.

Dundee's next major change was inaugurated in the 1730s, when the collapsing tolbooth was replaced by William Adam's majestic Town House. Once it was complete, the Council set about ensuring that the town's principal streets matched up to its new standard of dignity. It compulsorily purchased any derelict building or derelict site to sell it for redevelopment. Soon thereafter, it decided that the timber-galleried frontages of the principal streets not only presented a fire hazard but were old fashioned, so that most of them had been stripped off by the 1760s. Thus the burgh lost the arcades

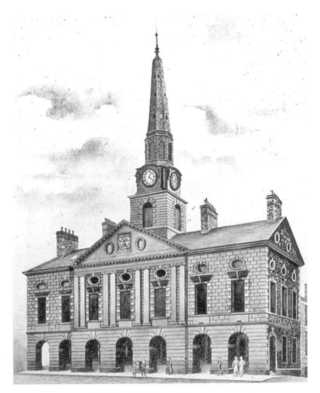

Dundee Town House.

that once lined its streets. The burgh then fettled up the town centre with better paving, new street lighting and a regularisation of building frontages. Down on the harbour, the elderly 1644 packhouses were already under threat of replacement when the 1755 tidal wave caused by the Lisbon earthquake swept in from the North Sea, scooped out the eastern side of the harbour, and flooded the shore lands. The packhouses were entirely rebuilt the following year, and the level of the streets, wynds and closes at shore level was raised from four to twelve feet, depending upon location.

The seventeenth-century trading pattern had been replaced by a new one. Ships were soon trading directly between Dundee, Charleston and the West Indies, whilst others were importing wine, fruit and exotics from Spain and Italy. New lines, however, were being developed. By 1756 shareholders were being sought for new whaling companies, presaging what was to become a major element of Dundee's business for the next century at least – not least in providing the oil for the street lamps. In 1766, a sugar master was imported from London to establish the Sugar House in Seagate, and the town had developed the manufacture of coloured thread, tanning

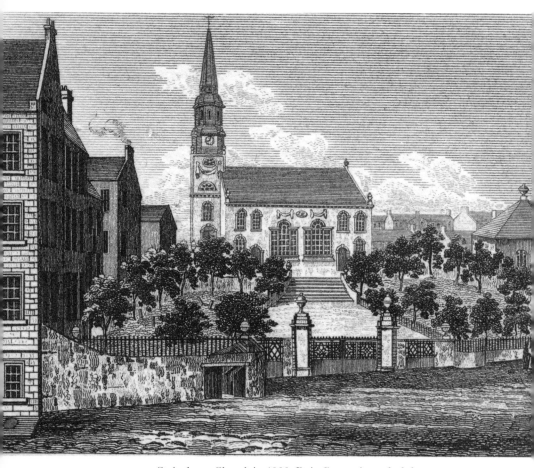

St Andrews Church in 1822. Bain Square is on the left.

and shoemaking. The key, however, was the manufacture of cheap brown osnaburgs linen, principally in the Forfar area. Flax was imported on Dundee vessels from the Baltic – principally from Riga, Danzig and St Petersburg – processed by spinners and weavers in the hinterland, and then re-exported to America, often via London. The Baltic once again had become Dundee's principal focus, and once again members of the trading families would be domiciled in the destination ports ('Riga Bob' Jobson living in Riga for example, and his neighbour, James Johnston, in St Petersburg).

It was not, however, a pretentious town. When Alexander Carlyle visited in 1768, flush with the founding of Edinburgh's New Town, he found little remarkable to note in Dundee, wilfully overlooking William Adam's splendid Town House. He might have come to a different conclusion had he visited a decade later. Once its principal streets had been smartened up and

regularised (and in the case of the Murraygate, almost entirely rebuilt), the burgh set about equipping itself with a complete quiverful of new civic buildings comprising one of the first systematic urban improvement programmes in Scotland: St Andrews Church (1772), the Trades Hall facing the High Street (1776) and the English Chapel opposite (1782–85) requiring the relocation of both the fleshmarket and the cornmarket to the shore, Trinity House (1790), the Steeple Church (1791), the Royal Infirmary (1794) and the Theatre Royal (1810). It was a sign of the burgh's unusual ambition that it had appointed a burgh architect as early as the 1770s, the position being taken by the town's wright, Samuel Bell. Bell was responsible for all these public buildings, for a number of new villas at the West End, and for the laying out of the new streets. In the course of his career he amassed a substantial property portfolio and wealth comparable to the greatest Baltic merchants. Three new streets between the town centre and the shore and harbour were opened up – St Andrews (1773), Crichton (from 1777) and Castle (1795) – and the harbour itself was under perpetual repair and extension. Whereas Crichton Street, feued out with smart apartments, was quickly successful, both Castle and Tay Streets, feued as terraces of houses in the new model of Glasgow and Edinburgh, remained largely unbuilt for another 30 years. The majority of the port's élite preferred to remain in large, suitably refashioned apartments in the town centre.

Dundee's character as a seafaring town developed alongside its trade. More Dundonians became captains of East Indiamen than did Glaswegians, and by 1821 the largest single identifiable group amongst the Dundee élite were not merchants and manufacturers, as one would expect in Scotland, but shipmasters. Whaling companies had their premises and boiling yards in the Seagate. Support services to the port in the maritime quarter had developed in the form of shipbuilding, blockmakers, ships biscuit-makers, numberless barbers and taverns, ropemakers, vintners and carpenters. Judging by where they lived, it appears that the maritime industry probably had its own doctors as well.

The manufacturers of cheap brown linen transferred easily to making sailcloth, and were therefore well placed to prosper from the war with the French after 1793. Moreover, many of the town's potentially troublesome young men joined or were press-ganged into the navy (for there was a press-gang rendezvous down by the harbour). The consequence was that by Scottish standards, the burgh remained unusually well-ordered, and that sense of decorum also governed the industrial areas in the suburbs that were beginning to emerge along the Scouringburn and the Dens Burn.

Although the town's population had been growing steadily, the expansion rate was nothing like Glasgow's. However, the figures may be misleading, since an industrial population, probably numbered in its thousands, had been growing where there was water power just outside the town's boundary. Nonetheless, there was still no indication of the typical urban problems of overcrowding and disease of other mid-nineteenth-century cities, which some have tried to project back into the eighteenth. Still almost entirely intact, the medieval town had gained a few new streets, the Nethergate Narrows had been removed, the street frontages had been regularised, and the timber galleries largely removed also. Almost all of its civic monuments had been rebuilt, and some new ones added. Nonetheless, sooner or later, the dense mass of building in the centre, penetrated only by narrow closes and wynds, would require to be addressed.

A sense of industrious self-satisfaction, however, was to prove Dundee's undoing. However well reformatted its centre and its apartments, and however smart its public buildings, there were few useful roads, and access to the harbour remained inconvenient. It was, essentially, an ancient unmodernised town. Yet in the late eighteenth/early nineteenth centuries, virtually all Scottish towns took the opportunity to construct new towns with a more efficient road pattern on adjacent burgh-owned land. Dundee's Ward lands and the Meadows adjacent to the town were available for Dundee to do likewise, yet it had no urge to follow suit: neither to have streets laid out like Glasgow, nor to promote suburban development like Aberdeen and Edinburgh. It did not even take the opportunity either to build a more efficient east–west route or to bypass the town's medieval 'narrows'. Thus, alone of all significant Scots burghs, Dundee did not equip itself with a fashionable classical quarter to provide the required context for its new public buildings. Since there appeared to be little demand for terraced houses, the burgh forewent the simultaneous opportunities of urban replanning. However, this failure to provide itself with a new town district was soon interpreted entirely negatively: Dundee had not done so because it *could not* do so – because it lacked both the money and culture. This lack of perceived modernity was to become an albatross around the burgh's neck.

Dundee's merchants and shipowners had been focused upon continuing problems with the harbour instead. This small tidal basin, so prone to silt sandbanks, was acting as a brake on commercial expansion. They regarded its condition as the consequence of inept management by a Council ignorant of the requirements of international trade, and therefore lacking an adequate strategy to deal with it. In 1815 harbour management finally became vested

in a new trust. The first steam mill had opened in Dundee in 1805 and Dundee was ready to leap forward. Over the next five decades, seaport Dundee ceded to Juteopolis.

PART ONE

SEAPORT 1500–1820
THE ARCHITECTURAL HERITAGE

※

DUNDEE FROM THE HARBOUR IN THE LATE
EIGHTEENTH CENTURY

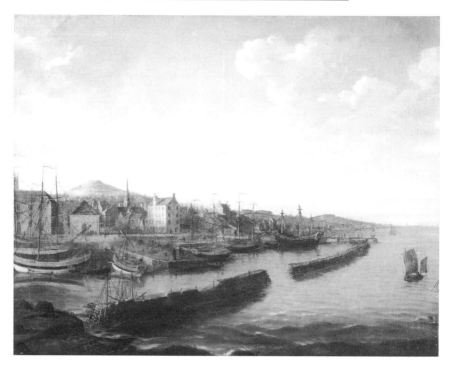

This painting is possibly the earliest representation of Dundee from the sea, and for the next 200 years this perspective became the burgh's favoured image of itself: namely, as a port. The late-afternoon scene, viewed from the Ross Head breakwater, was probably commissioned to celebrate the substantial remodelling of the harbour in 1770 completed under the guidance of the renowned English engineer, John Smeaton. Dundee's perennial problem was the vast quantity of silt washed down by the Tay, creating sandbanks in the harbour and blocking the entrance. Smeaton introduced three new

12

water tunnels to direct the flow from upstream to sluice the harbour out. This meant that the harbour was once again full of ships, with others waiting their turn anchored in the 'roads' downstream.

On top of the central pier (sometimes called the coal pier) stood a set of balances and the great sundial erected by the Guildry in 1649. The pressure on Dundee's harbour was so great that vessels loading and unloading were kept to a strict timetable which the sundial not only symbolised but helped make work. The imposing buildings to the left were the packhouses (civic storehouses) designed in 1756 by architect William Robertson to line the western harbour. The Lime Tree Walk or Merchant's Exchange at the centre led visitors up to the market place and heart of the town. The pedimented façade of William Adam's Town House, 1732–4, soared above the harbour, just as its other façade did to the market place on its north side. Castle Hill, on the right, was topped by a statue to Poseidon (as at Danzig and Gothenburg, with whom Dundee traded). Castle Hill House, built by Dr John Willison c. 1760, lay to its right. Now used as the vestry of St Paul's Cathedral, Castle Hill House incorporates masonry from much older buildings in its lower floors. The seven-storeyed building in the distance along the Seagate to the east was the sugar house, constructed in 1766 by Dundonian

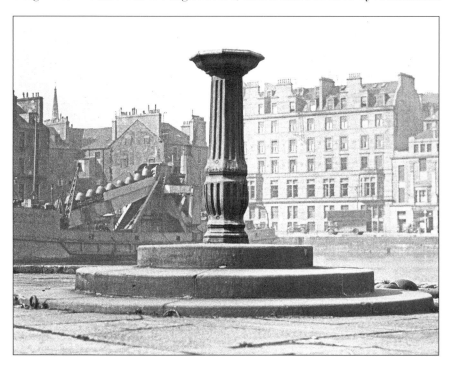

The Harbour Sundial.

entrepreneurs who imported a London sugar master to run it. It survived until after 1800, and in its heyday was processing the second largest quantity of sugar in Scotland that did not pass through Glasgow.

The Harbour Sundial

Long a principal feature of Dundee's main pier, this sundial (see previous page) was commissioned and erected by the Guildry of Dundee in 1649–50 at a cost of £33 10s 8d – a significant sum for the port to find only four years after the sack by the Marquis of Montrose. It was not just a symbol of the fact that Dundee remained a prosperous port, but had great utility in calculating the tides of the harbour. When the docks were redeveloped in the nineteenth century, the sundial (long replaced by chronometers and watches) was moved to the side of the new Earl Grey Dock.

Dundee c. 1587

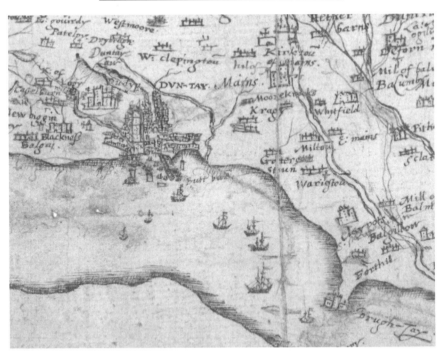

This representation of Dundee has been expanded from a minute sketch by the mapmaker/chorographer Timothy Pont, probably in 1587, making the town one of the first places he surveyed. His project to make a visual record of the whole of Scotland took over two decades, and it is still not clear why

such a remarkable project was undertaken. It is likely that mapping the realm was one of the principal objectives of King James VI, the best educated monarch in Europe, in modernising his country. Pont paid particular attention to building skylines and the profile of hills, probably to help people to orientate themselves: hence the profile of the Law shown behind Dudhope (Dudyp). The elevation of the tower of St Mary's Church symbolised the town centre. Both the East Port (the gate on the road to Arbroath) and the Wellgate Port (the gate on the king's highway uphill to Forfar) are clear. The harbour was evidently busy, for Pont drew more ships here than anywhere else on his surviving maps. It was bounded by the east and west bulwarks, and the chapel of St Nicholas Craig, indicated by a cross, lies to the left. It lay beside a defensive bastion erected by the Earl of Crawford in the early sixteenth century, and the town's arsenal, which had been converted from a windmill and was later to become the Cholera Hospital (see p. 94).

Dundee's urban form would change little over the next two centuries. The Cowgate and Seagate remained stretched out to the east, as were the Nethergate and Overgate to the west. If one took St Mary's as the centre of the burgh, the plan resembled a man stretched on his back, the church signifying his heart. Dundee's only sources of water and power – two burns – the Scouringburn (to the west) and the Dens burn (running down from the north) appear to have been far more significant then than they are today in their culverted state.

The names in Dundee's hinterland remain very familiar. Some, like Blackness, Logie, Craigie, Murroes, Pitkerro, Wester Powrie and Invergowrie were the country villas of successful Dundee merchant venturers, where they went to relax. When Pont visited it, the 1566 Strachan seat of Claypotts was being remodelled. Both its round towers had been decapitated prior to receiving the square tops which they have today. Judging by its outworks, Broughty Castle had evidently been strongly fortified – perhaps by the English, who had occupied it between 1548 and 1550 – but it appears as though ruinous. Substantial buildings of the impressively engineered fort of Brackenrig on Balgillo Hill, built by the English invaders in 1549 on the highest point in the locality, remained – as indeed they did until the mid nineteenth century.

Dundee from Blackscroft, 1678

In 1669, a Dutch military engineer, Captain John Slezer (pronounced Sletzer) was enticed to come to Scotland, eventually to be appointed Captain of Scotland's Artillery Train. To supplement his income, he began to prepare

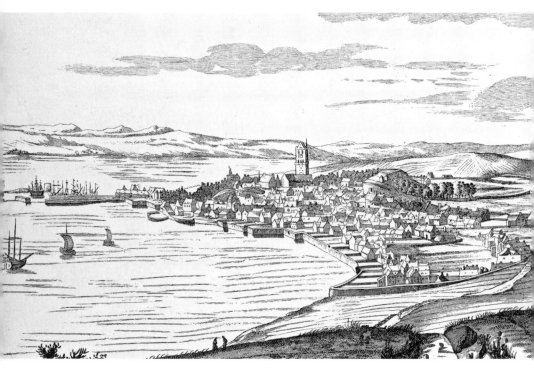

Dundee from Blackscroft, 1678.

two illustrated books, one on Scottish towns, palaces and abbeys, which he hoped would be subsidised by parliament, and the other on large country seats, funded by subscribers. Parliament agreed, but never paid him, so only one volume was published – the majestic *Theatrum Scotiae* (published in 1693) – combining aspects of both. Slezer died in debt in 1717 with the costs of his project never refunded.

He had visited Dundee in 1678 when he was awarded the freedom of the burgh, and produced three views of the town. His prospect of the burgh from the east shows a busy harbour surrounded by storage buildings. You can just make out the twin capped towers of the adjacent Provost Pierson's warehouse (later the Customs House – see p. 29) on the Shore. To the left of St Mary's steeple is the spire of the recently rebuilt Town's Hospital in the Nethergate (on the site of Dundee Contemporary Arts).

Slezer also depicts buildings on the sea (south) side of Castle Hill, which were to be demolished before Dundee's first modern maps were drawn up, and have therefore been forgotten ever since. As a result, no one expected to find buildings there, when work on the flats in Exchange Street was begun in 2000. However, one and a half storeys of an enormous storage area running

from St Paul's Cathedral to the sea were discovered, and extensive, well-preserved vaults of this complex still survive beneath Exchange Street and the Exchange Coffee House (later Winter's, see pp. 98)

The River Tay flowed along the back garden walls of the houses on the Seagate, whose route followed the line of the river. Note the East Port at the burgh's edge. The buildings in the Cowgate, shown as derelict, had probably been damaged by defenders and attackers alike in both the 1645 and 1651 sieges, and were presumably left ruined when the fashionable part of the town moved westward to higher ground to avoid flooding in the later seventeenth century. Nineteenth-century harbour expansion reclaimed so much of the foreshore that Seagate today is over half a mile from the sea's edge.

DUNDEE FROM THE NORTH, 1678

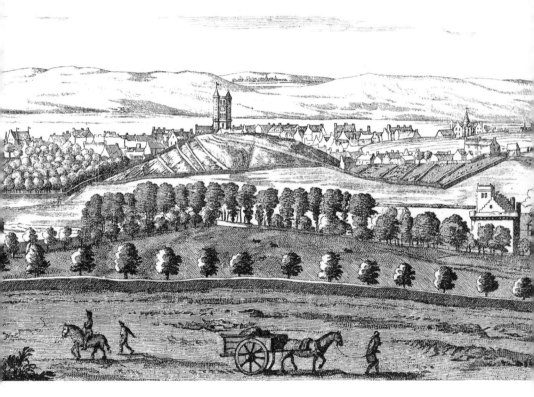

Slezer drew this from a point on the southern slope of the Law, about the junction of Dudhope Terrace and Law Terrace, and if you go there today, you can confirm just how accurately he drew, as one might expect of a military surveyor. In the foreground is Dudhope Castle, recently refashioned with the

aid of workmen from Holyroodhouse by Lord Charles Maitland, brother of the Duke of Lauderdale. (The twentieth-century restoration did not replace the steep roof and decorative dormer windows.) Just to its left on the skyline is the Town's Hospital in the Nethergate, which was partly on the site of the Roman Catholic Cathedral (whose spires can be seen there today), and partly on that of the Dundee Contemporary Arts (DCA) building. This drawing emphasises the extent to which old Dundee was constrained by its hills. The Corbie Hill behind the Overgate in the middle foreground has now been completely quarried away (see p. xxi). In the left middle ground are the Meadows and the walls of the Howff – the town's sixteenth-century graveyard. This view is also probably the only representation of the turrets and towers of the burgh's second tolbooth, visible just to the left of St Mary's. Then the smartest tolbooth in Scotland, it was built in 1560 after its predecessor had been burnt down by the English, and was constructed with polished stonework taken from the Greyfriars (the largest in Scotland) and roofed with timbers taken from Lindores Abbey.

DUNDEE IN 1776

William Crawford's was the first modern plan of Dundee, and was probably produced to celebrate the completion of the Trades Hall that year at the east end of the High Street. The High Street/Market Place and the harbour remain the focal points of the burgh. It had not yet expanded beyond its medieval boundaries, and there was still much empty land not yet built upon behind the Nethergate and the Cowgate. The area north of the High Street's long rigs remains open space, the Wards only recently opened, with tree-lined walks. The Meadows, with the Scouringburn canalised through them, were also used for bleaching.

Note the narrowing of the Overgate, Nethergate, Murraygate and Seagate as they approached the High Street, the intention being to make the market place as comfortable as possible by excluding the 'outdoor roare' of the wind. The narrows of the Nethergate were barely two metres wide, of the Seagate less than two metres, of the Overgate three metres and the narrows of the Murraygate almost four metres. Note also how the closes and wynds running through the densest part of the town downhill to the maritime quarter were all curved, also to keep the wind out. The map shows no buildings south of Castle Hill: the long-demolished buildings drawn by Slezer had been forgotten, the lower storey and a half now lying underground. On the

Dundee in 1776.

east side of the harbour was the public Necessary House, which provided a rendezvous for the press gang.

St Mary's tower stands apart, separated from the rest of the church by its ruined nave, on part of the site of which is the burgh school. School Wynd (later to become Lindsay Street) remains a small passage. On the northern slopes, by Chapelshade, there was only desultory building.

THE MARKET PLACE (HIGH STREET)

The Market Place, Hie Gait, or just simply 'the Cross' of the burgh, was the centre of civic life from the town's very beginning. The legend that located the original tolbooth and market cross in the Seagate at the foot of Peter Street is a myth deriving from an inaccurately translated Latin charter. The market

The Market Place (High Street).

place was always on the plateau of the raised beach, sandwiched between the hills to the north and the slope to the sea on the south, and it may, originally, have stretched as far westward as St Mary's Church. If it did, it must subsequently have proved too large; for the land lying to the east of St Mary's was colonised by a dense mass of tenements and closes called the Luckenbooths (locked-up booths) exactly as occurred with Edinburgh's Luckenbooths, or with Montrose's Raws.

The market place was effectively the burgh's principal space, an outdoor room in which most civic activity took place – trading, buying, selling, discussing, lawsuits – and the kinks in the burgh's various streets meant that its users were largely sheltered from the wind, as they were from the rain by the arcades or loggias lining the ground floor of the tenements. Its south side was dominated by the tolbooth, symbolising the town's ambition and wealth (the town's clock was in its steeple). Here also were the other principal burgh symbols: the Mercat Cross, proclamations from which were the only official source of news. It was the centre of burgh trade and of civic memorial. Here, for example, the Town Clerk Sir Alexander Wedderburn greeted the Old Pretender in 1715 brandishing the civic sword. The Market Place also had the Tron, or weighbeam, so that market goods could be weighed and checked for measure; the beautifully built ashlar Mealmarket at the West End and the similar Fleshmarket at the east; and the stance for the town's two fire engines.

The Market Place was continuously improved during the eighteenth century. First, it was refashioned when a new tolbooth was constructed in 1731–35 on the site of the old. In 1776, a new Trades House was erected on the site of the Fleshmarket and given a fine pedimented frontispiece in order

to enhance what was now becoming known as simply 'the Cross', followed a few years later by a similarly pedimented Union Chapel on the site of the Mealmarket. Both were designed by the town's architect, Samuel Bell (promoted from 'town's wright'). The ordinary blocks of tenements facing the Cross were also remodelled in the eighteenth century by the removal of their timber galleries and frontages, and their arcades below, to reduce the risk of fire. This was seen as a welcome sign of modernisation.

The Burgh's Main Streets

Early modern Dundee was concentrated around four principal streets which led outwards from the Market Place – the Overgate, Nethergate, Seagate and the Murraygate – and around the 100-odd wynds and closes which ran off or joined them. The Overgate and Nethergate led west, with the latter along the edge of the raised beach, originally paralleling the line of the river. The Seagate also ran along the river, but to the north-east. The Murraygate led to the north and east, branching into the Cowgate and the Wellgate; the latter of which led on to Rotten Row or Bonnet Hill (later Hilltown), which straddled the King's Highway to Forfar. Bonnet Hill lay outwith the royal burgh and, as a burgh of barony, was a settlement in its own right, with its own tolbooth and baron bailie. Only in the late eighteenth century were any significant new thoroughfares added to the town, when Castle Street and Crichton Street were carved through the urban mass, and it was only really in the nineteenth century that Dundee grew out of its medieval boundaries. The original four main streets still remain the principal shopping and commercial centre of the town, more or less on their original alignments. Yet they have undergone such radical changes that most of the buildings which stood there in 1800 have long since vanished.

The Overgate

The Overgate was the principal route between Dundee and Coupar Angus and the valley of Strathmore, leaving the town at the West Port. It grew to be home to some of the wealthiest burgesses of Renaissance Dundee, including

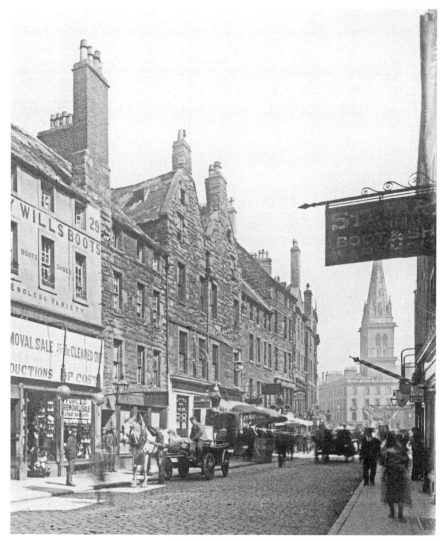

The Overgate in 1898.

David Hunter and David Wedderburn, as well as the location of the royal
mint when the latter was forced to quit Edinburgh for a spell due to plague.
It was also the seat of some of Dundee's trades – notably the hammermen
and cordiners (shoemakers). It was probably at its north-west corner that
Dr Patrick Blair set up his 'cabinet of curiosities' (museum) and botanic
garden in the later seventeenth century, on the sunny slopes of the Ward
lands running north between the West Port and the Scouringburn. This view
of the north side of the downtown end of the Overgate, beyond the narrows,
as it neared the High Street (with St Paul's church spire in the background)

presents an almost unbroken sequence of majestic seventeenth- and eight-eenth-century apartment buildings. Most were similar to Gardyne's Land (see p. 36), namely a seventeenth-century flat-fronted four- or five-storeyed façade facing the street, with perhaps two more in the roof. However, the twin stone-fronted five-storeyed buildings, gable to the street, represented the earlier fifteenth- and sixteenth-century generation of urban building. All these buildings fronted long rigs often built up into closes and courts, like the *traboules* of Lyons. Normally, the grander houses, like David Hunter's house, would lie behind, sometimes at the far end of a close.

DAVID HUNTER'S GREAT LODGING, METHODIST CLOSE, OVERGATE

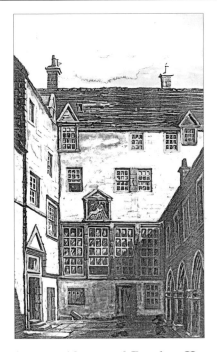

Perhaps one of the finest residences of Dundee, Hunter's Lodging stood behind the Overgate at the far (northern) end of the close, later known as Methodist Close after the location of the first Methodist chapel. It was be-lieved to have been the Franciscan Nunnery, or at the very least a building which had been used for some other ecclesiastical purpose. But the Gray Sis-ters' convent had been located outside the West Port. No matter how often this house was referred to as 'the Nunnery', the stone building that stood here was, instead, a splendid courtyard townhouse erected c. 1621 by David

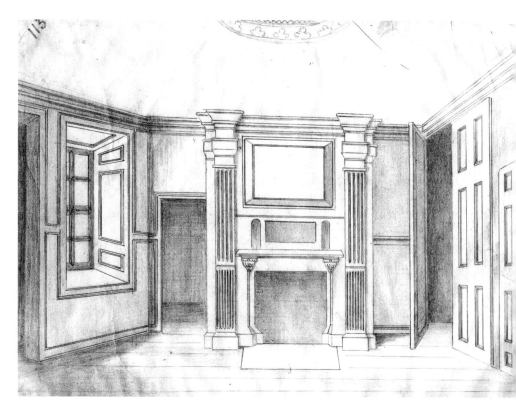

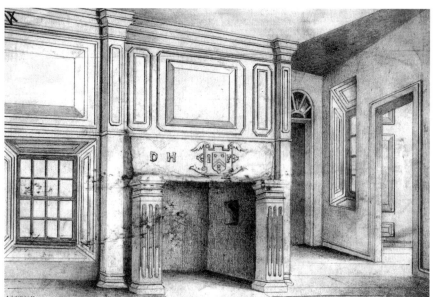

Interior views by Charles Lawson of David Hunter's Great Lodging.

Hunter. A member of a prominent local family of merchants, Hunter was Harbour Master and Kirk Master, and reluctantly accepted the appointment as burgh treasurer in 1620. To the Meadows behind, the mansion presented the form of a tall U-plan villa, a style then fashionable in Court circles. Facing the courtyard at the end of the close, however, it presented the appearance of 'a great lodging with portico, gallery, well, garden and houses', as a 1697 charter put it. A staircase on the left led to the main house, with its four huge windows straight ahead, and a gallery above the loggia lining the eastern edge on the right. Quite similar, in fact, to what you can today find in the Lyons *traboules*. David Wedderburn's house, likewise lying behind the Overgate, had a long gallery which he had painted with improving motifs in the 1590s. Charles Lawson's sketches (see his 'Interior of Hunter's Mansion') show that Hunter's principal apartment (indicated here by the four great windows) was finely panelled and decorated with elaborately carved fireplaces and lavish plasterwork. Hunter's Lodging became the Hammermen's Hall, but was swept away for the construction of Bell Street in the 1850s.

THE COWGATE

Most Scots burghs had a Cowgate, usually named after the principal route that livestock took from the burgh muirs to the market place. Before the eighteenth century, Dundee's Cowgate was not heavily developed, and a number of its mansions had been demolished to ease the defence of the town against the attacks in 1645 and 1651. It seems that they were left ruined as the heart of the town consolidated on the west side. In the eighteenth century, the sunny and clement slopes of Forebank, just above, became colonised by villas, and it was in this district, on the edge of town, that the Trades asked Samuel Bell to design their new church of St Andrews in 1772. Not long afterwards, the Baltic merchants settled on this locality for their Baltic Coffee House. The buildings half left in the photograph on the next page represent the outside edge of Bain Square, in which the Baltic Coffee House was located. In the broad of Cowgate outside St Andrew's Church, the Baltic merchants, shipowners, agents and insurers – collectively nicknamed the 'Coogate' because of their habit of gathering there – met to discuss affairs and undertake business. In the 1850s they moved westward to the new Royal Exchange on the edge of the Meadows.

The view on the next page is from the new (and thus wider) Panmure Street, which had been cut through to the medieval fabric of Murraygate (opening to the right) from the Meadows. It looks east along the Cowgate to

The Cowgate.

the bow-fronted birthplace of the Grimond family in the left middle distance. The Murraygate corner, then the substantial eighteenth-century block of Milne's Tobacco Factory, was entirely rebuilt in the Edwardian period. The Wellgate exited uphill on the left. The sense of enclosure of this ancient part of Dundee was shattered by the construction of the Wellgate Centre in the 1970s, which erased this historic part of the burgh.

THE WELLGATE LOOKING SOUTH

The Wellgate, named after Our Lady's Well which lay just behind the right foreground of the picture opposite, was never a long street. It ran down from Bucklemaker Wynd (later Victoria Road) to the Murraygate Port. It was the principal entry into the burgh from Forfar and the north-east, and lay at the foot of the separate burgh of barony of the Bonnet Hill (Hilltown). It became the centre of Dundee's tanneries, shoemaking and buckle-making

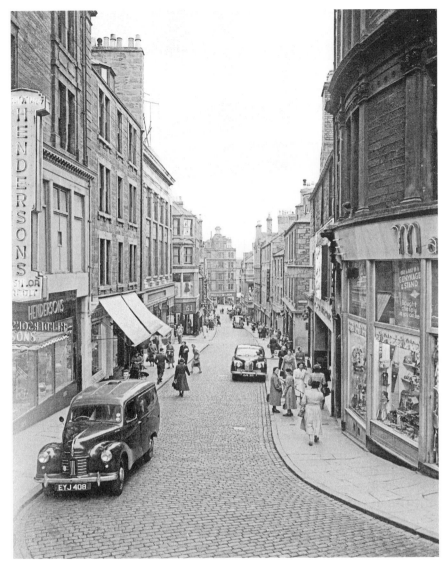

The Wellgate.

in the eighteenth century. In the nineteenth century the Wellgate became a principal shopping street, particularly once the town had expanded eastwards in the 1870s with the jute and linen complexes such as Dens and Bowbridge lying just uphill. Judging by this photograph, the street front had been continuously renewed, and the store on the corner on the left had been very smartly rebuilt in the American classical manner of the 1920s. All was demolished to make way for the Wellgate Centre in the 1970s, whose atrium follows the line of this street.

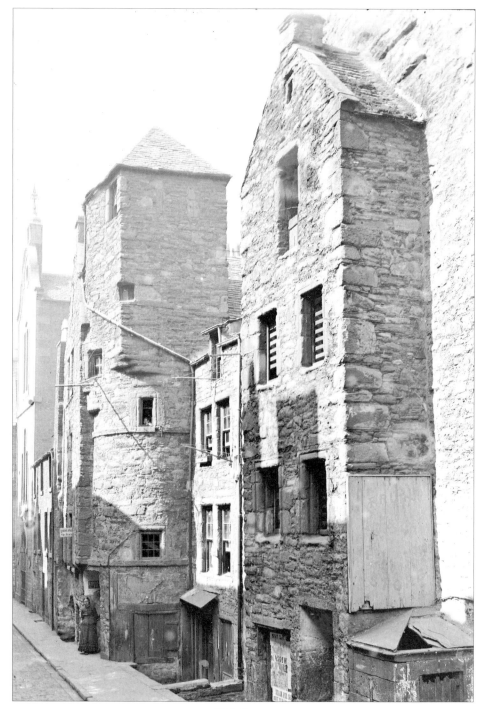

Fish Street.

Fish Street

This mid-nineteenth-century depiction of Fish Street illustrates the spine of Dundee's maritime quarter immediately before its destruction for city improvement. Fish Street ran from St Nicholas Craig along the Shore to the bottom of the Vault (later from the foot of Union Street to the Greenmarket), and its close proximity to the Shore identified it with the port. It had immense character. Blocks of apartments up to six storeys tall, originally facing the sea and reached by ample circular staircases capped by square studies (all originally harled), were the homes of the burgh's leading burgesses. Many of Dundee's wealthier bourgeoisie – the Yeamans, Wedderburns and Scrymgeours – who lived in the Overgate, also owned properties in Fish Street. The entrances to the houses are down some steps, the result of the ground level of the entire district having had to be raised up after the tidal wave in 1755.

Fish Street's setting was first vitiated by the construction of the 'New Shore' (rechristened Butcher Row in the eighteenth century) immediately in front of it; and then by the fishmarket, the packhouses and finally the arrival of the fleshmarket in 1776. In the mid eighteenth century, Fish Street remained the home particularly of shipmasters (sea captains) and others involved in shipping and the harbour trade. By the mid nineteenth century, it had become fairly dilapidated, and despite the construction of the Seamen's Chapel (on the left), its reputation for crime and loose morals affronted Victorian Dundonians. They were only too keen to replace the dense, unpoliceable, smelly and immoral multi-occupied slums with the smart shops and business chambers of Whitehall Crescent. Fish Street was finally removed c. 1886 as part of the second phase of city improvement. Nonetheless, Charles Lawson's contemporary sketches of its interiors reveal that they retained much early eighteenth-century panelling and decoration of high quality.

Provost Pierson's Warehouse

This great round-towered structure at the foot of Crichton Street, conjecturally reconstructed in 1836, was originally built c. 1560 (to judge from its round towers) on the flat shorelands by the very edge of the harbour, at the head of what was called the 'New Shore'. It had had many names: the Customs House, for example, after its use as such in the eighteenth century, or Provost Pierson's Mansion, after an original owner. But it was never a mansion. Judging from an enormous cross-wall which ran vertically through it, it was originally a huge storage building with additional rooms, and the Pierson

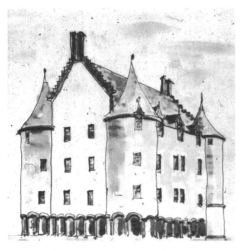

Provost Pierson's Warehouse.

apartment in its upper storeys was entered from a stair on the north side. The first Dundee building to greet visitors arriving by ferry (that is, the majority of visitors), it was a very public building, and its lower storeys were then adorned with fashionable stone arcades like those in the Howff. It is likely to have been built as Dundee's primary packhouse (or shipping store), before being superseded by the construction of the much more extensive Pack House Square in 1644. The rais-

ing of the street level in 1756 after the tidal wave made its arcades look a bit dumpy, and once its circular corner towers had been decapitated, it lost much of its éclat. It was removed for Whitehall Crescent.

BUTCHER ROW

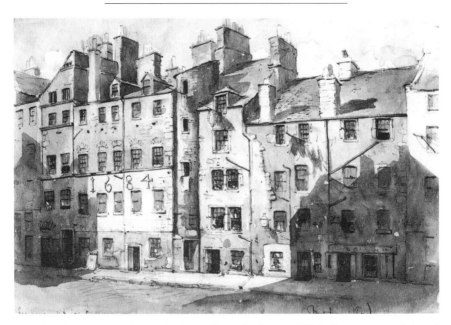

Butcher Row was built as the New Shore in front of Fish Street on reclaimed land probably in the mid sixteenth century. It was renamed when the flesh-

market was relocated from the High Street down to an opposite woodyard in 1775/6, with all the butchers following. It was both grander and more regular than Fish Street behind, comprising four to six storeys of well-appointed apartments facing the harbour. Judging from the date '1684' in large metal figures on the façade of James Wedderburn's great land (as is still customary in Bruges), and from the fact that its staircases, chimney stacks and gables rose up two storeys higher than the main building in the drawing, Butcher Row had been damaged during the civil war – either in 1645 or 1651 – and the upper part later rebuilt.

THE CHORISTERS' HOUSE

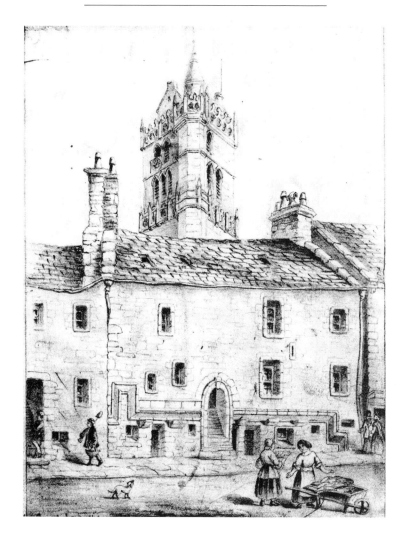

The cathedral-scaled church of the Blessed Virgin Mary of Dundee was the largest parish church in Scotland and was almost entirely surrounded by buildings, as in a cathedral close. The buildings on its south side were demolished in the 1790s when the Council finally addressed widening the narrows of the Nethergate. The buildings on the north side facing the Overgate survived, and a small alley – Mid Kirk Style – ran between the kirkyard boundary and the rear of the Overgate tenements. By the early twentieth century, it had become the site of a popular barrowmarket. The burgh was proud of its music, and continued to invest in its song school until the end of the seventeenth century. Judging by its name, this building had a formal association with the song school, possibly as the residence of either the master or pupils at the school (or both).

Whereas the roof and the top storey look later (the roof pitch appears too shallow for a medieval date), its elaborate façade indicated that the Choristers' House had been one of the most important buildings of Dundee. Within, there was oak panelling, a vaulted ground floor, and timber ceilings and panelling 'painted' in distemper 'with representations of animals, birds, fruits and flowers conventionalised'. In 1799, it became part of the town architect Samuel Bell's property empire.

Tally Street

Tally Street joined the Nethergate to the Overgate, running along the eastern edge of St Mary's kirkyard. It was effectively the western boundary of the Luckenbooths – that concentration of ancient buildings, closes and alleyways between the Overgate and Nethergate that had encroached into Dundee's market place, from probably the late fifteenth century. With Couttie's Wynd on the right, leading down to the Shore, Tally Street formed part of the main route between the harbour and the country, since it carried on north along Constitution Road (earlier Friars', then Burial Wynd). By the time of the photograph opposite, the ancient irregularities of the Nethergate – particularly the narrows (under three metres wide) – had been straightened out and regularised so that tramlines could be laid. The corner building was fairly typical of a late-Victorian emporium, the general merchants and jewellers A. L. Reis, who boasted of importing melodeons and continental clocks. The glazed windows of the top floor indicated William Ferrier's photographic studio. This site had earlier been occupied by the Mason's Lodge of Dundee.

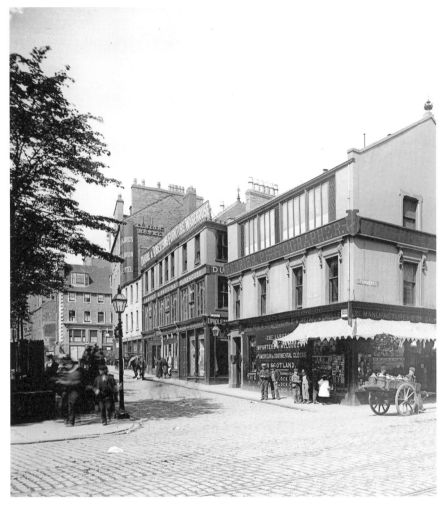

Tally Street.

THE WOODEN LAND, OVERGATE, DUNDEE

Dundee had been importing structural timber from Norway and the Baltic for use throughout Scotland since at least the fifteenth century. Timber for Falkland Palace, for example, was landed at Dundee, loaded onto rafts and sailed across the Tay to Newburgh, whereupon it was hauled overland to Falkland. This focus upon timber probably explains why some entirely timber-framed buildings could be found in Dundee, as opposed to those with merely the more normal façade of timber galleries, which were so very much more typical of Scots burghs during the Renaissance. The structure of the Wooden Land, which survived intact on the north side of the Overgate until

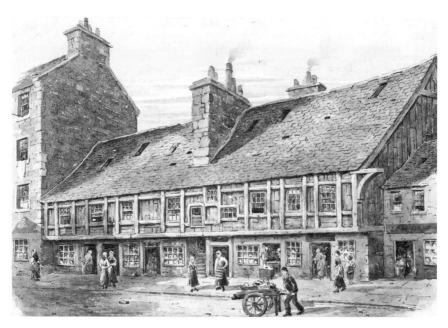

The Wooden Land, Overgate.

it was demolished in 1876, was entirely of timber. This long, chunky, heavily proportioned timber-framed building contained a single, spacious floor comprising a merchant's business chamber and private apartment sitting upon ground-floor storage booths below – a form not unusual for Scottish merchants in the eastern Baltic, with which Dundee had so much trade. The Arnott House, which still survives in Kedanai, Latvia, has a similar form, albeit in brick. The Baltic merchants' country villas in Dundee's hinterland followed this form too, although in a more elaborate manner and constructed in stone (see p. 4). Timber-fronted façades became unfashionable and were mostly removed from Dundee's principal streets c. 1768, leaving only the plain stone plinths behind. A timber-framed building such as this, however, could stay and last for a further century.

BLACKNESS HOUSE

Blackness House lay on a bluff to the north-west of Dundee, and was already a place of substance by the time Pont drew his map in 1587. It is most associated with the merchant family of Wedderburn, which ran perhaps the most extensive foreign trading network in Dundee in the late sixteenth century. Like Invergowrie House, Wester Powrie, Pitkerro, Murroes, Craigie and probably Logie, Blackness had the long, low characteristic form of a villa for

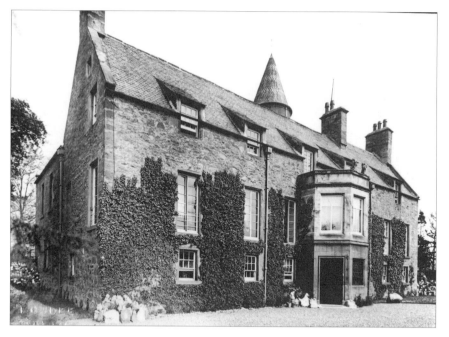

Blackness House.

a Dundonian Baltic merchant: a principal floor and attic floor above a ground floor of cellars and kitchen, all with a distinctively unScottish horizontal proportion. The Wedderburns having suffered for their Jacobite propensities, the estate of Blackness fell to the Hunters, one of whom – David Hunter of Blackness – was painted by Raeburn as a jovial good fellow. Too jovial, however, to pay much attention to the regular planning of his substantial estates on the western boundaries of Dundee. They were developed piecemeal and never achieved the graciousness of which they should have been capable. Blackness House was demolished in the early twentieth century.

WALLACE CRAIGIE

This ancient house, nicely set within its walled policies on the very banks of the Tay, appears in a hitherto unknown drawing of Dundee from St Roque's (see next page). A note on the drawing states that it has been copied by an original from a 'German' artist, and the implication is that it is a copy of a lost drawing of Dundee from the east by Captain John Slezer in 1678. Certainly, the steeple shown on the tolbooth implies that it belonged to the pre-William Adam tolbooth – in other words before 1733. Note how the sea laps the walls of the Seagate gardens which, by the mid eighteenth century,

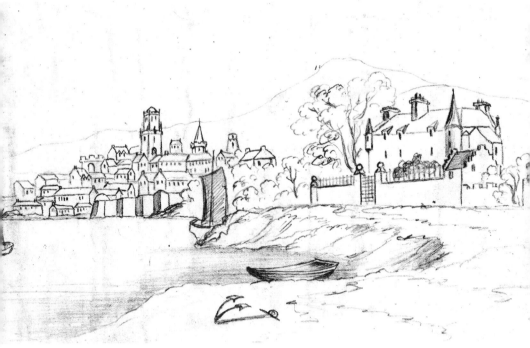

Wallace Craigie by an unknown artist.

had been occupied by whaling companies. There is no sign of the 1766 sugar house.

Wallace Craigie was remarkably similar to Invergowrie House, with the characteristic low-slung proportions and decorative turrets of the early seventeenth-century Baltic merchant villa.

GARDYNE'S LAND

This drawing (facing page) shows the façade of Gardyne's Land facing Gray's Close, to the rear of the north side of the High Street. This prestigious site, which faced both the tolbooth and the Market Place, was of immense antiquity, and contains a thirteenth-century well. The building expanded from a tower (which was later hollowed out into a courtyard) at the centre of an extraordinary complex extending both out into the High Street and back along Gray's Close up to the Meadows. Some of the ceiling timbers in the wing on the left have been dated by dendrochronology to 1593. The huge timbers in the attic facing the High Street are enormous – entire trees – but since they have been stripped of their bark they cannot be accurately dated.

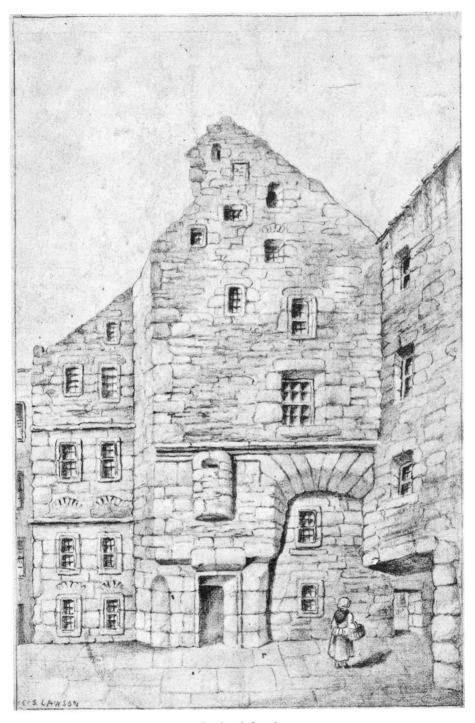

Gardyne's Land.

Several separate buildings made up this complex, and this building origi-
nally probably had no connection with the others in the close. The circular
projection contained a narrow turnpike timber stair for the rear wing rising
five storeys above. The chambers on its left were all remodelled in the mid
seventeenth century. In 1720, this wing was occupied by the banker George
Dempster, and was probably damaged in the food riots that year. A later
proprietor was the burgh architect Samuel Bell. Some of its rooms were later
used for craftsmen such as clock-makers and MacSween the bagpipe-maker.
The only chamber to survive with its early decoration is the panelled bed/
business chamber on the top floor, facing the Market Place. It dates from c.
1708–20, and has an elegant curved buffet for displaying china. Following an
intensive decade-long rescue programme by the Tayside Historic Buildings
Trust, the entire complex has been converted into a youth hostel. The dining
room of the eighteenth-century New Inn next door has been restored as the
hostel's canteen/meeting place.

The painted ceiling – dislodged when Keillers were converting the
property for accommodation for their workers in the adjacent marmalade
factory – comprised improving mottos and aphorisms devised by Francis
Quarles in 1636.

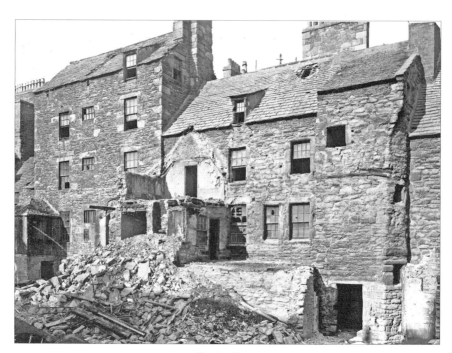

Gray's Close.

GRAY'S CLOSE

Properties facing Dundee's principal streets developed backwards along their gardens or long rigs – as was typical in Scottish royal burghs – linked by the closes that ran along their boundaries. There were approximately 100 such closes opening back from the principal streets in Dundee – the same number as in Edinburgh. These gardens, or rigs, became colonised by buildings, as accommodation for other members of the family was sometimes built along them. One of the best survivals of Dundee's pattern of rig development lay to the north of the High Street, where the Forum Centre, which replaced Keiller's marmalade factory, now sits. This photograph of the rear of Gray's Close, when the rigs were being demolished for Keiller's expansion, shows just how tightly packed these closes and courts opening off Dundee's principal streets had become by the later nineteenth century. The majority of the buildings were probably occupied by craftsmen's workshops. Gray's Close was home to skilled artisans such as the Smith family of clocksmiths, and to no fewer than six provosts.

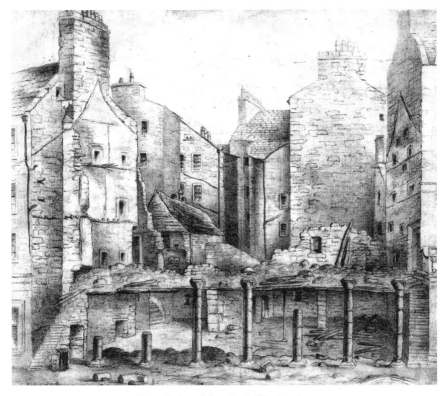

Demolition of Our Lady Warkstairs.

OUR LADY WARKSTAIRS

The two adjacent five-storeyed buildings known as Lady Warkstairs lay in the Luckenbooths, immediately to the west of the site of Dundee's original tolbooth, at the western end of the Market Place. These buildings were vengefully burnt, along with the tolbooth, by the English when they quit occupying the town in 1548–49; the buildings known as Lady Warkstairs, standing immediately to the right of the Union Hall, which almost certainly dated from the 1550s, survived long enough to be recorded. By the 1870s, Warkstairs retained one of the very few surviving timber frontages sitting upon an arcade or loggia at ground level (the pillars of the arcades were only rediscovered during demolition) that had been typical of the principal streets of Renaissance Dundee, as indeed of most of the principal Scots burghs. The pillars supporting the projecting façade of the building formed an open piazza, and booths lay behind. Stairs on each side – one for each house – led to the floors above. There was no connection between the premises on the ground floor and the grander apartments above. The depth of these arcades was sometimes regulated – in Glasgow, for example, they were exactly 11 feet – just less than 3 metres – deep; whereas Dundee's arcades varied in depth between two and three metres. Warkstairs was an important civic building and, as Charles Lawson's sketches show, had an interior of remarkable quality. It was demolished in 1879.

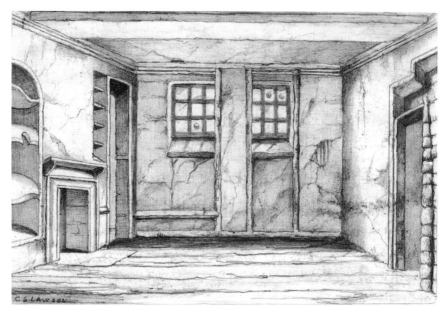

Lady Warkstairs interior.

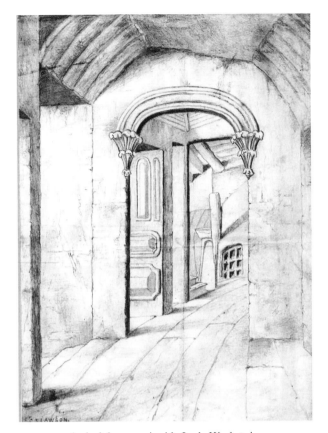

Arched doorway inside Lady Warkstairs.

WHITEHALL CLOSE

Only in Edinburgh and Dundee – throughout Britain – could you find medieval tenements rising above four storeys. Six storeys was the norm in this part of Dundee, and they could rise as high as eight, for the maritime district, lying between the Nethergate, High Street and the New Shore, was perhaps the densest part of ancient Dundee. It was crossed by myriad lanes, closes and wynds that provided sheltered access and occasionally little courts. The narrow closes that ran between the Shore up to the High Street/Nethergate were curved both to moderate the slope and to control the wind, in a typical Baltic fashion. Closes such as Whitehall Close acted as lungs for the inhabitants of this district, as well as routes between the courts, entries and other common areas. Before they became overcrowded, country gentlemen had their town residence in such closes. Here was where Sir Patrick Lyon, a kinsman of the Earl of Strathmore and ardent royalist, had his town residence.

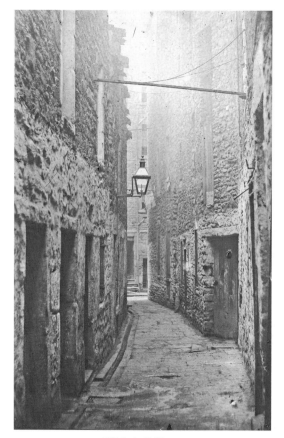

Whitehall Close.

On the restoration of Charles II in 1660, he erected royal arms on his house and renamed it Whitehall, after which the close took its name. Some of the carved stones rescued from Lyon's lodging can be seen in the architectural museum in the upper chamber of the tower of St Mary's. Whitehall Close was demolished for Whitehall Street in 1886.

COUTTIE'S WYND

Couttie's (earlier Spalding's) Wynd once formed part of one of the principal thoroughfares between Dundee's harbour, the town centre, and the slopes of Dundee Law inland. It curved up from Fish Street, crossed the Nethergate in front of the east gable of St Mary's Church, and then continued up Friar's (later Burial) Wynd (now Constitution Street), past the Howff to Dudhope. Prior to opening the eighteenth-century streets of Crichton Street (begun

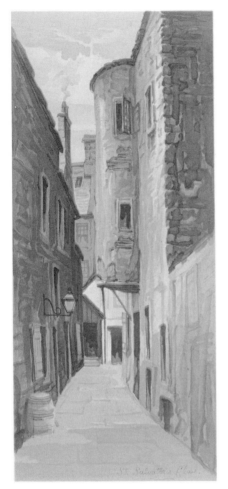
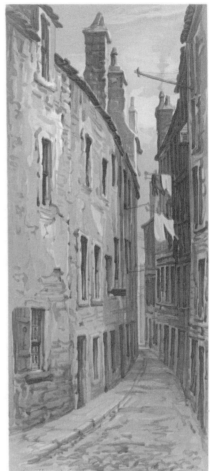

Couttie's Wynd

in 1777) and Castle Street (1795), Couttie's Wynd was one of Dundee's three principal routes between town and harbour. Typically, it was curved.

It was no mean thoroughfare. In 1782 it had two taverns, and its residents included two barbers, a chaise renter, a hammerman, maltman, mason, a lady merchant and a baker. Even after the construction of both Union Street in 1824 and Whitehall Street in the 1880s, which led to it becoming a back lane, Couttie's Wynd was still a sufficient thoroughfare for the Victorian shop fronts to be brought round to face into the wynd. It contained houses until they succumbed to the expansion of Draffen's department store in the 1930s. Now a back lane with wheelie bins and extractor fans, it awaits the revival that has so transformed similar closes in Edinburgh over the last decade.

STRATHMARTINE'S LODGING, THE VAULT

The Vault, a large enclosed, partially arcaded court or piazza behind the tolbooth, was the second most important location in the burgh after the Market Place. It took its name from the vaulted pend or archway at the foot, which led out onto the Exchange or Lime Tree Walk. It was the crucial area for merchants arriving in Dundee by sea. Between 1550 and 1560, the burgh began to concentrate all its public buildings into a single axis between harbour and market place, with the Vault at its centre. Here were rebuilt the town's grammar school, the tolbooth, the Guardhouse and the burgh weighhouse – a significant public building that had been converted from the abandoned St Clement's Chapel. To this building, merchants and shipmasters had to bring their goods for weighing prior to sale. One side of the weighhouse was a gallery with storage beneath.

Towards the end of the seventeenth century, the Laird of Strathmartine recast his town house in the south-west corner of the Vault, resulting in this splendid baroque mansion with its pillared forecourt, octagonal stairtower and flamboyant doorway. It may originally have had a further wing parallel to the one on the left, which would have conformed to the U-plan aristocratic villa or town house then typical of noble French townhouses. The architect

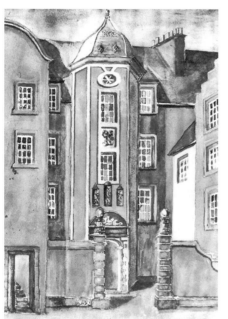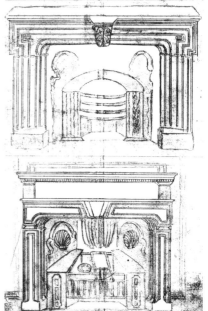

Strathmartine's Lodging (left) and details of fireplaces within the house.

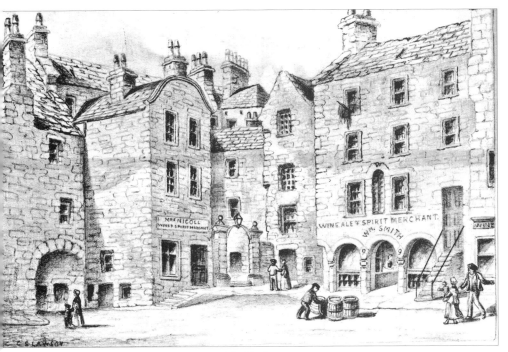

The Vault.

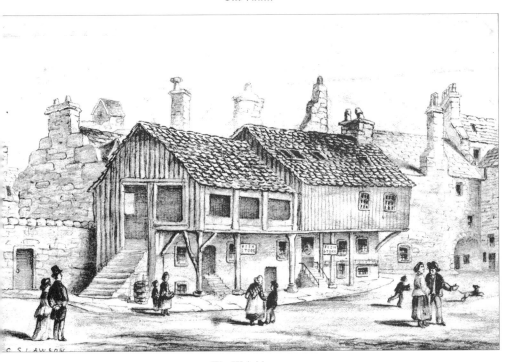

The Weighhouse.

of Strathmartine's Lodging is not known, but it might have been Alexander McGill. The interiors were as lavish as the exterior. The chimney pieces were elaborately carved, and the great staircase – like the one at Glamis Castle – had a hollow newel in which lights, or perhaps heaters, may have been hung.

The Lodging's setting became encroached on by other buildings, and sank into slumdom in the nineteenth century. It was finally demolished along with the Town House to allow for the construction of City Square in 1930–31.

TINDALL'S WYND

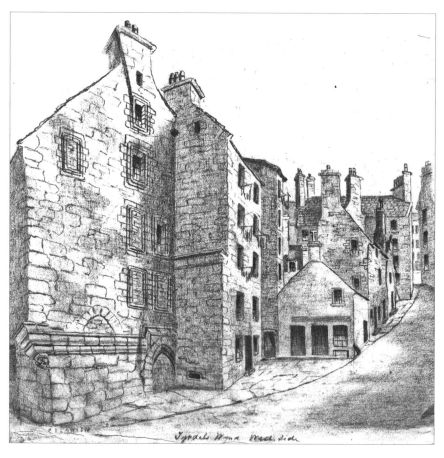

Tindall's Wynd was the ancient cart route from the Market Place running downhill to Castle Wynd and the shore. Its squint angle was at least partially determined by the profile of Castle Hill, which lay immediately to its east. It

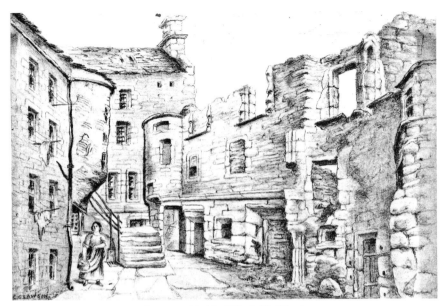

Courtyard behind Tindall's Wynd.

narrowed as it approached the Market Place just to the east of the tolbooth. Unusually, it was not curved. Tindall's Wynd was much wider than most Dundee closes, reflecting its role as one of the burgh's primary thoroughfares. It was also the location of many high-status dwellings and courts, much patronised by shipmasters long into the nineteenth century. Tindall's Wynd had some fine courtyards opening off it, some of which resembled those that still survive off St Peter's Street in Copenhagen.

The gable on the left is most curious. Constructed of finely squared masonry, with a low chamfered plinth, string course and blocked Gothic windows, it can only have been the east gable of St Clement's Chapel, Dundee's original church (named for the patron saint of sailors). After it had been made redundant in the early sixteenth century, its graveyard became, effectively, the area known as the Vault, and the chapel was converted to the burgh weighhouse by George Lovell in 1565. This chapel had traditionally been assumed to be located on the site of the tolbooth, on the south side of the market place. This drawing demonstrates that it was down at sea level.

Stewart's Court, Seagate

Given its importance to Dundee's history, there are surprisingly few views of the Seagate and the courts and buildings that led off from it. Its houses and gardens lined the sea wall. Possibly it was overlooked because after

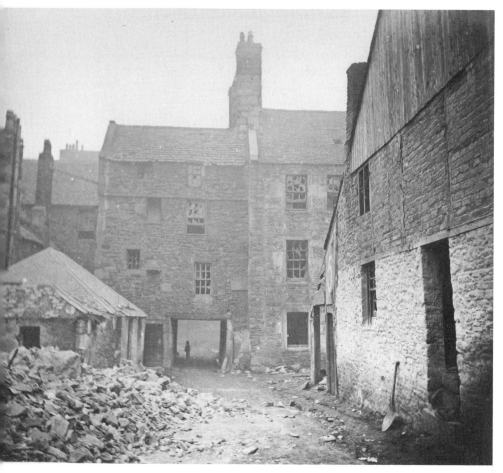

Stewart's Court.

semi-abandonment in the seventeenth century, it became quasi-industrial in
the eighteenth, with the arrival of the Sugar House in 1766 and the whaling
companies, followed by the glass works, just to the east, and then the gas
works. It became the service end of the port, with the smell of the whale-
boiling yards pervading shipmasters' houses and warehouses alike. In the
nineteenth century, it became even more industrial, with bonded warehouses.
But the Seagate had once been a street of substance that had included the
town houses of the Duncans of Lundie and the Grahams of Fintry.

The c. 1875 view of Stewart's Court off Gellatly Street above was taken
when the city improvement scheme to widen the narrows of the Seagate
had just begun. The blocked windows, carved stones and remnants of but-
tresses indicate that the medieval buildings of the Graham chaplainry had
been much modified when colonised as dwellings, and probably lowered by

a storey. A staircase might have been lopped off the building just to the left. The whitewashing of the lower storey on the right implies that there used to be an enclosed courtyard here, since whitewash was used (in vain) in the Victorian era as an antiseptic for courtyards where dung was collected before being taken out by scavengers. By the time of this photograph, the condition of Stewart's Close had become desperate.

INTERIORS

The sketchbooks of Charles Lawson are an extraordinarily rich resource for studying the interiors of Dundee's lost buildings. Indeed, thanks to Lawson, there is probably a greater collection of drawings of the ancient interiors of Dundee than of any other Scots city. Lawson's drawings tended to be of buildings about to be demolished by the City Improvement Acts, so the rooms tend not only to be empty of people but also devoid of furniture and decoration. Only a single person appears – an old lady with a cat living in a garret room in the maritime quarter – in his interiors. Lawson was particularly fond of garrets, attics, stairs and endless cellars. In amidst this fascinating record of neo-slum social history, he also recorded many interiors of extraordinarily

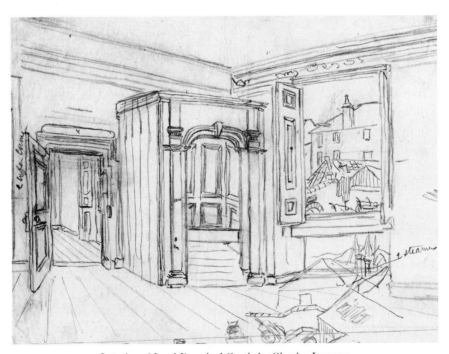

Interior of Lord Douglas' Castle by Charles Lawson.

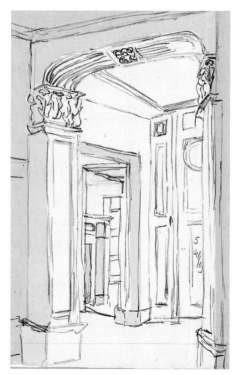

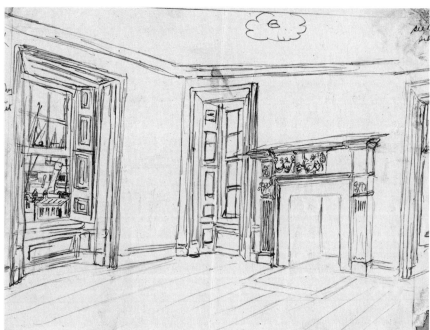

Interiors in Bradford's Land by Charles Lawson.

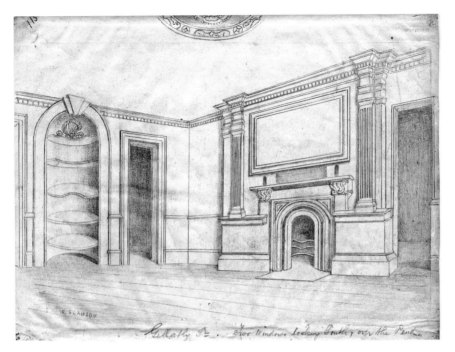

Interior of an apartment in Gellatly Street by Charles Lawson.

smart apartments and houses, with their carved over-mantles, panelling, lavish baroque plasterwork and Adam fireplaces. His drawings reveal rooms – even in their derelict state – of great distinction. The principal chamber of an apartment in Gellatly Street, with its Corinthian pilasters, had been drawn to record where a large painting framed above the fireplace had been stolen. A fine drawing room in Bradford's Land in Butcher Row overlooked the harbour. Lord Douglas's home contained the same semi-circular buffet evident in many other apartments. Spaces appear to have been divided and sub-divided, each gracefully framed with elaborate plaster cornices, carved timberwork and panelling.

THE TOWN'S HOSPITAL

Until the nineteenth century, entrance to Dundee by the Nethergate Port was dominated by the Town's Hospital. The site of Monk's Holm (virtually lying beneath Milne's Buildings) had originally been granted to the Trinitarians or Red Friars; and in 1530 Sir James Lindsay granted adjoining land for a hospital for the support of the 'sick, infirm and elderly persons dwelling therein by his appointment'. After the Reformation, the hospital became the responsibility of the Town Council, and was used to house and care for 12 decayed

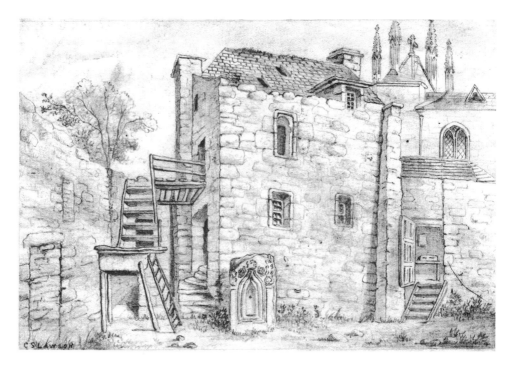

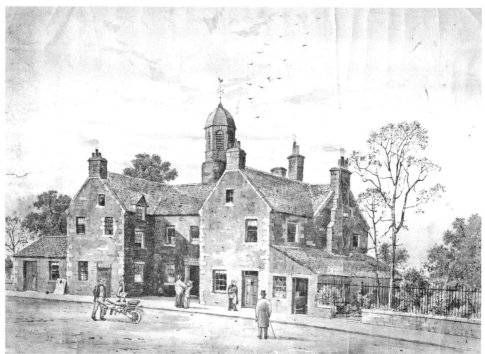

Depictions of the Town Hospital at different periods.

burgesses. Since it had been gifted the fruits of the majority of the monastic lands donated to the burgh by Mary, Queen of Scots in 1564, it was remarkably well-endowed. Around 1678 a splendid new hospital was constructed, taking the fashionable U-plan of John Mylne's Cowane's Hospital in Stirling – if on a vastly different scale and with a spire (later removed for a cupola). The principal chambers, some decorated with elaborate plasterwork, included a chapel on the first floor, with a gallery and dormitories on the floor above. It was decided in the mid eighteenth century that it was better to maintain the needy in their own homes (a Georgian 'care in the community') and the re-dundant building was converted first into a charity workhouse (which proved unsuccessful), and then used instead to house French prisoners of war in the late 1750s. In 1793 the burgh feued out the Hospital Gardens for Tay Street. Some of the building was removed to make way for Provost Riddoch's house, some for the Roman Catholic Cathedral in the 1830s, and one wing remained in use as the Town's Academy before being replaced by a garage in the 1930s. The site is now occupied by Dundee Contemporary Arts.

Classicising the Port

Plan of Dundee in 1793

William Crawford (junior)'s plan of Dundee (see next page) was probably drawn up both to celebrate the opening of the new turnpike road to Coupar Angus (Tay Street) and the publication of the Rev. Robert Small's *Statistical Account of Dundee*. It records the burgh at a dynamic point in its history, when substantial schemes for its improvement had begun. The Nethergate was extended along Perth Road as the new turnpike road to Perth, replacing the Hawkhill; the new turnpike to Coupar Angus had been opened through the Hospital Gardens; and a gentler turnpike road to Forfar than the Hill-town was planned along King Street. Improvement was in the air. Since farm carts had to be able to reach the harbour without having to negotiate the narrows of the Overgate, Murraygate or Seagate or the tight wynds between the High Street and the harbour, new routes to the harbour included St Andrew's Street and Castle Street. There were plans to remove the narrows of the Murraygate, Seagate and Nethergate. The town appointed Samuel Bell to draw up plans for terraced houses in Tay Street and Tay Square, but Dundonians preferred to remain in their apartments in the town centre. The houses proposed for South Tay Street were only completed 30 years later, to the designs of the subsequent new town architect, David Neave.

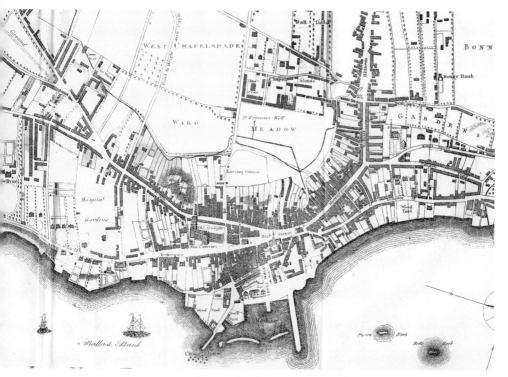

Crawford's plan of Dundee in 1793.

The new street debouched into Nethergate opposite the Town's Hospital (the plan was to go through it), and the site is now occupied by the Dundee Contemporary Arts Centre and the Roman Catholic Cathedral. On the west side of the hospital, Provost Alexander Riddoch built himself a mansion in 1793 (now the Clydesdale Bank), designed by Samuel Bell. Numbers 64 and 66 Nethergate were built by flax merchants domiciled abroad, such as James Johnston, merchant 'in St Petersburg' and Robert Jobson 'in Riga'. Jobson's house, like that of his cousin John facing him across the road, was larger than the normal neat Bell villa and more ponderously pedimented, somewhat in the manner of the then recently published *Rudiments of Architecture*.

The shoreline, celebrated for its beaches, ran along behind the garden walls of the houses on the south side of the Nethergate. The arrival of the Dundee & Perth Railway through the mudflats in 1847 ruined all that. To the north of the town, the fields of Chapelshade had been transformed into a late-eighteenth-century suburb of villas with its own chapel of ease – and Dundee's first 'new town' square, Irvine Square, which opened off what was to become Bell Street.

THE TOWN HOUSE

Alarming cracks had appeared in 1730 in the front wall of Dundee's enormous 1560 tolbooth. Its façade, leaning at least 4 inches out of true, had become separated from its roof. The town summoned William Adam, then Scotland's finest architect, to inspect the building. He concluded that the old tolbooth was irreparable, but that its materials – its polished ashlar stonework, taken originally from the Greyfriars, and its great roof, which had earlier covered the abbey of Lindores – could be dismantled and re-used in a new building – as they were. Adam's replacement Town House, constructed between 1732 and 1734, provided the burgh with one of the smartest new civic buildings north of London.

Like its equivalent in Amsterdam (which might have inspired it), the Town House had two pedimented show fronts, one facing the High Street and market place, and the other dominating the harbour and its shipping. This exceptionally ambitious building had the standard accommodation – rooms for magistrates and city clerks, and two great chambers of the Council and the Guildry – but on an outstanding scale and to exceptional quality. The ground floor was commercial, with space for the Town Guard, the principal chambers were on the principal floor, and there were cells for those awaiting

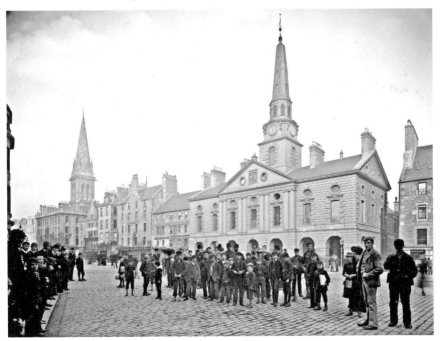

High Street and the Town House.

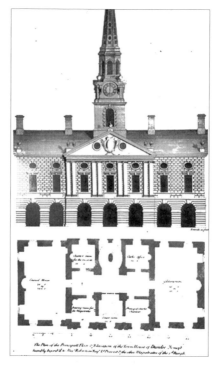

Town House elevation.

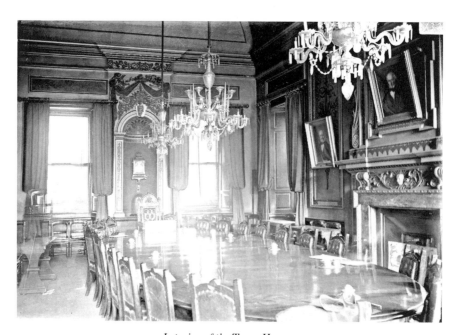

Interior of the Town House.

trial in the attics. The projection of the arcades or loggia, locally nicknamed 'the Pillars', were probably aligned with the arcades of the tenements that flanked the town house on each side. Once the latter's arcades were scraped off in the late 1760s, the frontage of the Town House came to project that much more prominently into the street. Since the Town House construction costs came in over budget, some details proposed for the steeple were never completed and it was not for another 25 years that the Council Chamber was fitted out – and then it was used for theatres and concerts. Before that both Council and Guildry used the other chamber, which had been lavishly fitted out with plasterwork by the celebrated Thomas Clayton, and lit by a splendid chandelier presented by the nabob surgeon, George Paterson of Castle Huntly.

The Town House was demolished to make way for the creation of City Square almost exactly 200 years after its construction. Various schemes to save it were prepared: either by removing it stone by stone to a new location on the site of the Luckenbooths, or by retaining it as a loggia in front of City

'The Pillars', the Town House colonnade.

Square. That would have prevented the void in the centre of the south wall of the market place that now exists. Some of its stones were re-used in the house of Greywalls, Perth Road, which must thus be at least partly built with the stones of Dundee's Greyfriars. The Lindores Abbey roof timbers were probably burned.

Town House Colonnade

Known by Dundonians as 'the Pillars', the loggia beneath the Town House was the location of Dundee's most fashionable shops, and provided useful shelter in bad weather (see photograph on previous page). The entrance to the Council Chambers and Guildry room lay at the centre, where the uniformed men are standing, which led up an oval staircase at the rear with a fine view over the shipping in the harbour.

The Trades Hall and High Street

Dundee was bent on progressive improvement in the late eighteenth century. Profiting from feuing out their lands by the Cowgate, and the opening-up of St Andrews Street (later Trades Lane) between the shore and the new church, the Trades decided to invest their new wealth in building a block of shops on the site of the fleshmarket on the gushet between Murraygate and Seagate at the east end of the High Street. Realising that the town also needed an adequate hall and meeting place as well as funds for the Trades, they expanded their ambition to embrace a hall/coffee room above the shops and asked Samuel Bell to design it. His fee was £42 10s. Seeking to ennoble the location, Bell persuaded the Trades to return to the Council to seek permission to add a 'fronton', or pedimented façade, facing the High Street, in homage to the Town House. A tall cupola on top lit the staircase at the centre. When complete, the glory of the Trades Hall was its 15 × 10 metre hall, which acted as a coffee shop and newspaper room (and sometimes doubled as a meeting room or theatre). Additionally, each Trade had its own chamber. Income was generated from the shops on the ground floor, with their elegant bowed windows. The north-west shop was taken by the notorious Provost Alexander Riddoch.

The Trades Hall was doomed by the 1871 City Improvement Act which, by widening the narrows of the Seagate and Murraygate, squeezed it into oblivion. Before its demolition, the view east along the High Street bore a striking affinity to the view in Copenhagen looking north at the centre of

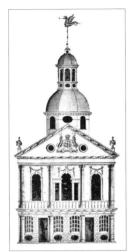
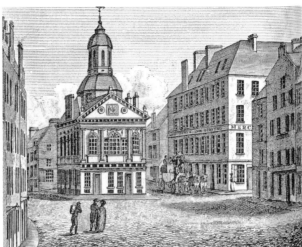

Trades Hall elevation, and as it appeared on the High Street.

Strøget. At the centre of both was a domed building with streets curving away on both sides. In the right corner rose a tall church tower, and a road led down to the harbour to its hard right. Whilst the differences are self-evident, the underlying similarity of urban form underscores the extent to which Dundee's architecture reveals it as a Baltic port.

Union Hall

In the pursuit of civic improvement, the burgh decided to remove the meal market at the west end of the High Street down to the Shore in 1782, just as it had done the fleshmarket seven years earlier. With it went the stance for the town's fire engines. In its place the far more imposing English Chapel appeared in 1785, designed by Samuel Bell to face his Trades House across the Market Place. The focus of the design was the outscaled first-floor Venetian window, something of a leitmotif in Bell's designs, with shops on the ground floor. That one of the three great classical civic monuments of Dundee's market place was an Episcopalian church provides clear evidence of the growing recovery of that denomination in Dundee's life. Episcopalianism had been strongly linked to Jacobitism – many Dundonians had been involved in both the 1715 and 1745 rebellions and suffered thereby. The Episcopalians had had to retreat from St Mary's Church to a large chapel on the edge of town by the West Shore, where they continued with unabated strength and the patronage of most of the lairds from the surrounding countryside. Once St Paul's Cathedral was built the chapel became the Union Hall.

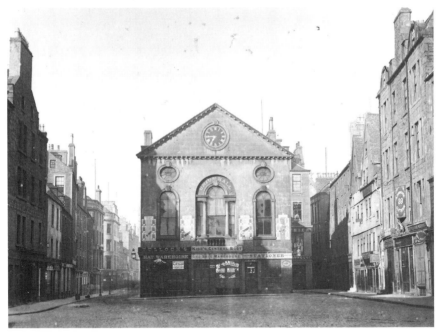

Union Hall. To the right, Our Lady Warkstairs can be seen.

SAMUEL BELL 1739–1813: BURGH ARCHITECT

Samuel Bell, acknowledged as the town's wright by 1772, became the burgh's architect by the end of that decade. It was expected that the design of the town's principal projects would come to him, and thus it was. It was rare for a town to appoint a burgh architect at that date, which may be taken as a symbol of Dundee's urban ambition. Bell subsequently designed St Andrew's Church (the Trades Kirk) in 1772, laid out St Andrew's Street through the Trades' ground in 1774, designed the Trades Hall in 1776, laid out Crichton Street in 1777, designed the English Chapel in 1782, the Seamen's Fraternity Hall down by the Shore in 1790 and the Steeple Church in 1791. His reputation was such that neighbouring towns invited him to assist them, as in the case of the steeple at Forfar. His design for St Andrew's Church was copied in both Irvine and Banff.

When the new turnpike to Coupar Angus was proposed through the Kirklands in 1793, Bell laid out Tay Street. He stipulated design conditions for the houses lining it, and probably designed the large houses on its north-east side. He also designed Provost Riddoch's house in the Nethergate (now the Clydesdale Bank), with its sophisticated curved windows. When Riddoch had the Nethergate moved from its north to its south so he could have a paved, illuminated approach to his house, Bell remodelled the Morgan Tower opposite with his characteristic Venetian windows. He may also have had a hand in the design of the contemporary Milne's Buildings lying to the west. Almost certainly he designed the smart new villas designed for the Baltic merchants 'Riga Bob' Jobson, his cousin John Jobson, and the Petersburg merchant James Johnston just to the west (nos 84 and 86 Nethergate), and the four small villas facing the Nethergate known as Whiteleys. In 1795, he laid out Castle Street and provided the design for Dundee's Theatre Royal on its west side 15 years later. Bell was a substantial property owner (his assets included Gardyne's Land), and when he died, he established a charitable fund to support his mentally handicapped son. His wealth on death was equal to that of the grandest of Baltic merchants.

THE SAILORS' HALL, YEAMAN SHORE

Trinity House – otherwise known as the Hall of the Fraternity of Masters and Seamen in Dundee – stood at the corner of Yeaman Shore and South Union Street, on the other side of the head of Craig Pier from the Lighthouse. It was designed in 1790 by Samuel Bell in his characteristic manner. The Fraternity, which achieved its Royal Charter in 1774, was essentially a charitable organisation for sailors and shipmasters, although it also had the responsibility for erecting lights, beacons and buoys in the Tay to guide sailors through the notorious sand banks. Replacing an earlier building on nearby St Nicholas Craig, Trinity Hall contained a fine Fraternity Hall on the first floor, identified by Bell's typical motif of a Venetian window, which became much used for town balls and assemblies. There were business rooms on the ground floor, and a lecture room in which aspirant ship

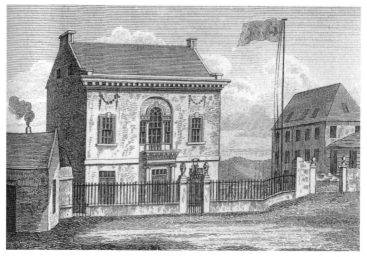

The Sailors' Hall.

masters were required to attend classes on navigation, doubling as a church on Sunday.

WHITELEYS

Dundonians were distinctly unenthusiastic about constructing the classical terraces which were beginning to be seen in Edinburgh and Glasgow in the later eighteenth century. Most of the town's élite were content to remain in their town-centre apartments and have them fashionably refitted with carved timberwork, elaborate plasterwork and Robert Adam fireplaces. A few suburbs emerged to the north and the west, but instead of terraces, they more closely resembled a smaller version of the detached villas of tobacco-lord Glasgow than Enlightenment Edinburgh. Clusters of closely spaced villas began to emerge just outside the town's boundaries in Chapelshade, and on both sides of Nethergate and the Perth Road. An early group were the four respectable villas known as Whiteleys, on a bluff overlooking Nethergate, with an excellent view south over the Tay. These small, three-bay houses were almost certainly designed by Samuel Bell, and varied only in their detail: the type of pediment above the doorway, or whether the corners of the houses were emphasised by pronounced stone quoins or flattened pilasters.

The houses in the photograph (opposite page) have all been altered by the addition of nineteenth-century bay windows, and the eastmost one was subsequently rebuilt in gentle Jacobean. They were probably selected by University College Dundee because they were cheap. Because industry from

Whiteleys, at the point when the four houses were being amalgamated for
University College, Dundee.

Hawkhill – particularly a jam factory – was pressing up against their rear walls, they were no longer as fashionable as once they had been. The college first linked them all together, and they remained the heart of the college until their demolition for the Tower Building in the 1960s. Two villas of this type and generation still survive on the other side of Perth Road.

PARK PLACE

By 1818 Dundee's leaders were finally ready to quit their central apartments to test the attractions of villa life in the growing suburb on its western fringe. Thus a street of élite villas was designed along the edge of the Hospital Park and they were perhaps David Neave's – and Dundee's – finest. Typically of David Neave, they were both larger and more sophisticated than Samuel Bell's villas, albeit set just as close to each other. They were distinguished by pediments above elevated doorways and a gracious sense of proportion. These beautiful houses gazed westwards over the sloping fields of Blackness. Unfortunately the Town Council allowed a sugar refinery to be built at the top by the West Port, and the street quickly lost its cachet. By the middle of the century, Park Place had been infiltrated by industry seeping down from the north. In 1885, two villas at the centre of the terrace were demolished for the Harris Academy, and eventually the entire street would be given

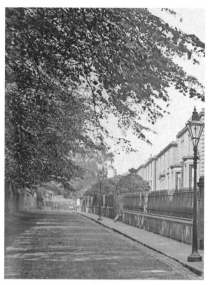

Park Place.

over to education. The last untouched villa to go was John Jobson's, a late eighteenth-century house designed by Samuel Bell which faced across the Nethergate to his cousin Robert's villa (also designed in 1790 by Samuel Bell, and which remains today). John Jobson's villa was demolished for the Bonar Hall in the 1970s. Two villas at the upper end of Park Place remain entombed in the Dental Hospital.

A key dynasty of later eighteenth-century Dundee, the Jobsons had their origins as farmers at Foulis, and in the seventeenth century some moved to the burgh to be shipmasters. They were as influential in the eighteenth century as the Wedderburns had been earlier. Charles Jobson was burgh treasurer in 1745, and later freighted ships directly for Charleston, America. David, a Writer to the Signet (a lawyer) was elected to all the Tailors, Hammermen, Glovers, Bakers, Weavers, Cordiners and Book Scriveners. The merchant John Jobson, a dyer, was successfully involved in whaling, and became Deacon of the Waulkers in 1768. His son David was elected a dyer in 1749. David Jobson, a cordiner, became cashier of the Dundee Bank. and his cousin Robert Jobson – 'Riga Bob' – spent time as a flax agent in the Baltic on behalf of his family. D. and J. Jobson were bakers, and Andrew Jobson a tailor. Jobsons were particularly significant in the Council, Trinity Hospital (the Seamen's Fraternity), the Infirmary, and the Trades House. Instrumental in the removal of Provost Alexander Riddoch in 1817, Riga Bob eventually became provost in 1836. Ex-councillor David Jobson was the only member of Dundee's élite to perish in the Tay Bridge disaster in 1879.

TAY SQUARE

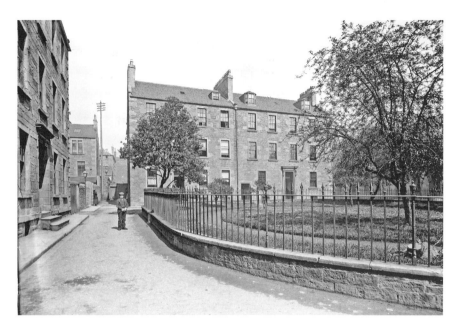

It may seem odd to include Tay Square in a book on 'lost Dundee', since it still exists, but the gracious atmosphere recollected in this photograph is departed. Taking advantage of the two new turnpike roads between Dundee and Perth and Coupar Angus, the Town Council instructed Samuel Bell to feu out a new road through the gardens and orchards belonging to the Town's Hospital, to join the two. Tay Street was meant to be a parade of two-storeyed, slated, ashlar terraced houses in the model soon to become the norm in other Scottish towns. Unfortunately Dundee's élite – particularly the shipmasters – were disinclined to move, so only a few stances were taken up.

The high point of this new development was to be a Georgian town square, at the south end of the street, known as Tay Square. Take-up remained slow and, as can be seen from this photograph, the original concept for two-storeyed terraced houses gave way to taller buildings containing apartments. Some dark red masonry in the side wall of the building straight ahead indicates that a much earlier structure, possibly Dundee's Blackfriars, was located somewhere nearby. The east side of the square remained unfinished for almost 25 years, only completed in 1818–20 by David Neave, Bell's successor as town architect; but with what grandeur and ambition. Neave constructed Dundee's finest neo-classical terrace, and lived in one of the houses. When the Town Council failed to enclose the centre of the square and keep it free

from rubbish, it was sued by the residents of Tay Square, for it was only the garden at the centre that gave sufficient value to the surrounding houses.

Tay Square was never completely finished. Moreover, the square's amenity had been damaged by the spread of industry south from Hawkhill. The gap on the left was eventually filled by the Dundee Repertory theatre in 1982. Only the two building blocks in the centre of the square's north flank and the terrace lining the east remain. The west side has been completely rebuilt, the buildings in the left distance have gone, and the railed garden has been replaced by car parking and a hard landscape of aggressive modernity. The square has largely foregone its gentility.

The Theatre Royal, Castle Street

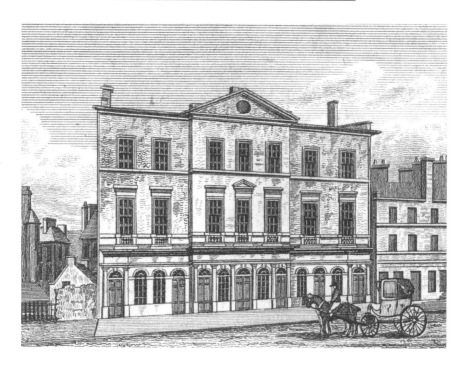

A theatre was a prerequisite of a cultured town. There had long been a timber theatre down on the shore, and the Guildry Room in the Town House and the Coffee Room in the Trades House were also borrowed from time to time, as the need arose. However, in 1810, subscribers decided to take advantage of the feuing out of Castle Street, and purchased three feus in the street to construct a Theatre Royal. The sum of £3,500 was raised in shares of £25, and quickly subscribed. It was to be Samuel Bell's last design for Dundee. Given

the vulgar flamboyance then exemplified in the theatres in Edinburgh and Glasgow, Dundee's was plainly elegant: an ashlar façade with a string-course, and pediment containing a bust of Shakespeare. Despite the theatre's high ambitions, it was not especially supported by the townspeople and by 1817, the manager had to depend upon ships' crews to fill his seats. It is not surprising therefore that the Theatre Royal turned more towards vaudeville to stay alive. It was set on fire by ignorant exuberance during one such performance, largely gutted and then converted to other uses.

DUNDEE ROYAL INFIRMARY

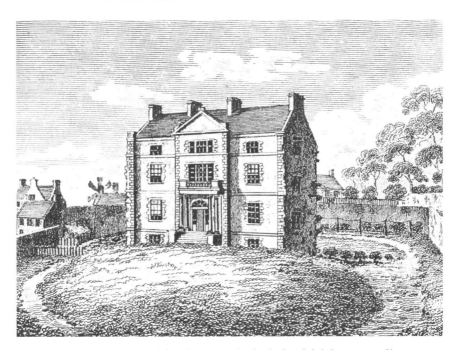

Although Dundee was held to be a particularly healthful town, a dispensary had been opened in 1782 by Dr Robert Stewart, with the town's minister Dr Robert Small; and its success led them to gather support – particularly from the Jobsons – to raise subscriptions for the construction of an Infirmary in 1794. No self-respecting burgh could be without one any longer. Edinburgh's Royal Infirmary had been designed by William Adam in 1728, and Glasgow's in 1792 by Robert and James Adam. It seems likely that Dundee sought the same designers. However, Robert Adam had died in 1791 and James Adam in 1794, so Dundee had to put up with the Adams' former chief assistant, the uninspired John Paterson. The site chosen was on the Forebank slopes to the

east, away from any harmful contagion from the town centre. Initially, demand for the hospital was so low that its wings were not constructed, finally being added in 1824 by David Neave. When the new Dundee Royal Infirmary was opened on the slopes in Dundee Law in 1852, the old infirmary was converted into a model lodging house. It was demolished for the construction of Victoria Road.

DUNDEE ROYAL LUNATIC ASYLUM

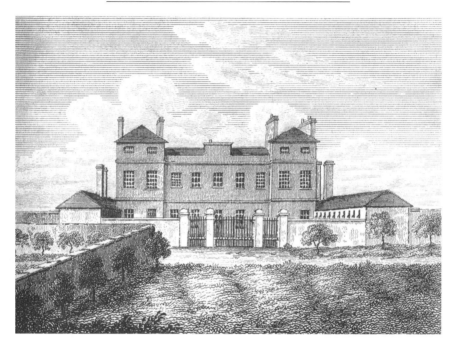

A fashion for incarcerating lunatics grew in the later eighteenth century as the possession of a lunatic asylum became yet another symbol of a town's moral purpose. Various monumental plans were tested out, including the centrally-controlled 'panopticon' favoured by Glasgow. Fairly swiftly on the heels of the success of the Infirmary, Dundonian subscribers turned their attention to a Lunatic Asylum and launched a fully fledged proposal in 1812. The site chosen was on open ground some way to the north-east of the burgh, near the site of Baxter Park. The architect chosen was the man Sir Walter Scott referred to as Scotland's greatest architect, but who died very young – William Stark. Stark had been assisting the construction of St Petersburg, where he may have met the Dundonian flax dealer, James Johnston. However, he had also developed a reputation of specialising in lunatic asylums. His Dundee proposal, completed in 1819 after his death, showed that he was

moving away from the monumental centrally controlled institution to a more open and sympathetic design. The plan was for a fairly low central block with single-storeyed wards enclosing nursery gardens in which inmates were expected to work for therapeutic purposes. The image was that of a rural farm, and the main asylum building more closely resembled a country house than have lunatic asylums before or since.

LOGIE HOUSE

The small estate of Logie, high on the approach road to Dundee from Coupar Angus, not far below Lochee, had been bought by the Town Council and then sold again to the Read family, who had done well with the East India company. It was then bought by Isaac Watt, who reformed it in the Regency period with the typically large windows and a fine columned entrance, designed either by David Neave, or perhaps by James Black (his successor as town's architect who had arrived in Dundee in 1817), prior to going bankrupt. This photograph, taken in the late nineteenth century by a jute mill supervisor, Alexander Wilson, shows a distinctive, horizontally-proportioned white box whose ground-floor windows were much smaller than those on the first floor above. That almost certainly indicates that it was a re-casting of a Renaissance villa of one of Dundee's Baltic merchants similar to Pitkerro, Blackness, Invergowrie or Craigie. It was probably Watt who conceived the

notion of planning a 'new town' in the form of a grid of small streets just downhill, now recollected only by the grid layout of the late Victorian tenements, and its elegant summerhouse marooned in a back court. Many villas, attracted by its south-facing slopes, equable climate and outstanding views, dotted Dundee's immediate hinterland in the early nineteenth century. One by one, they succumbed to the town's expansion. One of the last to survive is Annfield, off Blackness Road, hemmed in by later industry, tenements and housing.

St Paul's Episcopal Chapel, Castle Street

The striking difference between this view of Castle Street and the same view today is how much remained unbuilt in 1821. Castle Street had been opened in 1795 in order to provide better communication between the High Street and the Shore, and had to be blasted through the castle rock with gunpowder. Unfortunately, the land at the foot was owned by the provost, Alexander Riddoch, and his partner, Andrew Peddie, who held out against the Council for more money for a further 13 years. The street was laid out for terraced villas by Samuel Bell, who stipulated the design conditions. Since there was no great desire in Dundee to quit apartment living, the street took a long time to develop. By 1821 the east side of the street was barely half built.

Most of the houses in Castle Street were designed later by David Neave, who replaced Bell as town's architect in 1811, the finest being no. 26. They were plain, four-storeyed terraced houses (or maybe apartments) above delicately glazed Regency shops on the ground floor.

The focus of this drawing is the mock-Gothic Scotch Episcopal Chapel sitting above a fine neo-classical ground floor entrance, not unlike Neave's contemporary Thistle Hall in Union Street. Prior to the building of Sir George Gilbert Scott's St Paul's Cathedral on Castle Hill in 1855, Dundee's variously splintered Episcopalian congregations occupied a number of buildings in the burgh, and this was at least the third. Behind the gap in the street wall to its right lay Provost Riddoch's Graving Dock, carved out of part of the 1644 Packhouse Square. Masts of vessels in the port may be seen behind.

SCHOOL WYND CHURCH

The School Wynd Church, constructed in 1825 probably from designs by David Neave, was a 'burgher chapel' with 1,100 sittings. Its staunchly noncomformist congregation were descendants of the anti-burgher (i.e. those who refused to swear the burgher oath) Secession Church, and it appealed particularly to men of independent mind and to the industrious poor. Architecturally, this

simple yet elegant chapel followed Calvin's injunction to let light into worship, with its enormous Venetian windows and glass cupola. This was no centre of mystery: it was a building for the open discussion of God's Word.

Originally facing the narrow School Wynd, the church's setting became much grander with the creation of Lindsay Street, in good time for its reputation to spread with its appointment of the polymath, the Rev. George Gilfillan, as its preacher. Gilfillan, one of Dundee's great kenspeckle figures of the Victorian period, rejected narrow Calvinist dogma, opposed the concept of perpetual damnation, and preached a gospel of mercy and forgiveness. His church became the centre of an extensive social and educational network. A close friend of John Leng, Gilfillan promoted poetry and the arts, and was the editor of the celebrated *Gilfillan Burns*. Even though attacking Burns for immorality, Gilfillan never claimed to be perfect. After a New Year dinner in 1867, a policeman found him sitting down at the docks, intoxicated, reciting Shakespeare.

Market Place Looking West

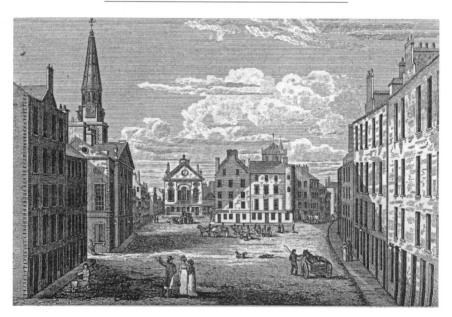

This 1821 drawing emphasises how all routes entering the Market Place from the west were narrowed to control the wind. To the right, the Overgate curved out to the West Port, and thence to Coupar Angus. The Nethergate, beside the English Chapel on the left, led westwards to Magdalen Green and to the turnpike road to Perth. Between them was a great wedge of masonry

known as the Luckenbooths (locked-up booths), It stretched as far back as St Mary's, penetrated by a few streets and lanes like Thorter Row, which had been built by the later fifteenth century. The building with the truncated circular turnpike stair on the Overgate corner is thought to have been occupied by General Monk in 1651 after his conquest of the town, although it was also reputed to be the birthplace of the Duchess of Monmouth at the same time.

Timber-galleried frontages no longer graced the tenements facing the Cross, and by the time of this drawing, their ground floors had been converted from merchants' booths into fashionable shops. The Luckenbooths and the Overgate were removed in the early 1960s for the Overgate Shopping Centre.

View from the River, 1803

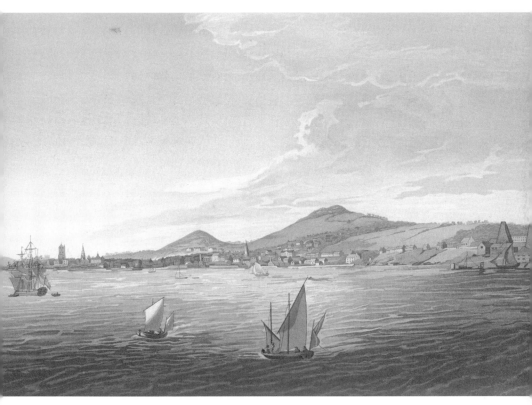

This view of Dundee from the 'Roads' (anchorage) shows the burgh immediately before the decades of enormous harbour expansion that were launched in 1815. The burgh had done very well out of the Napoleonic War, being a naval station (blue jackets in the foreground), although trade with the Baltic had been interrupted (vessels came into Dundee by convoy) and the trade

with the West Indies had been harassed. Baxter Brothers' first expansion was supplying sailcloth to the navy – including the sails on HMS *Victory* at Trafalgar – and shipping in Dundee had increased greatly, mainly either in coastal trade to London, or vessels used for fishing. Such was the demand that most of the sailors in the fishing business obtained exemption from the press-gang.

Physically, the principal visible change is the arrival of the brick cones of the short-lived Dundee glass works at Carolina Port, begun in 1790 and employing over 100 people. It survived barely two decades.

DAVID NEAVE, TOWN'S ARCHITECT

Son of a Forfar mason, David Neave (1773–1841), was appointed Dundee's town architect in succession to Samuel Bell, and held the post from 1813 to 1833. He may have trained or worked with the renowned architect David Hamilton of Glasgow, since, like Hamilton, he was in partnership as a builder, had his own marble workshop (in Castle Street) and, like Hamilton prepared a portfolio of house plans and elevations to use as a marketing document for new clients (now in the RIAS collection in Edinburgh). Even his signature had the distinctive backward-sloping italic form of Hamilton's. Although not as architecturally crisp as Hamilton, Neave's designs showed knowledge of the architecture of Sir John Soane, who had designed two villas in Glasgow, possibly with Hamilton as executant architect. It was Neave's misfortune that most of Dundee's public buildings were relatively new and did not require replacement. Worse, two of the three civic buildings constructed during his watch as town's architect – the Seminaries (or High School) and the Exchange Coffee House – were awarded to assistants of the fashionably overbearing William Burn (then in the town assisting it with its 1825 Replanning Act) instead of to him.

Nonetheless, Neave's principal public building – the Thistle Hall in Union Street completed in 1829 (see p. 75) – was a building of considerable sophistication. In 1824, he completed the wings of the Dundee Royal Infirmary. He designed a number of churches – Edzell, Chapelshade, Lochee and North

Tay Street – the schools of Liff and Abernyte, and the County Buildings in Forfar in 1823. He was responsible for some large country houses, like Balruddery, and many of the houses and cottages lining the south side of Perth Road, which carry his distinctive fanlights. He produced endless but unsuccessful schemes for feuing out the sunny slopes of Forebank as a fashionable suburb. Even his plan to smarten up the eastern end of Broughty Ferry produced no takers.

In 1824, he was appointed one of the town's surveyors by the new Police Commission, with duties including street widening, levelling and paving. He maintained a direct labour force. He will be best remembered, however, as the favoured architect of Dundee's mercantile élite. He completed South Tay Street in 1818, and the first section of King Street in 1825, and designed 21 – at the very least – neat classical villas in Park Place, Perth Road, Magdalen Yard, Seagate and down into Roseangle. Their interiors were cleverly planned, smart whilst remaining unpretentious, with some fine ceiling plasterwork. With their flattened pilasters and flat-topped pediments, they distinctly resembled David Hamilton's villas in the Glaswegian hinterland. They were easily a generation more sophisticated that Bell's earlier villas.

THE THISTLE HALL, UNION STREET

In 1824, the Council realised that a new vehicular access would be needed between the expanding harbour and the Nethergate, and had to choose between widening Couttie's Wynd or carving an entirely new street through the dense closes of the Maritime Quarter. It chose the latter. This wide, gently sloping street, called Union Street, was similar to many such streets connecting the centres of towns to their harbours in the 1820s. It was designed and laid out by David Neave, and largely comprised of apartments above shops rather than terraced houses. Determined not to put developers to any expense, the Town Council relaxed the customary requirement to abide by Neave's feuing design, and – save for the corner pavilions – required only that they had to conform to the standard four-storey height.

The Thistle Hall, Union Street.

At the centre of the west side of the street, the Thistle Operative Lodge of Masons bought two stances so that it could provide the town with a more fashionable place for assemblies, balls, concerts and routs (a less formal type of ball) like the Trades Hall in Glasgow. Neave was appointed to design it, and it became probably his most distinguished public building, deploying the spare neo-classical architecture much in favour in northern Europe (notably Gothenburg, with which Dundee did much trading). The Thistle Hall was thus the only building of any pretension in Union Street. Neave's drawings demonstrate with just how much care he tackled the project. Unfortunately, the Thistle Hall lost much of its original crisp classical quality and most of its majesty in the later nineteenth century, when it became overwhelmed by the Royal Hotel and an additional floor was inserted into the Hall itself.

To provide an additional source of income, the Masons let out four shops on the ground floor (as had been the case beneath the Trades Halls both in Dundee and in Glasgow). This drawing was prepared as his business card by one of the shopkeepers, Alexander Gilruth. He obscured the nature of his competitors' shops (save for the hatters at the top end) to emphasise the exotic merchandise contained in his warehouse of jewellery, toys and fancy items.

THE EXECUTIVE

The young Dundee portraitist Henry Harwood painted 'The Executive' (next page) in 1821, but it is still not clear what his agenda might have

The Executive.

been. Ostensibly a portrait of those who governed Dundee discussing civic affairs in front of the Trades House on the gushet between the narrows of the Murraygate to the left and the narrows of the Seagate to the right (an echo of a comparable drawing of the *illuminati* of Enlightenment Edinburgh pacing up and down Parliament Square), it is at the very least satirical, for his figures are distorted and given sarcastic nicknames. The deacon of the dyers, Cathro (third from left, nicknamed 'Set of the Mills'), is made to appear almost simian. Although it is tempting to attribute the genesis of the picture to propaganda for one side or another in the bitter harbour dispute, that seems unlikely, for he satirised equally Provost Patrick Anderson – Provost Riddoch's supporter and successor, who had prevaricated over the harbour improvements (the tall man in the top hat nicknamed 'the Previous Question') and the shipowner, George Clark (the man on the right, nicknamed 'the Go-Between'), who had originally led the Baltic merchants and shipowners in their campaign to wrest control of the harbour from the Town Council in 1815. It is as though Harwood was saying 'a plague on both your houses'. The smartest dressed – sixth from the right – is the glover George Rough

(nicknamed 'Interdict or man of the breeches'), whose shop can be seen on the right. The shop on the left, selling fashionable crockery and cutlery, had belonged to Alexander Riddoch for the previous 40 years. Castle Street opened hard right, in line with the façade of the Trades Hall, to extend down to the harbour. Merchant's Hotel, on the corner of Castle Street, had been initiated as a Tontine Hotel in 1790, failed and was privatised, eventually to become one of the principal hotels of the port, superseding even the New Inn on the other side of the High Street.

ARCADIA ON TAY

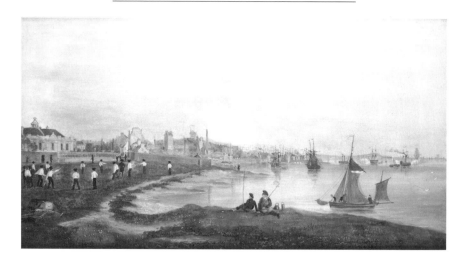

This painting by George McCullough is the last depiction of Dundee as a seaside town, before its shoreline was ruined by the arrival of the Dundee & Perth Railway line in 1847. Schoolboys play cricket on Magdalen Green beside the glorious beaches of the Tay estuary. These beaches were enormously popular for bathing, recreation and fishing; and the walk down to Battery Point in Magdalen Green was the proper thing to do on a Sunday afternoon. The newly built classical – almost Egyptian – villa on the left, 'The Vine', built as an 'art-gallery house' for the MP and art collector George Duncan, was a sign of the suburban quality of this district. It had been designed in 1836 either by William MacKenzie, city architect of Perth, or by George Matthewson. The villa was conceived around a circular top-lit hall/gallery at the centre, intended for picture display, from which opened the principal chambers. Service rooms were hidden in a considerable annex. Roseangle, still largely rural, ran up beyond it to Perth Road. The villas on the sea side had gardens that stretched down to the beach, and some had their own

jetties. Dundee to the east was dominated by St Mary's Tower, and its 'roads' (anchorage) and harbour were full of shipping.

Fifteen years later, this had become a scene of railway lines driven through the shallows of the foreshore, with their sidings and coal yards.

JUTEOPOLIS 1820–1900
INTRODUCTION

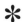

Dundee entered the nineteenth century in very good heart. It had dragged itself out from the disasters of the seventeenth century during the eighteenth, accustomed itself to new industries and activities, adapted itself to new markets and carved a new position within Scotland. The harbour problem had finally been sorted in 1815. Although tentative mechanisation had begun with the first steam-powered mill in Blackness in 1805, industrial expansion only accelerated after the first substantial wave of mill building in 1818. The burgh thereafter entered six decades of such rapid expansion that by the 1880s it would be transformed from a seaport to an internationally renowned industrial city: not a mixed industrial city like Glasgow, however, but one perilously close to a town dependent upon a single industry – that of processing jute – and its offshoots. The nineteenth century, therefore, was the period in which Dundee became 'Juteopolis', and came to be characterised by the legendary 'Three Js': jute, jam and journalism. Although the seeds might already have been sown for all three, such an outcome could never have been forecast in 1820.

Unlike virtually all other Scots burghs, Dundee had not modernised itself; no new street pattern, no reorganisation for the turnpike roads and no districts reserved exclusively for either the middle class or industry. No plans had been drawn up to govern how the town's Ward lands and Meadows, lying immediately to its north, might best be developed. This was the logical place to align a new east–west route bypassing the medieval centre, but the opportunity was not taken. It was this lack of foresight that condemned the medieval town to death in the 1870s. Sooner or later, it would present an unacceptable blockage to commerce.

With its early success with osnaburgs, coloured thread and sailcloth, Dundee was well set to develop its linen industry, which it did with such pace and expedition that by the 1830s it had become the largest linen manufacturer in the United Kingdom. In 1833, Thomas Neish – one of the 'Coogate' Baltic merchants – who dealt in Russian flax, and was vice-consul for the

Dock Street.

Emperor of Russia, imported a cargo of jute from India. Even when he failed to make an initial success of it, he persisted until jute was finally poised to take prime position in Dundee's economy by the 1850s.

The most radical changes to the burgh were stimulated by changes in the transport networks. Dock construction was swiftly under way in the 1820s, transforming the sea front entirely. The shipowners, manufacturers and merchants who had wrested control of the harbour from the Council had been correct in their assumption that it was the old, unreformed state of the harbour that had been restricting the growth of trade. The first two docks were not even complete before two larger ones were planned for downstream. Indeed, had it not been for improved cargo-handling machinery and, eventually, some eleven miles of railway track lining the harbours and wharves, two further docks would have been constructed away out into the Tay estuary: their plans were all drawn up and ready.

Even greater changes to the town followed the arrival of the railways. Dundee's civic leaders feared that the town would be bypassed if canals or railways from Perth were routed north to Aberdeen inland through the Vale of Strathmore. If that happened, Dundee would be isolated on – as they put it – a peninsula. Consequently, in 1824, the burgh began a campaign to locate itself at the heart of the Scottish/United Kingdom railway network which it would sustain over the following 50 years.

Its first scheme was to link the port back into Strathmore to plug into any railway routed up that valley. In 1825, it commissioned a railway up and through the shoulder of Dundee Law, horse-drawn across the Sidlaws, and then down into the hamlet of Newtyle. It would provide farmers with a seaport outlet, and Dundonian manufacturers with an inland market. It was never as successful as planned, and its impact upon the town itself was largely restricted to nuisance value, running across Bell Street and the Nethergate at ground level and interrupting the traffic. It was a further example of the town's lack of a coherent urban strategy.

The Newtyle Railway not having met with the success that they had hoped, Dundonians quickly turned to two further railways: one to Arbroath, opened in 1838, and the other to Perth, which was delayed and not opened until 1847 (the year the first scheme to construct a railway bridge across the Tay was mooted). These two new railways changed the face of Dundee utterly. It had always been possible to bring the railways in overland, behind the town, as had been done in Greenock, but the burgh had made no plans for accommodating them, with the result that the railway companies bought up the foreshore and mudflats east and west, and drove their tracks through them. Thus, they cut off Dundee's celebrated beaches, and marooned all

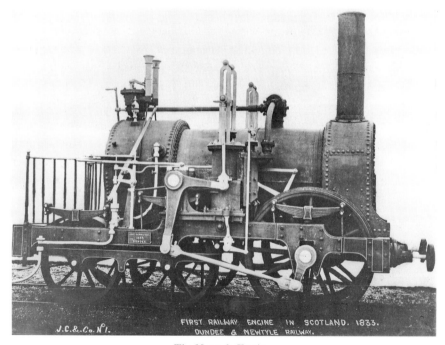

The Newtyle Engine.

those houses and industries with their own piers and jetties – notably the whaling companies in the Seagate – causing a number of industries to go bankrupt. The railways severed the burgh from the sea that gave it birth and greatly reduced the amenity of the West End. Dundee was transformed from a seaport to an industrial city with a harbour.

Textiles may have been dominant, but they were not Dundee's sole industry. A healthy engineering industry flourished in Dundee, developing and producing machinery for textiles, for locomotives and the railways and for shipbuilding. The original shipbuilding area of Dundee by the West Shore had been displaced by the construction of the new harbours, and it was relocated into much more spacious territory along the newly created Marine Drive – a road running along the sea side of Camperdown Dock, and terminating in the first of these new shipyards, Panmure Dock. However, the engineering foundries and workshops were mostly scattered in the backlands, like the mills. This random, rather than planned, industrial expansion spread up the slopes to form a thick ring of miscellaneous mills, factories and workshops, interspersed with random blocks of tenements accessed only by cul-de-sacs, surrounding the town on three sides. In contrast to industrial cities like Glasgow, therefore, the necessary industrial utilitarianism of Juteopolis was not confined to predetermined districts but seeped into most parts of the town. Large mills grew like a cancer within otherwise élite districts – excellent examples being the enormous Mid Wynd Works, which insinuated itself between Perth Road and the Hawkhill, and the Seabraes Works which grew to glower over the villas of Roseangle, ruining the leafy nature of this early *rus in urbe* suburb with its smart villas by David Neave.

The great urban opportunity presented by the Ward lands and Meadows was squandered. In place of the streets conceived in 1825, or the sequential plans to use the site to provide Dundee with an echo of Edinburgh's New Town by James Brewster (1832), George Angus (1834) and Charles Edward (1846), the area became colonised by factories, foundries, warehouses and woodyards – dominated by the colossal and rather splendid neo-Italian Ward Mills. The lack of control was symbolised by a muddle over something as simple as street alignments: such a minor detail and so easy to get right. For even neighbouring churches built in this district had different alignments, as though there were no firm street pattern. Worse, they allowed the High School to be built to a different alignment from that of the Town House which, originally, it was meant to face.

In 1858, jute finally became Dundee's principal import and manufacture. The burgh's population had grown by 45,000 since 1821, and it was to

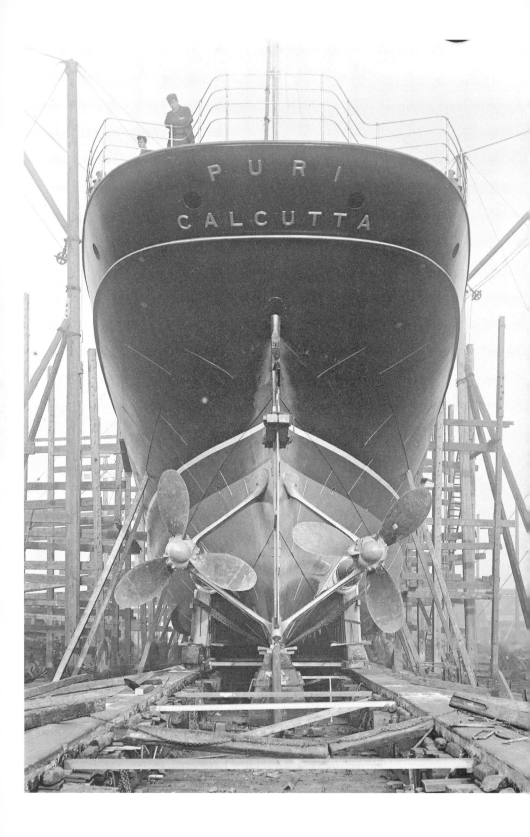

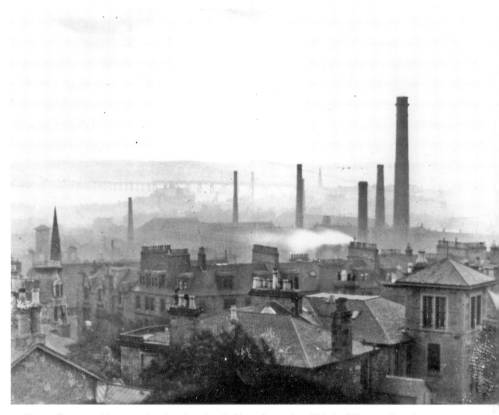

Above: Factory chimneys dominating the skyline. Opposite: Shipbuilding at Dundee.

grow by a further 80,000 over the next 40 years, because there was plentiful work and the town retained the reputation of being a healthy place. The burgh had become a destination of choice, and it even sent recruiting ships to Belfast seeking workers. Moreover, the town centre had not yet segregated itself, in stark contrast to other Scots cities. Into the 1860s, doctors and other professionals still lived in the Murraygate, cheek by jowl with craftsmen and candlemakers, in a manner long abandoned elsewhere. To be sure, the jute barons were living in jute palaces in the West End, West Ferry and Barnhill. However, contrary to the myth of exploited workers and fat plutocrats, jute palaces were little more than inflated suburban houses – however flamboyant, if not vulgar, they may have seemed – far from the scale of opulence of the great capitalist mansions to be found near Liverpool, London or in America. Indeed, the most famous – the Grimond house of Carbet Castle in Broughty Ferry – more resembled a bungalow on steroids. Moreover, they also lacked that sense of being detached from the town from which their wealth derived. James Cox's house of Clement Park, Lochee, was within eyeshot of the Cox

The colonisation of the Meadows.

Brothers' Camperdown Works. Whatever was to happen later, the notion of a class war is an inadequate way of explaining mid-Victorian Dundee.

As the town grew, however, so did a sense of embarrassment that the old town centre was no longer adequate. The street pattern remained unreformed, and traffic jams – particularly between the docks and factories – were increasing. The closes remained dense and narrow, and the gardens between them had largely been built up by the 1860s. Disease had become more prevalent. Dundonians became impatient with their ancient seaport: it was insufficiently grand to dignify the past. Commenting on the closes of the maritime quarter, a correspondent to the *Dundee Advertiser* observed that it looked as though Dundee's buildings had been dropped from the sky by a demented pigeon; another observed ruefully that Adam's splendid Town House was 'murdered by its situation'. The new Dundee wanted something smarter than the douce but shabby market place, with its ageing classical civic monuments. This feeling that Dundee's success was no longer reflected in its built environment led to the construction of the Royal Arch down on the shore (see p. 104) as the principal icon of Juteopolis. Greater pressure was building up on the old town centre; and the more the town added industrial layers round its rim, the worse that pressure would become. Sooner or later it would have to be tackled.

The Baltic merchants moved first. In the 1850s, they quit their old Exchange in the Baltic Coffee House on the corner of the Wellgate for a new corner site in the eastern Meadows at the end of the new Panmure Street, where they erected the Royal Exchange. The corner site implied that they

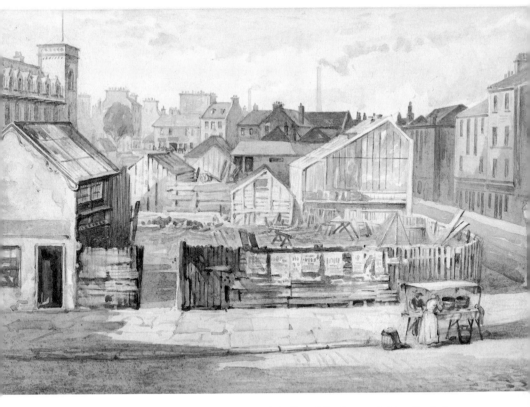

The Meadows in the 1850s, after the arrival of the Royal Exchange (left): effectively the site of a possible Royal Exchange Square. The buildings straight ahead and right represent the 'back dykes' of mediaeval Dundee.

had conceived of an entirely new square – a mercantile centre equivalent to Glasgow's Royal Exchange Square – which would form the desired modern and opulent business centre for the town to compensate for the outmoded High Street. The Town Council, however, does not appear to have supported the project with any practical help or control, and the scheme remained half complete until the Albert Institute colonised its south side.

Although there is little evidence of it surviving in the urban fabric, Dundee had a higher percentage of professionals in its population in 1841 than Glasgow. One might therefore have expected something equivalent to a smaller version of Glasgow's West End. But there is none, for Dundee's industrial development followed an idiosyncratic path. Its greatest jute and linen manufacturers created virtual principalities for themselves, and most of their workers lived nearby. Most had their own schools, and Baxters and Keillers attempted subsidised housing for key workers. So whereas the various

classes tended to congregate with their own kind in other towns, the employ-
ees of each of these textile 'principalities' in Dundee lived adjacent, with the
result that the professional classes or the middling sort never created the
quality suburb that can be found elsewhere – or certainly not until the 1850s
and 1860s. Moreover, only a few of the greatest jute barons became involved
with Council affairs, leaving the direction of the city to councillors who had
the background and perspective of small shopkeepers. Probably as a conse-
quence, the Council displayed not a tithe of the strategic thinking of the jute
barons. In the meantime, the population continued to swell. Between 1821
and 1861 Dundee's population had more than doubled, and it had doubled
again by 1901: an increase of over 500 per cent in just 80 years.

Dundee developed unrivalled expertise in the construction of jute mills
– and these were buildings of which the burgh was very proud. The term
'mill' is misleading, since there was no single building, as a rule. In the 'Low
Mill' the jute fibre was softened, prepared and carded; in the 'High Mill' it
was spun into yarn. It was then woven into cloth or canvas in the 'Factory'
before being given its final sheen (finishing process) in the calendar. A mill
complex might also have an engine house, warehouse, cooling pond, school,
an office, a waste works and a dye works. Architecturally, the principal and
tallest structure would be the High Mill: a dignified, wide-span building with
regular windows, with a neo-classical or Italianate campanile projecting from
its roofline sometimes sitting upon a lift shaft, and containing both bells and
a water tank: the principle, in other words, of 'dignifying construction'. The
elegant cast-iron roof trusses, often cast with curious Gothic detail, provided
the necessary wide span.

It was probably the railways that catalysed the town's next step. In 1866,
the North British Railway had had to withdraw from any plans to build a
Tay Railway Bridge for reasons of near-bankruptcy, and the Dundonian élite
(whose idea it had always been in the first place) established the Tay Bridge
Undertaking to build it themselves, agreeing to raise the necessary capital.
They appointed James Cox (long a railway buff) as chairman, and the lawyer
Thomas Thornton as agent. Probably as a result of Cox's growing prominence
in Dundee affairs, there was a growing demand for him to stand for the Town
Council. Reluctantly he agreed in 1868 after being lobbied by his own work-
ers. He became provost in 1870, and brought a managerial approach to burgh
affairs: the following year the Council appointed its first burgh engineer,
William Mackison from Stirling, and then steered a 'City Improvement Act'
successfully through parliament. It was a sign of the power enjoyed by the
Improvement Trustees when Thornton suggested to the railway companies

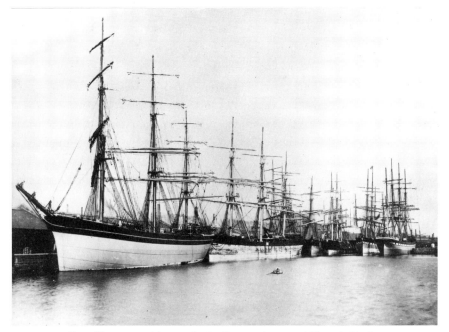

Jute clippers stacking up in the Camperdown and Victoria Docks.

that they should combine to use a single central station on the lines of a German *Haubtbahnhof*, offering to use Improvement Act powers to help them obtain the land. The land in question was that entire district lying between the High Street and the harbour – i.e. the maritime quarter – with the main entrance from the High Street. This striking sign of ambition (no other Scottish town had such a station) also indicated the disregard in which the burgh's élite now held its mediaeval inheritance. Fortunately railway rivalry could not be soothed sufficiently to make the scheme work, so the project remained abortive.

The Improvement Trustees' objectives were managerial rather than social: wide, efficient streets could take trams, remove bottlenecks, offer more valuable property to sell, provide good sewers and create the dignified urban environment they felt they needed. Housing the poor was irrelevant. They speedily proceeded to remove old Dundee; and just ahead of them would be the artist Charles Lawson, and the photographer Alexander Laing. Lawson sketched over 600 interiors and exteriors, probably at the commission of the antiquarian A.C. Lamb, reaching the properties when their rooms and shelves were already emptied, awaiting demolition. His sketches are of national importance since they provide a more extensive record of pre-modern Dundee than exists for any other town in Scotland.

First to be tackled, predictably, were the traffic blockages caused by the narrows of the Murraygate and the Seagate, and the winding Fenton Street. They were replaced with the splendid commercial boulevard of Commercial Street, conceived on a Parisian scale, which was used henceforth as the principal avenue along which to drive distinguished visitors through the town. The next wave of improvement in the 1880s took out Fish Street, Butcher Row and that solid mass of buildings and wynds between them and the Nethergate – in other words, most of the maritime quarter. The activities of a sailors' quarter such as this had offended Victorian nostrils, so its loss was not universally lamented. In the words of J. M. Beatts, in his *Reminiscences of a Dundonian* (1882) 'Every citizen must feel pleased in seeing the commencement of the demolition of the nest of pestilence and crime situated between the Nethergate and Fish Street, and it is to be hoped that the

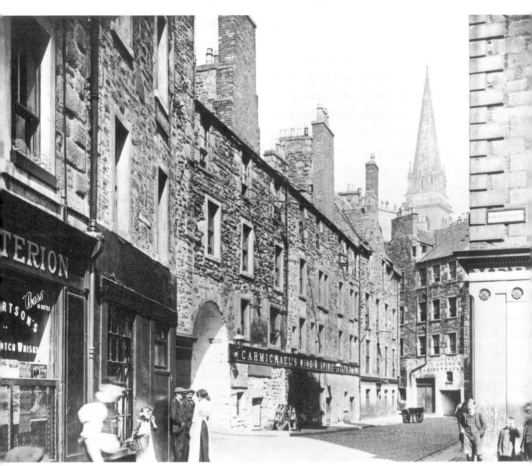

The head of the Greenmarket linking into Castle Wynd. The arched entry into the Vault is on the left.

Nethergate looking west after the demolition of Union Hall and the introduction of trams.

resolution of the Police Commissioners to proceed with the work will prove
a wise measure.' Only A.C. Lamb and Charles Lawson lamented the passing
of the ancient seaport. As it was emptied of its former inhabitants, it was
colonised by the homeless, by squatters and by an even greater number of
taverns, thus making its removal inevitable. The new Whitehall Crescent and
Street provided a much more stately – almost continental – entry to the city
for visitors coming by train.

Improvement improved little for the poorest. The areas being cleared
contained Dundee's oldest buildings and, by virtue of their condition, the
cheapest lodgings, which had been densely colonised by the destitute. When
the buildings were torn down, no provision had been made to accommodate
such people, and the dispossessed necessarily sought lodgings in the next
cheapest location – which would be the next area scheduled for 'improve-
ment'. The people cleared for Commercial Street probably doubled up in
the Fish Street area; and when cleared from Fish Street moved on to the
Vault or the Overgate – and so it goes. Even had the trustees not targeted
them already, this increased pressure upon ancient fabric would surely have
condemned them to death anyway. The improvement process, once begun,
would bring down the Maritime Quarter, the Vault and the Overgate like
dominoes.

The first Tay Railway Bridge finally opened in 1878 and the second in
1887; and between these two dates, Dundee enjoyed what was probably its

final significant jute boom, resulting in much refitting and extension of mills and factories. The town centre had been modernised, equipped with widened and better-lit streets thronged with trams, and now projected itself as a modern town – a city, after 1893 – with the attached seaside resort of Broughty Ferry for those wishing to improve their health.

By the end of the century, however, new strains in the town were becoming evident. The socially integrated town centre of mid century no longer survived. Suburbs to the north, east, west and across the river now absorbed most of the middling sort, leaving the old town centre to those with least choice. The swathe of mixed industry and housing that encircled the town centre had become virtually impenetrable, its 200 chimney stacks making central Dundee barely visible on a bad day. The town's failure to enforce any of the urban planning that was being achieved in Glasgow meant that Dundee's industrial ring lacked any sense of quality or urban grandeur – even though individual mills and factories could be technically and aesthetically magnificent. As city improvement proceeded, the really poor were crowding in upon each other in increasingly difficult circumstances. Dundee's social problems were probably no worse, pro rata, than those of Edinburgh and Glasgow; but where those cities developed greater segregation between industry (and the attendant poor living conditions) and comfortable residential areas, in Dundee industry felt all-pervasive.

It came to a head in 1905 with the publication of the 'Report of the Dundee Social Union'. Focused upon a sample area, it revealed a grim picture of poverty and disease, and their consequences. Although the report warned of the dangers of applying its conclusions to the entire city, that was what people did. The report was taken to characterise Dundee as a whole.

The consequence was that Dundonians began to conclude that the problems facing the city were so great that the only possible course was to rebuild it from scratch. Given that they saw nothing of historic Dundee worthy of respect, it reinforced the mindset of Dundee's city fathers that the future lay in modernity at almost any cost. As jute, engineering and shipbuilding began their long decline, the lack of belief in the city metamorphosed into a lack of self-respect amongst Dundonians themselves. They took a perverse pride in the fact that, to the rest of Scotland, Dundee was beginning to be symbolised by William McGonagall.

JUTEOPOLIS 1820–1900
THE ARCHITECTURAL HERITAGE

CRAIG PIER

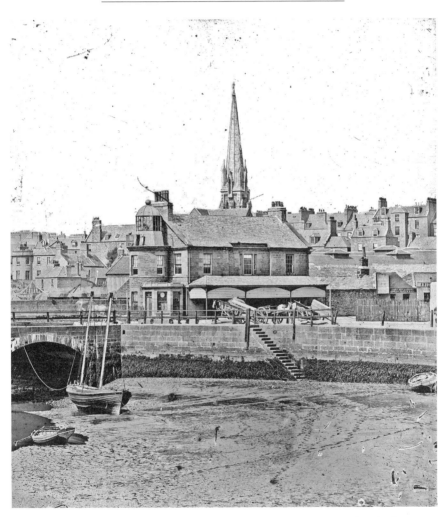

This photograph, looking from the edge of the King William IV dock across
the Craig tidal harbour, must have been taken c. 1850. The port buildings to

which the lighthouse was attached must have been rebuilt since 1822 (see p. 74) presumably by David Neave. The Sailors' Hall lies just out of sight to the right, and a pleasant bow-fronted villa occupied the West Shore just west of the lighthouse. The ridge of the Nethergate and the recently built St Paul's Church can be seen on the skyline. The octagonal staircase on the right probably indicates the foot of Malthouse Close. To the left of the photograph can be seen the mouth of one of the water tunnels proposed by the engineer John Smeaton in 1770 to channel the Tay's current into the bottom of the harbour to scour it out. He had suggested that these channels be arched over, and the Craig Pier in effect did this. It became the principal arrival point at Dundee.

The Cholera Hospital

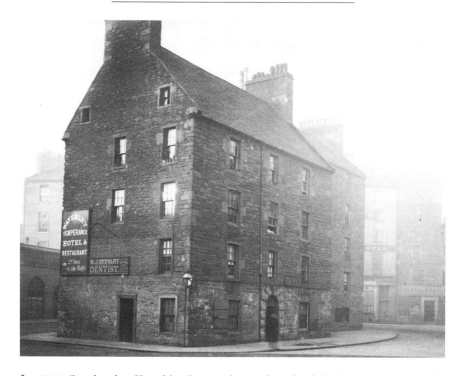

In 1832, Scotland suffered its first major outbreak of cholera, and despite its reputation for being a healthy town, Dundee was not exempt. Between 17 May and 15 November, some 511 citizens died of the disease (although that was a lower percentage of the population than in Scotland's other principal towns). Curiously, cholera was less prevalent in Dundee's dense, crowded medieval closes, where one would have expected it, than in the unregulated, rapidly

growing industrial suburbs like Hawkhill, on the town's western fringe. At the height of the epidemic, conditions had become so bad that a substantial irregular building, set apart from the town on Lower Union Street, was selected for conversion into an isolation hospital for cholera victims. Once the crisis was over, the building was refitted as lodgings.

In fact, it had been refitted several times before. As may be gauged from its grandiose doorway, this structure had been very significant in Dundee's earlier history. Almost certainly, this building had begun life as the town's shore windmill, rebuilt by David Strang in 1550, at the western extremity of what was called the 'new shore'. It was then converted into the burgh arsenal and remained as such for more than a century. Its location on the edge of the town, more or less encompassed by water, was highly appropriate. It was relatively safe from marauders, and far enough from the burgh should it explode.

DUNDEE HARBOUR, 1833

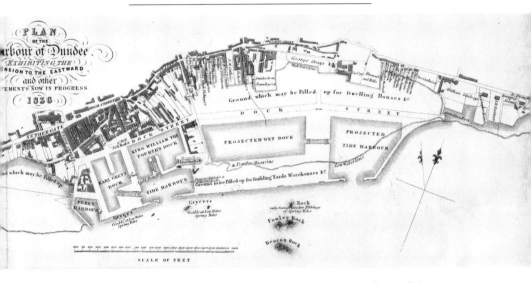

After control of the harbour had been wrested from the Council in 1815, Dundee's harbour expanded so quickly that plans for its expansion were prepared every four years or so until the 1850s. In recognition of this, Dundee equipped itself with the second-largest Customs House in Scotland. This plan, prepared by the architect-trained harbour engineer James Leslie, was the second of such plans, and outlined the port's ambition. The original harbour is the enclosed one farthest left. The dock in the centre is the King William IV dock, which was to be opened in 1834. The purpose of this plan was to

carve two further docks out of reclaimed land to the east, and these became the Victoria and Camperdown docks. Between the current and proposed docks, the site for the proposed Customs House can be identified, and a new road, to be called Dock Street, would join them all together. The Seagate, to the right, where the whaling companies had their private jetties, was to be marooned – with its tidal sandbanks merely identified as 'land available for building'. In fact, they lay as stagnant water for years, used only by Dundee urchins who liked to fish amongst the dead dogs.

The most dramatic change to the foreshore, however, was still to come. In 1838, the Dundee to Arbroath railway was driven through the tide, eventually to arrive just eastwards of the Customs House. The arrival of the Dundee and Perth Railway Company in 1847 likewise cut off the villas of Perth Road and the Nethergate from the sea that used to flow along the bottom of their garden walls. As the docks and railways colonised the foreshore, Dundee changed its character from a seaport to that of an industrial town.

THE HARBOUR AND DOCK STREET, 1836

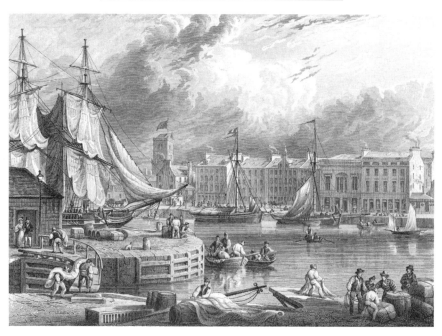

As soon as Dundee's first enclosed dock was opened in 1821, pent-up demand required a second, and the King William IV dock opened in 1834. This view, taken from the lock gates of the west, or Earl Grey dock, shows that Dock Street had become the modern façade that Dundee now presented to visitors.

The prominent Venetian window illuminating the Exchange Coffee House lit the great chamber inside.

So long as the docks prospered, the streets leading down to them – Union, Crichton, Castle and Commercial – all flourished. After the docks were filled in and replaced by the ring road and the Tay Bridge access in the 1960s, the economy of this part of town withered. The building to the east of the docks is now the office of the Dundee Heritage Trust.

THE SHORE 1843

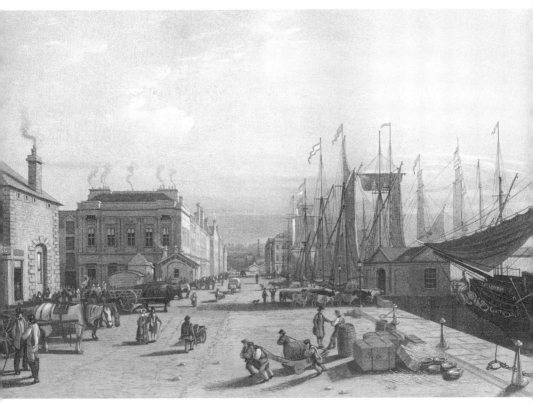

Dundee had become the leading linen town of the United Kingdom in the 1830s, and its two new enclosed docks, the Earl Grey and William IV docks, were quickly packed with shipping – so much so that there were already plans for more docks downstream before they were finished. The Shore had already been modernised. The burgh weighhouse had been removed from the Vault (allowing it to be converted into a militia building) into the eastern pavilion of the 1755 packhouses (on the left). Dundee's oldest pier, to the right, still faced up Exchange Walk, but the space was no longer an élite Merchant's

Exchange. It had declined, first, into the fishmarket and then made a further descent into the Greenmarket. The Shore had been straightened out and regularised into Dock Street. In the distance can be seen the gable of the largest Customs House in Scotland, designed in 1842 by harbour engineer James Leslie, who had himself trained with the great neo-classical architect in Edinburgh, William Playfair.

The Exchange Coffee House was designed in 1828 by the Edinburgh architect George Angus, who had already been working in Dundee assisting the architect William Burn when the latter was advising the Council on the replanning of the town centre and the opening of Union Street. This imposing structure was constructed for the town's international merchants, who had relocated themselves from the Trades Hall in the High Street down here so that they might be closer to the new docks. The Coffee House comprised an enormous, beautifully-lit chamber on the principal floor, where merchants could read newspapers or buy and sell the cargoes that they could see through the window. Later converted to the Assembly Rooms, the building subsequently became celebrated as Winter's Printing Works, from which many small books on Dundee's history were published between 1890 and 1914.

The Exchange Coffee House had been erected on top of a much earlier structure. The pre-1755 dock level was 12 feet lower, and may still be reached down a turnpike stair. There are vaulted cellars with their original storm doors, the stone flags at the centre scraped where barrels have been dragged in from the ships. This is the only accessible surviving portion of the 1644 Packhouse Square.

SHAPING THE TOWN, 1846

This plan of Dundee by the architect Charles Edward (opposite page) shows the final attempt by a tidy mind to use the town's rapid expansion to create an architecturally noble urbanism. The Council had been gifted the Meadows and Ward lands to the north of the town as common land by Mary, Queen of Scots in 1564. By the eighteenth century the western end of the Ward had been laid out as a public recreation space, with grand avenues and rows of elm trees, whilst the east end was used for bleaching and fairs. Dundee, unlike other Scottish towns, refused to commission a classical 'new town' on its land, giving rise to a risk that this asset might be developed piecemeal instead. Four attempts were made to lay out these lands in the approved urban fashion during the early nineteenth century. An Improvement Act in 1825 proposed regular streets streaking northwards of the High Street

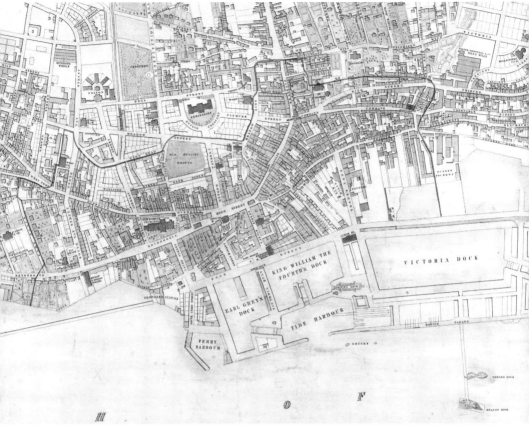

Plan of Dundee by Charles Edward.

and Murraygate to enclose a square. Only Reform Street was built. In 1832, James Brewster proposed an oval ellipse of elegant terraced houses enclosing the new High School like a nut in a shell, with churches facing each other at either end. The only echo of this plan is the line of Euclid Crescent.

In 1834, George Matthewson proposed a simpler variation without the churches – although the western one had already been built. By comparison with other new towns in Scotland it was too late. Even Reform Street took until 1859 to be completed. Yet although the fashion for classical residential suburbs had passed, a town's quality was still judged by the regularity and grandeur of its urban planning. The 'improvements in progress' of Edward's plan referred to the final proposal to create a dignified district in the area bounded by Meadow and Bell Streets, tapering to the west until they met North Tay Street. Solid squares represented buildings that existed, whereas hollow squares represented ones that were being proposed. Brewster's oval

ellipse had largely vanished, along with its proposed east–west route, super-seded by a grandiose concept of large houses with prominent end pavilions, in the manner of Edinburgh's Moray Place. The problem was that since, care-lessly, the High School had been permitted to be built at a different angle from the Town House, these two civic monuments did not face each other up Reform Street.

The area bounded by Ward Road, Lindsay Street and Willison Street, similarly planned for elegant building, remained unbuilt until later occupied by sporadic factories and industry. Lindsay Street was laid out to focus axially upon the Sheriff Court but the latter was built (again) at the wrong angle. Edward proposed similar formally feued streets for both Forebank and Dudhope, but both were to remain imaginary.

The Watt Institution

Probably a direct descendent of Dundee's Rational Institution, the Watt In-stitution was the burgh's first foray into higher education. It was founded on 11 November 1824 as a Mechanics' Institution at the instance of the flax spinner James Brown, and with the patronage of the provost, Patrick Anderson. Its first

clerk was the lawyer Christopher Kerr, the burgh's town clerk for many years, the year before he initiated the Dundee to Newtyle railway. James Cox was then an apprentice in his office. Although the Watt Institution was directed at all classes of tradesmen, it was specifically targeted at the skilled worker, and so subscriptions were kept down to ten shillings per annum. The plan was to hold a series of lectures annually, and provide a library and a museum, as had the Rational Institution. It began well, with 400 members enrolling, but then ebbed and flowed with the volatile textile economy. Initially, members met in the Associated Burgher Meeting House in Barrack Street, but in 1836 they bought land for a permanent base in Constitution Road, just uphill.

The elegantly neo-classical – almost Egyptian – headquarters was designed by George Matthewson in 1838, and its opening coincided with a return of prosperity to the town. Its front pavilion contained a library of 1,000 volumes, with a laboratory on the ground floor, a lecture theatre above, and a museum projecting to the rear. Unfortunately, the inherent economics of the Institution remained difficult, burdened as it was by debt. Eventually it proved no longer able to sustain full-time lecturers as it had hoped, and the last to be thus appointed was the electricity pioneer, James Bowman Lindsay.

The boom years of the Watt Institution were the early 1840s, when its membership revived, exhibitions were held in the museum, and the lecture hall became too small for its audience. Its finances remained dire, and to help, Lord Kinnaird proposed adding another hall to its rear for staging public meetings and concerts (see Kinnaird Hall on p. 137), and the Institution was suggested for a School of Design. In 1849, however, the Institution was finally closed, throttled by its accumulated debt. Its library and museum continued, however, and the popular lecture series was recommenced a few years later. The Institution's headquarters were finally converted to other uses. Yet the Watt Institution's rational classical origins still lurk beneath its later disguise of mid-Victorian iron-cresting.

The Newtyle Railway Station

Dundee's nineteenth-century leaders were fearful that the town's position on the Tay would have the same effect as being on a peninsula, and that the burgh would be bypassed if communications from Perth north to Aberdeen were to follow a line through Strathmore. Once Robert Stephenson had proposed running a canal from Perth through Strathmore to Arbroath, the danger had become manifest. Desperate to pre-empt this, the Town Council

The Newtyle Railway Station.

decided to undertake the construction of a railway from Dundee across the Sidlaws to a tiny hamlet in Strathmore called Newtyle. One of the first railways in Britain, its economics were based upon bringing agricultural produce to Dundee docks in return for imported goods and urban manure delivered back to Strathmore. The plan drawn up by the engineer, Charles Landale, required the train to be winched up the slopes of Dundee Law, after which it would be drawn by horse across the Sidlaws before descending down into Newtyle. Landale chose a gauge specifically to cope with the introduction of steam locomotives should that ever come about (possibly the first use of the term 'locomotive' in this context in British history). Unfortunately, the goods traffic never really emerged, and even though passenger traffic took its place, the line was never profitable. The railway soon required refinancing, and a gentler if longer route via Ninewells was opened in the 1860s.

The original Dundee terminus faced Meadow Street near the Howff. Above, on the left, rises the east wing of the unfinished classical Sheriff Court. It was designed by George Angus in 1833, but completed by a different architect over two decades later. The campanile of the short-lived Bridewell behind it is symbolic of how Dundee's beautiful recreational 'Ward lands' were being casually colonised rather than planned. On the right, the serpentine path of the New Howff graveyard (see p. 110) winds uphill. From this terminus, the

Newtyle railway was extended southwards down Lindsay Street at ground level, only a few feet from the ceremonial entrance to St Mary's Church, Dundee's historic icon, prior to crossing the Nethergate (causing huge traffic disruption) and down through Yeaman's shore to the harbour. It was a classic example of Dundee's lack of planning strategy.

THE SEA'S EDGE

This is the only surviving image of how, before the arrival of the railways and the construction of the docks brought enormous nineteenth-century land reclamation, Dundee was built up against the sea's edge. Depicted in the early 1850s, to judge from the newly built St Paul's church, its viewpoint must have been near the current income tax offices, given its view of the tower of St Mary's. It can only have been taken from the railway causeway that had

been driven through the foreshore flats in 1847. The sea wall of the gardens of the houses facing the river remained intact, with the water butting up against it. Behind the trees Yeaman Shore linked the harbour to the Nethergate, a route continued by Long Wynd, which led up to the Overgate. The classical bay-windowed villa on the left, with its pleasant garden (on the site of the current Marketgate) is in the manner of David Neave (see p. 74).

Only the two churches' towers survive. Instead, there is Dundee's inner urban motorway, feloniously appropriating the title Marketgate from the High Street. The redevelopment is indifferent to the port's original maritime character and views of the sea.

THE ROYAL ARCH

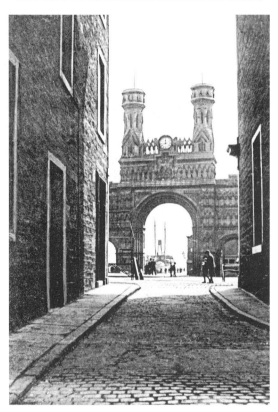

The tight frame of a cobbled wynd in this photograph ties Dundee's docks, represented by the Royal Arch, right into the heart of the town's maritime quarter. Victorian Dundee required a more modern civic symbol than the early eighteenth-century Town House, and the arrival by sea of Queen Victoria in Dundee in 1844 provided the opportunity. A triumphal arch was constructed

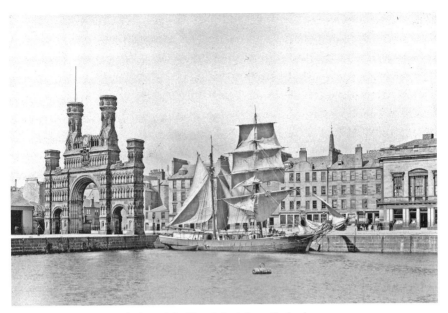

A view of the Royal Arch from the harbour.

of timber, erected where it symbolised the passing from harbour to town, created a suitably formal setting for the regal arrival and reception ceremonies. Tars huzzahing from every masthead greeted the queen and Prince Albert's formal welcome and introduction to regional dignitaries, before her carriage passed beneath the arch up to her first holiday in Aberdeenshire (long before the construction of her holiday house at Balmoral). Apparently, she was unimpressed with the lack of grandeur in the remainder of the town.

The burgh appears to have accepted that Dundee lacked an icon to represent Dundee to the world, and that since the town's character was still that of a port, the icon should be constructed down by the harbour. It was to be as symbolically significant to Dundee as the Euston Arch was to London. Dundonians desired a symbol of the progress of the town and its international trading ambitions, in particular, of the jute trade with India, which would become the dominant staple of Dundee in only nine years. An architectural competition was held in 1849 to design a permanent arch positioned on the axis of the Greenmarket. A number of architects submitted designs, mostly classical or neo-baronial in style, among the unsuccessful ones being those by Charles Fowler and J. Dick Peddie (some of which may be seen in the Wellgate Library). However, the Earl of Panmure, already a benefactor of Dundee by having provided the land for the Dundee to Arbroath railway at under cost, (see p. 143), preferred the powerful quasi-historic neo-romanesque design of the Glasgow architect James Thomas Rochead, in an apparent echo of an

ancient cathedral façade like that of Tewkesbury. A highly capable designer in any style (i.e. he believed in none!), Rochead was to become famous for his phantasmagorical 1859 Wallace Monument near Stirling – a piece of unsubtle Scottish mythmaking (now appropriately graced by a statue of Mel Gibson). Dundee's Baltic merchants were outraged at Rochead's design. The Wallace Monument bore as little resemblance to any historic Scottish architecture as the film *Braveheart* bore to history, and, similarly, this new proposed romanesque arch for Dundee did nothing to symbolise the international ambitions of the traders, manufacturers and merchants who now ran the town. The design caused sore division, but Panmure prevailed. However, once erected, the arch quickly became the iconic symbol of Dundee.

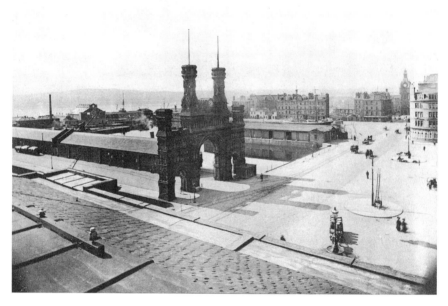

This summer view of the arch, taken from the roof of the Exchange Coffee House, can only have been taken on a Sunday, so quiet is Dock Street and the harbour. Scarcely a soul moves to disturb its shadow. In the distance, the Caledonian Railway's clock tower in South Union Street terminates the view on the right. The view must date from c. 1890, since the corner of Whitehall Crescent has already replaced Dundee's ancient packhouse, the railway station is complete, and yet no modern traffic can be seen. Nothing of this view remains save the gable of Whitehall Crescent. Even had the buildings survived, they would no longer be visible from this angle since the view would be blocked by Tayside House.

South Union Street and the Caledonian Railway Station

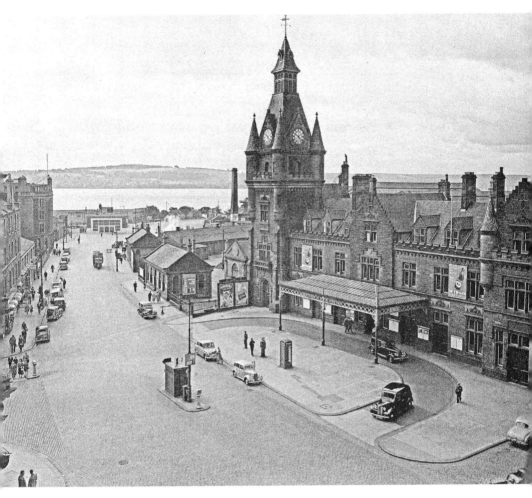

South Union Street provided the western wall of Dundee's harbours, and had been colonised by buildings since at least the seventeenth century. Being at the edge of town, it was where dissenting chapels, theatres and travelling circuses tended to gather, alongside shipbuilding and the Seamen's Fraternity's Trinity House. By the Victorian era most of that had already been replaced. The smart pavilion in the distance was built in the 1930s for the Tay Ferries, which represented the only way of crossing the Tay by foot or car till the road bridge was built. The west side of the street was a melange of competitive railway structures, the grandest of which was the Caledonian Railway's Dundee West station, designed to face down Dock Street by Thomas Barr in 1889–90.

Overly bombastic in nature, it was a gesture of defiance by the Caledonian, for the railway had just lost its monopoly of the railway line from Perth to Arbroath via Dundee. It was now compelled to share the line with its deadly rival, the North British Company.

The North British's own station is invisible, since it had to be built underground. When a scheme for a railway through to Aberdeen had been proposed in 1864, the engineer, Thomas Bouch, designed it to run along a viaduct 24 feet high and solid from end to end (save for small gaps for existing streets), right along the shore, severing the town from the sea. It caused outrage and parliamentary petitions. Consequently, once the Tay Railway Bridge became a reality in 1877, the line was put below ground along the northern side of the docks, virtually beneath Dock Street, so as to minimise disruption to dock traffic. The North British's Tay Bridge Station was also constructed below ground. Putting the line underground required extremely hard bargaining with both the Harbour Commissioners and the Town Council. That is the line that remains in use today, with a 1960s box on top of the original station.

Only the gable of the Tay Hotel on the left survives of this scene. The remainder was roadway until recently, although it is now graced with the occasional office block and relieving glimpses of the mast of the *Discovery*.

The Maritime Quarter

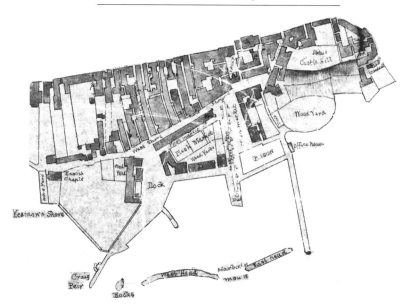

Map of the Maritime Quarter.

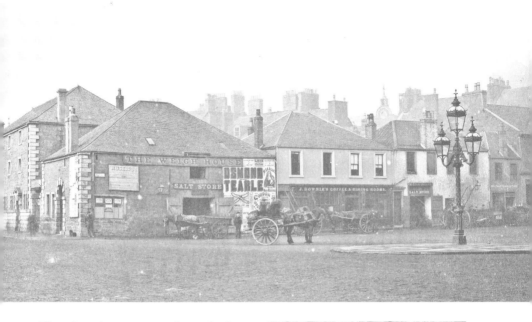

The view above encapsulates the heart of Dundee's dense maritime quarter, prior to its removal in the second phase of city improvement c. 1886. The pinnacle of St Mary's tower rises in the distant skyline above the thick quarter of impenetrable building, through which narrow closes such as Key's Close ran between the Nethergate and Fish Street (see p. 29). Key's Close contained little courtyards, off one of which lay the surviving portions of the Earl of Crawford's town house, or Lindsay's Lodging. Another was so tight and narrow that it could only be sketched from the schoolroom of the Panmure Mission chapel in Fish Street. The clock and cupola of the Panmure Mission chapel itself can be seen centre right; after improvement, it followed the seamen downstream to Candle Lane.

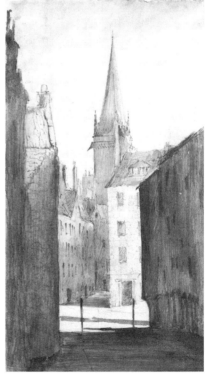

View of St Paul's tower from the Maritime Quarter.

THE NEW HOWFF

Dundee's great graveyard, the Howff (meaning meeting place) had been in continuous use since 1564, when it had been converted from the Greyfriars' orchard for that purpose, and by the early nineteenth century it had become seriously overstocked. Moreover, the increase in infectious disease was leading many towns to build cemeteries on their outer edges to reduce the risk of contagion, particularly following the virulent cholera epidemic of 1832. In 1834, Dundee located its new cemetery on the lower slopes of the Law at the northern edge of the town and christened it with some originality the New Howff. It was laid out as a picturesque graveyard, probably influenced by both Glasgow's Necropolis and the great Parisian cemetery Père Lachaise (although it lacked the latter's irreligious classicism and intent to recreate a Roman sepulchre in the manner of the Appian Way). Tombstones would interact with weeping yews and lugubrious laurels – to say nothing of the forbidding burial enclosures – to present an experience of impending mortality. This photograph shows how the graveyard was meant to continue in a meandering manner up Dundee Law on the east side of Dundee Royal Infirmary, which had been removed here from King Street in 1852: a highly efficient juxtaposition if you think about it. Between them, however, lay the sloping

black line of the Dundee to Newtyle railway, which halfway up the slope was not unlike a funicular railway.

The New Howff was largely removed for the inner ring road in 1962 and a multi-storey car park was built over its southern end. Some desultory grave-stones were collected and repositioned against its western wall, which divided the graveyard from (originally) the Newtyle Railway (now the Sheriff Court car park). Most of the sense of lugubriousness has evaporated.

THE CITY CHURCHES, NETHERGATE, 1836

ST MARY'S CHURCH

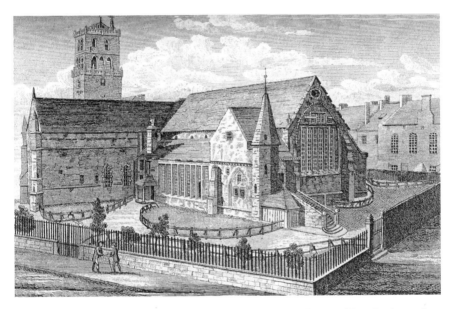

St Mary's Church (or the church of Our Blessed Virgin Mary), Dundee's mother church, was established by David, Earl of Huntingdon in c. 1191. It was the largest parish church in Scotland, more richly endowed even than St Giles in Edinburgh, with 48 chaplainries and altars. Its great tower, begun in the late fifteenth century, was capped by the open-crown spire of the period. When the church was burnt by the English in 1548 the upper part of the tower was badly damaged, the crown spire destroyed and the nave gutted. The crown spire was never replaced. The king's Master of Works, Sir John Scrymgeour of the Myres, assisted with the rebuilding in 1551 and to him may be attrib-uted the unusual rectangular windows of the choir. After the Reformation the church was split into three: the east end was divided into two separate

churches, the Burgh Library was established in the crossing, and the nave was occupied by the burgh's Song School. Being the largest building in the burgh, the church figured prominently in the civil wars and the steeple was fortified in 1641. In 1645, the nave was gutted once more during the Marquis of Montrose's vicious attack. It was never rebuilt, and became the site for the town's grammar school in the eighteenth century.

In 1791, to cope with a growing population, the Council asked Samuel Bell to design a new church – the Steeple Church – on the site of the nave.

The Loss of St Mary's

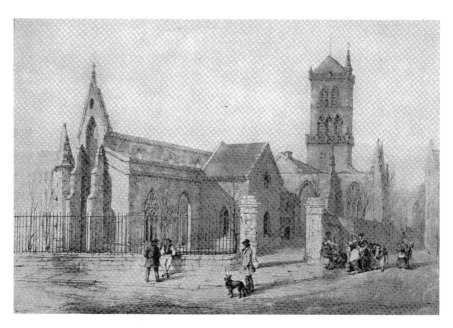

A number of medieval Scottish churches were burnt down in the early nineteenth century as the result of a demand for better lighting. Chandeliers had been introduced, which scorched ceilings and set them alight (usually overnight). In 1841 the Church of our Blessed Virgin Mary went on fire and the crossing, choir and transepts were all gutted. The ancient and extensive burgh library, housed in the Crossing, was destroyed. St Mary's tower and the Steeple Church escaped almost unscathed, as did the sacristy (still roofed in this illustration) and most of the walls and windows which had been remodelled by Sir John Scrymgeour of the Myres, in c. 1550. The ornate late Gothic window tracery emphasises the strong similarity between this church and St Michael's, Linlithgow. This drawing, however, reveals just how much of St Mary's had survived and could have been incorporated into rebuilding.

However, to create work during a temporary trade depression, the decision was made to remove the remnants of the old building entirely and substitute a new church designed by the architect William Burn, who had previously been working in Dundee at Camperdown House, Invergowrie House, Duntrune House and on plans for the city centre. Burn, who had already shown his taste in modernising churches by his soulless remodelling of St Giles' in Edinburgh, was no more sympathetic with his work at St Mary's. This view emphasises the importance of the churchyard walls and railings in lending St Mary's a greater sense of dignity, scale and enclosure than her current skateboard park.

The Crown Spire

Crown spires had been added to notable urban buildings during the reign of James IV as symbols of national freedom. They represented what was called an 'imperial crown', signifying that the King of Scotland was emperor in his own country, and thus beholden to nobody else. Imperial crowns were adjoined to the great parish churches of Edinburgh, Aberdeen, Linlithgow, Haddington and Dundee, as well as King's College, Aberdeen, and the Glasgow and Linlithgow tolbooths. St Mary's, probably erected c. 1485–95, would have outclassed them all. However, when the English set fire to the town in a fit of pique in 1548 they destroyed the upper part of St Mary's tower and the crown spire with it. It was afterwards replaced by its current caphouse, but the stone springers that once carried the structure of

ST MARY'S TOWER SIR C.C.SCOTT'S DESIGN FOR CROWN.

the crown spire above can still be seen in the gloom of the bell chamber. At parapet level above it is evident that the caphouse has been built around the lower parts of the crown steeple.

The drawing on the previous page was produced speculatively by the notable English architect Sir George Gilbert Scott, either when he was working on St Paul's Cathedral in the 1850s or on the Albert Institute in the following decade. His design did not quite accord with the surviving portions and greatly irritated those who held that the crown spire had never been completed in the first place. The project was dropped. It is a curiosity of Dundee, therefore, that two of its principal civic monuments – St Mary's and the Royal Exchange – lack their crowning glory.

THE DENS WORKS

AN INDUSTRIAL PARADISE

The Dens Burn provided Dundee with its second source of power; it descended around the eastern edge of the burgh from the rear of the Law, and a community of textile workers gathered at its foot many centuries ago. During the nineteenth century that community of looms was replaced by Baxter Brothers' Dens Works, one of the most extensive linen manufactories in the world. Baxters had begun by manufacturing linen in Angus near Glamis, doing particularly well with sailcloth. It was their sails that HMS *Victory* was using at the Battle of Trafalgar. The Baxter empire commemorated in this 1869 poster had begun almost 50 years earlier, with the construction of smaller mills and warehouses at Lower Dens.

The notion of factories as 'dark satanic mills' – a phrase coined by William Blake – was not a High Victorian concept, no matter how much the twentieth century has bought into it. This celebratory perspective was produced in 1869 by Baxter Brothers of the Dens Works, which had remorselessly colonised the eastern fringes of old Dundee between 1820 and 1890. Baxters had produced a number of commemorative drawings of their works over the previous two decades, but the one on the opposite page presented their most complete image: a vision of the works at the top, with a detailed plan of all the buildings at the bottom. No smoke sullies this vision. The three tall chimneys of this great industrial complex were designed like hollow Egyptian obelisks, reflecting the taste of their celebrated chief engineer, Peter Carmichael. The Dens Burn, which had been dammed into a series of cooling ponds, provided the energy and buildings were disposed on either side. Princes Street, the main road to Forfar, divided Upper Dens from Lower Dens.

Of particular interest is the portrayal of the eastern district of Dundee as though it were in Tuscany: gently terraced slopes graced with cypress trees form the setting of noble mill buildings, Italianate campaniles and crisp

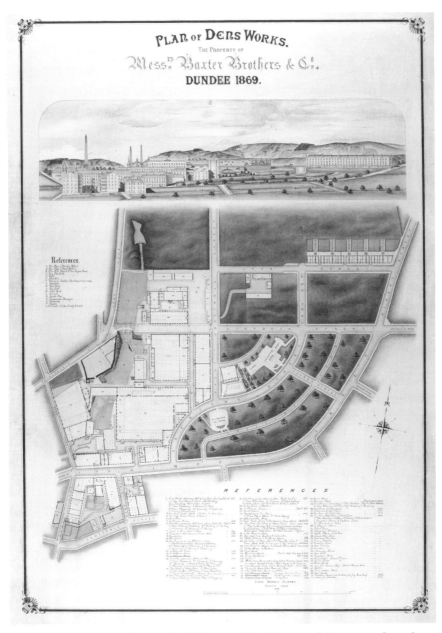

obelisks against a background of distant hills. Three buildings stand out from this vision of paradise. The first, a low building with a spreading veranda and cupola facing Crescent Street, was Baxter's Half-Time School. Behind it, isolated in countryside on a higher level, were the mill stables. Finally, on the right-hand boundary lining Lyon Street, Baxter's constructed their experimental philanthropic housing for their workers in 1866: five stairs of very

BAXTER'S OLD HALF-TIME SCHOOL AND SCHOOL-MASTER,
MR ANDREW STRACHAN.

Top: Baxter's Half-Time School. Bottom: Baxter Brothers workers' tenements.

plain, four-storeyed yet very respectable tenements that contained thirty two-room and seventy-three three-room flats. Unfortunately, the costs of erection could not be covered by rents that their mill employees could afford, and some tenants did not take adequate care of their property, so the

experiment was not repeated. At its peak in the 1860s, Dens employed 4,500 people, making it second only to Camperdown in size.

Dens Obelisk

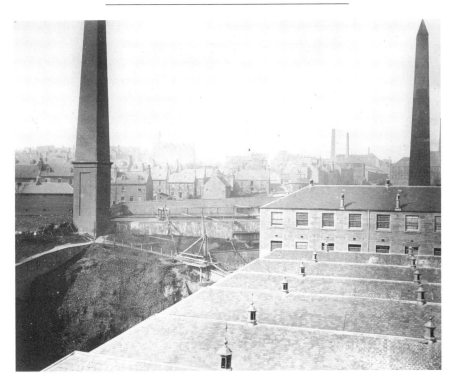

This photograph, c. 1867, shows the base of two of Dens' obelisk chimneys, one on either side of a cooling pond. In the middle distance there is excavation for a new pump room for the Dens Calendar building, which was powered by the sharp drop in water level from one pond down to the next.

Dundee's Streets and Mills

An Industrial Streetscape

Princes Street (pictured on the next page), opened as a gentler and more congenial route north-east to Forfar than up the Hilltown, ran up through the centre of the Dens complex. The massive 21-bay Upper Dens mill, festooned with wreaths on the left and complemented with flags and bunting on the other side of the street, was almost certainly decorated in celebration of King

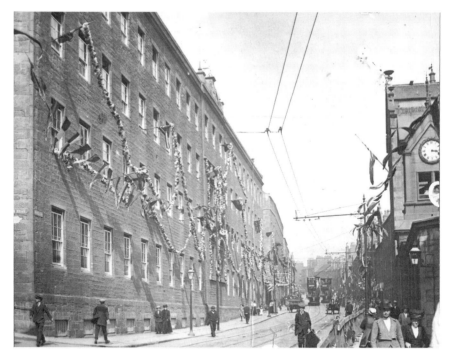

Princes Street.

George V's visit to the city in 1914. The boiler house of a great mill was often the most distinctive feature of its architecture. Power had to be distributed vertically to each floor before being distributed horizontally, and this was usually signalled on the exterior by a change in the rhythm of windows (bays). As a rule, boiler houses had large single windows, sometimes one above the other on every floor, and often floridly in three parts (known as tripartite), in echo of the classical Venetian window. Most of the decoration was concentrated around boiler house windows at the centre (since that is where the chimneys rise from the roof).

The scene is one of brisk and prosperous industry. It was an easier, safer and less noisy life before cars and lorries had arrived, and all transport was restricted to carriages, carts and trams.

THE MILL COMMUNITY

This photograph (opposite page) of predominantly young workers hovering outside the main entrance of Dens Works, taken in 1908, has a vaguely festive atmosphere – even though the photographer is attracting some typical attitude from one of the mill boys. Some were bare-footed, which was not

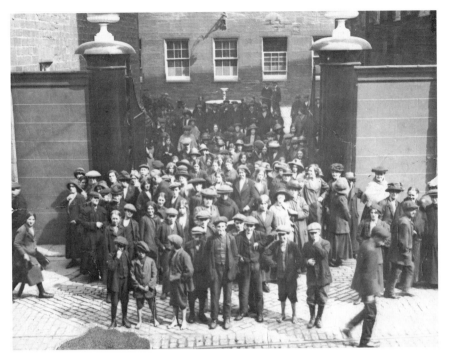

Workers waiting outside the Dens Works.

untypical in British cities at the time. This group is standing waiting for something in the late afternoon, rather than representing the end of a shift, when thousands would have poured out of this gate.

LOCHEE

Lochee was originally a weaving hamlet by the Locheye Burn, in a little glen to the north-west of Dundee Law. It was adopted by the Cock Family (who changed their name to Cox) as a centre of weaving, and the village grew into a prosperous town during the nineteenth century, particularly once it was absorbed into Dundee, and then connected to it by tram. This view of the town (see next page), drawn c. 1870 by Charles Lawson for the Lawson Brothers' *Guide to Dundee*, reveals both its extent and its weakness. Its weakness was over-dependence principally upon a single employer, the Cox Brothers' Camperdown works. However, Camperdown's enormous success encouraged the growth of a prosperous community and the development of subsidiary trades such as furniture-making. Far from it being a poor mill town of female weavers and kettle boilers (as typical Dundee myth would have it), Lochee was a town of double incomes. Many of the women worked in Camperdown

119

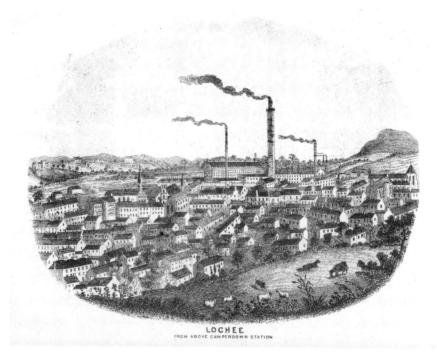

LOCHEE
FROM ABOVE CAMPERDOWN STATION

works (and also owned their own houses), whilst their men worked down in Dundee. The resulting double income meant that Lochee town centre was prosperous, with quality-goods shops, and attracted custom from a good number of nearby villages.

The classical parish church gracing the western entrance to Camperdown Works (left centre), designed in 1829 by Dundee's town architect David Neave, indicates the prosperity of the village long before the Camperdown Works was begun in 1850. The remarkable St Mary's Church on the right, overlooking the road to Dundee, was designed in 1865 by J. A. Hansom. Its splendidly tall and wonderfully lit choir is a re-creation of the Jerusalem Church in Bruges, rare in these isles, the family church of the Adorno family. Anselm Adorno had spent time in Scotland in the reign of James III, becoming Keeper of Linlithgow Palace and Baron Cortachy, before being assassinated near Tantallon and buried back in his Jerusalem Church in Bruges.

Most of what can be seen in this view was demolished as a consequence of implementing the 1952 Development Plan for Dundee, replacing the organic community with rational isolated blocks of tall flats.

THE CAMPERDOWN WORKS

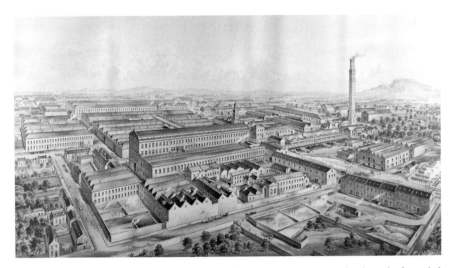

This perspective of a great industrial principality depicts the jute industrial complex of the Cox Brothers' Camperdown Works in the later nineteenth century. James Cock, who was born in 1739, inherited a weaving business with 280 looms from his father David. By 1850, the time had come to rationalise the business. Most textile works expanded over time, accruing new mills and new chimneys as they grew, but what distinguishes Camperdown by comparison with all its rivals, is its *a priori* planning and design, coupled with enormous ambition. No other jute works were laid out around their own railway siding – a branch of the Newtyle railway that had opened in 1861. (The locomotive can be seen running through the centre of the site, presumably carrying finished jute products to the harbour.) No other jute works employed 5,000 people.

There were 57 boilers at Camperdown, but all their smoke was carried in underground channels to feed out of the works' single 280-foot-tall chimney stack, designed in 1865 by George Cox (the engineering brother) with the architect James Maclaren. Affectionately nicknamed Cox's stack, this patterned brick Venetian campanile symbolised the fact that Camperdown and all its boilers had been planned from scratch, probably by George Cox, youngest of the five Cox brothers, with advice from Peter Carmichael of the Dens Works. The height and location of the stack can almost certainly be attributed to a desire for the chimney to be visible over the shoulder of Dundee Law to those approaching Dundee by ferry.

The focus of this perspective was the High, or Sliver, Mill, an extraordinary 40 bays long and built 1857–68, with a 100-foot tower topped by a cast-iron

The Cox brothers. Left to right (back): Henry Cox, Thomas Hunter Cox, George Addison Cox; (front): James Cox, William Cox.

Italianate campanile at its eastern end. Everything in this scene is efficient and tidy, conveying the impression of a clean, regulated and organised industrial city, encompassed by pleasant villas and gardens. Most has gone, leaving the Sliver Mill (as flats) and Cox's Stack (which would present a wonderful spectacle if it were illuminated in the evening) as an isolated monument. The expanse of industrial sheds north of the Sliver Mill is now the car park of the Stack's Leisure Centre.

The eldest brother and chairman, James Cox, was an extraordinary entrepreneur. Trained as a solicitor, he moved into the family business with his brothers Henry, Thomas, William and George. In traditional Dundee mercantile fashion, one brother was dispatched to represent the firm in the mills on the Hooghly River in Bengal. James became one of the few jute barons to involve himself in Dundee's urban politics. As one of a group with his (one presumes) friends the journalist John Leng and the lawyer Thomas Thornton, Cox would try to inject vision into the city. They would meet in Thornton's office in Royal Exchange Buildings (see p. 133), and agree on a course of action. The following day, Leng would pen a mighty editorial in the *Dundee Advertiser* demanding that something be done, and suggesting a public meeting. Cox would chair that meeting. His *Autobiography* recounts

that he had been approached to stand for the Town Council in 1869 but had refused; he was eventually persuaded by a lobby of his own workmen. Cox became Provost, and then chairman of the City Improvement Trust. He may also have been an early patron of William McGonagall, who wrote to him seeking sponsorship.

A lifelong railway buff, Cox was appointed chairman of the Tay Bridge Undertaking in 1864 and then director of the North British Railway Company. Consequently, when the first Tay Bridge was constructed 1871–77 it was aligned on Cox's Stack, which could be seen poking over the shoulder of the Law. Greatly affected by the collapse of the first Tay Bridge in December 1879, he died of pneumonia contracted as a consequence of making an incautious voyage to inspect its replacement.

TAY WORKS

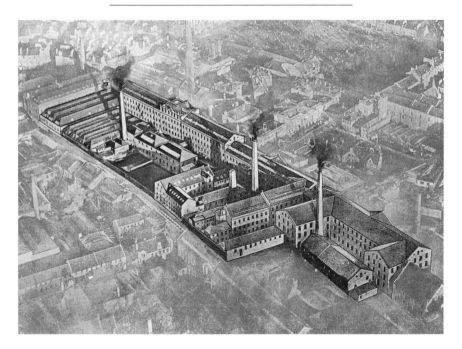

The third of the great industrial principalities was Gilroy's Tay Works, whose enormous New Mill lined the north-western edge of the medieval city. Begun in 1836 by W. Boyack using power from the Scouringburn, it was extended before being bought out by the Gilroy Brothers in 1849. At 650 feet long, the New Mill was probably the largest textile mill in the United Kingdom when it was completed in 1855. Tay Works was also the largest single firm in Blackness, the ancient heartland of the Dundee textile industry. From this view

and the four chimney stacks, it is obvious that the Tay Works had evolved gradually in the normal way, adding the boiler houses, weaving mills, calendar and hackling sheds. At its apogee Tay Works comprised eight separate mills, a dyeworks, calendar, factory, warehouses and engine works. In the faint background the Sheriff Court can be seen facing down Lindsay Street. Tay Works is survived only by the principal mill buildings facing Marketgate, now used as student residencies and hotels.

Mill Interiors

During the so-called 'golden age' of hand loom weaving, adult males, many of whom were their own masters working in their own homes, earned high wages and were renowned for their prowess as poets and political debaters. By the turn of the nineteenth century, the trend was towards loom sheds housing a number of hand looms, although factory weavers never predominated. Wage levels for Dundee's 5,000 or so weavers eventually declined to desperately low levels, the hours of work grew longer (when webs were available), and work discipline intensified as the industry became dominated by 'manufacturers' – employers who were often yarn merchants. Male hand loom weavers continued to work in Dundee well into the nineteenth century – as shown here in the

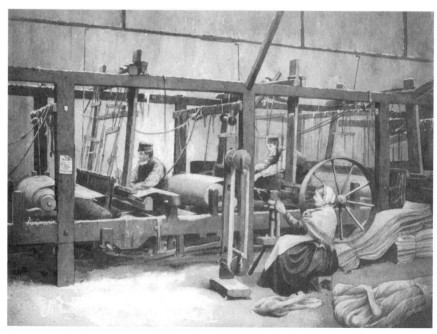

Mill interior in the 1850s.

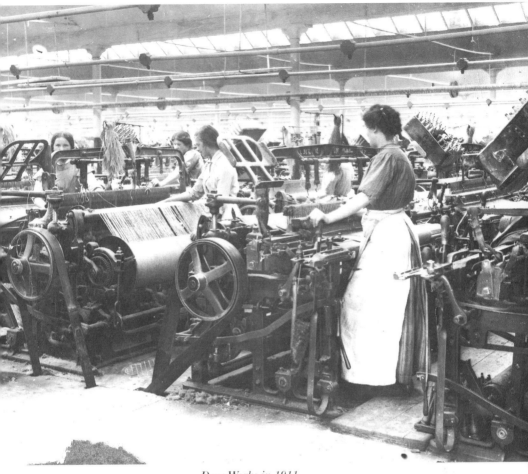

Dens Works in 1911.

picture opposite of c. 1850. However, from the 1840s, and with the increased use of the power loom, growing numbers of women were employed, as can be seen in the photograph above of Dens Works in 1911. Over time, weaving became almost wholly a female occupation in an industry – jute – which employed three women for every man or boy. Dundee's factory weavers – who learned their trade over a period of between six weeks and a year – were considered to be a cut above their sisters the mill spinners, not least because the weavers were paid more, dressed better for what was cleaner work and enjoyed some control over the pace at which they worked. Many of the weavers were married, and indeed in Dundee as a whole by the turn of the twentieth century, more married women were employed than in any other Scottish city. With women outnumbering men by three to two, it was little wonder that Victorian and Edwardian Dundee has been described as a 'woman's town'.

THE SCOURINGBURN

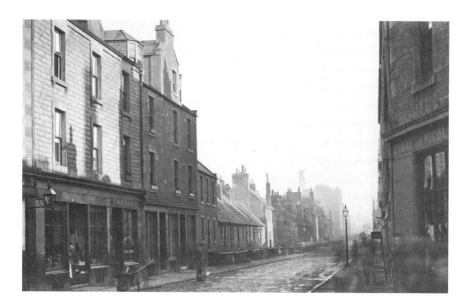

The Scouringburn was western Dundee's principal source of water power, running from the north-west down through the Pleasance and the swan ponds of Dudhope into the Meadows. It was dammed at the town's mill pond (on the site of the McManus Galleries) to provide water power for the town's mills just below the castle hill. The burn then turned right to run beneath the Murraygate and Seagate before emptying into the sea. Where the incline was steepest and its water power the strongest – on its upper reaches – the Scouringburn's valley developed early as Dundee's first industrial area. The burgh's first large brewery was constructed on its upper slopes, at the Pleasance.

The old route to Lochee and Coupar Angus ran from the West Port along the burn's side; and during the late eighteenth century this route was colonised by artisans and weavers who built a hamlet named Scouringburn after the river. In time it grew to be the spine of Dundee's largest industrial suburb – that of Blackness. The Register of Sasines reveals that its cottages were owned by ordinary people such as weavers, carters, cobblers and even labourers. As Blackness developed and the buildings got bigger, the older cottages with their courts, wynds and entries opening off the main street, became intermingled with factories and their dependencies. At its eastern end, by Hawkhill, it developed a reputation for ill-health and overcrowding, being the district worst hit by the cholera outbreak of 1832. It thus became a suitable

case for city improvement, and it was the improvement commissioners who had this photograph taken.

Balfour Street

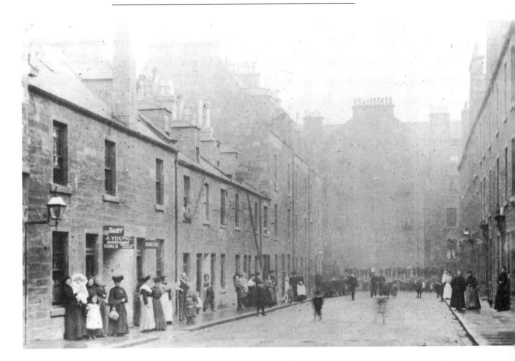

There could be no better illustration of the difference between industrial and non-industrial Dundee than Balfour Street, off Hawkhill, for it exemplified the total randomness of urban settlement in the town, and the lack of strategic planning that the City Improvement Trustees were determined to remedy. Balfour Street was a cul-de-sac that extended southwards from the industrial quarter of the Hawkhill, and comprised very respectable – if very plain – houses and tenements. It was blocked at the bottom, however, by the rear elevation of the tenements facing Airlie Place.

The original concept for Airlie Place drawn up in the 1850s was for a suburb of elegant houses facing streets running from Perth Road to the Hawkhill. Probably fearing that the Hawkhill was so industrialised that the amenity of the houses on the southern slopes facing Perth Road might be gravely damaged if the industrial character of Hawkhill were allowed to seep outwards, Airlie Place was turned into a cul de sac. This was fairly typical of industrial Dundee, and the resulting difficulties provided the justification for drastic urban surgery. Only cobbles now remain of Balfour Street.

JUTE PALACES

In Dundonian demonology, nothing exemplified the town's history of class struggle more than the comparison between the inflated and overblown mansions of the jute barons – known as jute palaces – and the tenements of the oppressed. Little suited the city's twentieth-century *schadenfreude* better than the fact that all but a handful of the former houses were demolished between the world wars. Implicitly, it was symbolic of the ultimate victory of the proletariat.

Only, it wasn't. Before the scale of de-industrialisation became felt in Dundee, and the plain tenements of Blackness Road became doubly and trebly overcrowded as the work ran out and the workers' funds with it, these working-class apartments were the sought-after and respectable abodes of skilled families. They were less elaborate than their Glaswegian tenement equivalents, partly because the town failed to feu out controlled urban development as had occurred in north-west Glasgow, and partly because a skilled worker in Dundee's low-value textile industries earned less than a skilled worker in Glasgow's high-value engineering industries. So if the lodgings for

West Ferry Villas from the air.

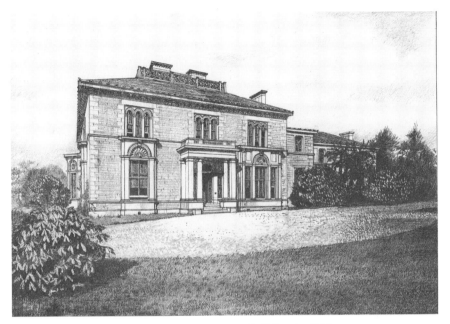

Hazel Hall, drawn by David Walker in 1958.

the workers were less poor than the myth, were the plutocratic jute palaces less obscenely wealthy?

Indeed so. Extravagant a few may have been; and very well-appointed they all were, but they were nothing like as huge or as remote as great capitalist mansions were meant to be. Nothing in Dundee compared with the mansions of the major industrialists of Glasgow, Liverpool or Chicago. Nor were they particularly remote: James Cox's house of Clement Park was within eyesight and easy reach of his works at Camperdown. Most of the rest were set in relatively ordinary plots facing Perth Road, or in West Ferry, Barnhill or Broughty Ferry.

Four key palaces illustrate the evolution of such houses from villa to jute palace. In 1854, Edward Baxter – the man who ran Baxter Brothers' financial end in London – commissioned the Glasgow architect Charles Wilson to design Hazel Hall, facing onto Perth Road in the West End. However, this elegant, classically Italianate pavilion was not what most people associate with a jute palace: it was not overblown enough. The previous year, however, the English architects Coe and Goodwin – then working on their competition-winning Dundee Royal Infirmary on the slopes of the Law – had been commissioned by the Edward family of Logie Works (which included the Coffin Mill) to design Farington Hall. They produced a genuinely English Gothic manor house using the same Normandy Caen stone that they had

specified for the DRI: at last a mansion entirely overblown for the Dundee context. A further 12 years had to pass before the next appeared: Castleroy, built for George Gilroy of Tay Works. This eschewed the gigantic classicism of his great mill for a Tudor manor house interpreted through the eyes of the Perth architect Andrew Heiton (with none of the soaring grace of Farington, but a boxed-in design with crenellations and crowsteps). Allegedly set upon domination of the little seaside village of Broughty Ferry, which had

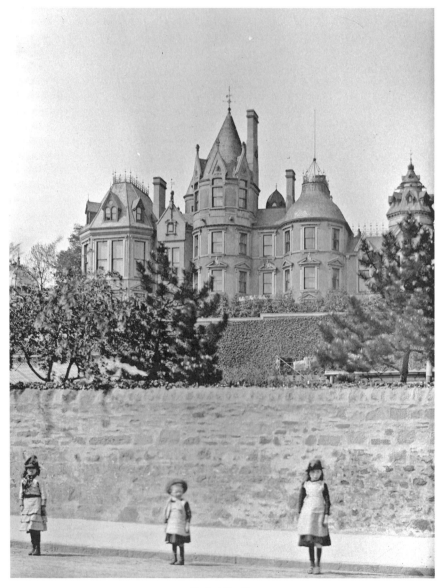

Carbet Castle.

only just reached a state of full development, Joseph Grimond (Bowbridge Works) set about transforming Kerbat House into the apotheosis of the jute palace, Carbet Castle: the approach being to extend the house horizontally, each extension given its own character, all bound together with incredible iron fretwork added to rooftops and ridges. The French decorator Charles Frechou produced beautifully decorated ceilings for the dining room in 1871 in the phase designed by T. S. Robertson. The majority of the jute palaces, however, were neither baronial nor Gothic, but modestly Italianate in general appearance, characterised by a tall campanile in one corner.

Whereas there was considerable homogeneity amongst the great baronial houses of the Glasgow industrialists scattered down the Clyde estuary, or of the lesser industrialists in suburbs like Helensburgh and Bearsden, there was no homogeneity amongst Dundee's jute barons in what they wanted from their houses. They were only large dissimilar fish in a relatively small pond.

THE GREENMARKET

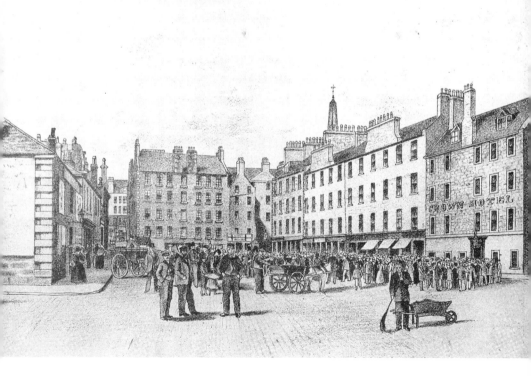

Dundee's Greenmarket was originally the higher status herb market held in the broad of the Nethergate opposite the west end of St Mary's Church. (The current use of the name Greenmarket for the flatlands between Dundee Contemporary Arts Centre and the sea is without historical foundation.) It was only in the mid nineteenth century that both name and market transferred down to the Shore, and it occupied the space formerly known as the Exchange or the Lime Tree Walk that had so impressed Daniel Defoe in 1725. Occupying the large area between the docks and the Vault and framed between the Exchange Coffee House on the east and the packhouses (later Whitehall Crescent) on the west, it swiftly became popular as the venue for fairs and travelling circuses. As the photograph below implies, it attracted all manner of people and various kinds of markets, and – latterly – soup kitchens. In 1873, the year this photograph was taken, W. J. Smith witnessed a street preacher addressing 'the crowd, the quack doctor vending his nostrums, the cheap John and the ballad singer, galvanic batteries, beef and sweetie stands, and exhibitions of dead and living wonders, forming altogether a curious medley'.

This and the picture on the previous page depict different aspects of the Greenmarket. The first looks across to the already partially demolished

The Greenmarket in 1873, showing the half-demolished Pierson storehouse.

Provost Piersons's warehouse just prior to its final removal for Whitehall Crescent, whose incomplete gable can be seen looming threateningly behind. The second is taken from Dundee's original pier, looking up towards the heart of the town. In the far left, Crichton Street, opened only in 1783, provided a new connection up to the Nethergate. In the far right, the route would either have turned right into Castle Wynd and then left into Tindall's Wynd, to arrive in the market place just to the right of the Town House, whose steeple can be seen rising above the chimneys. A shorter but more difficult route led through the pend to the Vault – the square behind the Town House.

ROYAL EXCHANGE SQUARE

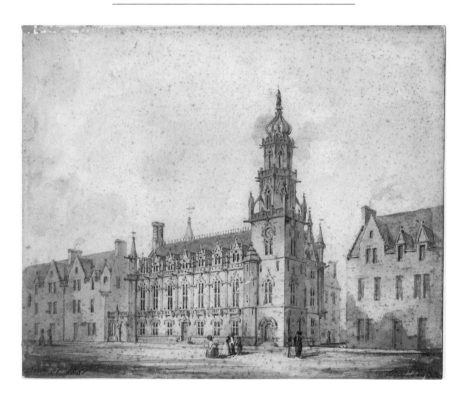

In the late eighteenth century, Dundee's Baltic merchants had been responsible for importing flax from St Petersburg and Danzig, having it manufactured into cheap osnaburgs, and then exported again to Charleston, South Carolina. They had been central to Dundee's repositioning of itself after the burgh's seventeenth-century setbacks.

Customarily, the Baltic merchants had clustered at the corner of the Cowgate, Murraygate and Wellgate. There, in close proximity, could be

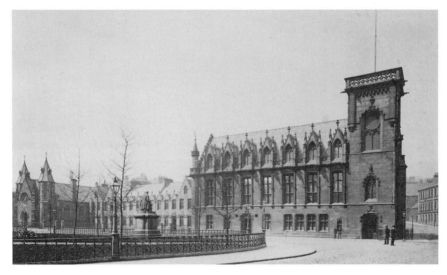

North side of the Square, with the Royal Exchange and Royal Exchange mansions.

found the shipowners, ship brokers, commission agents and insurance agents (known as the Coogate), all of whom were needed to facilitate the expansion of the Baltic/America trade. In the later 1790s, the mason Walter Bain began constructing a fashionable 'square' called Bain Square, on the corner of the Wellgate and Cowgate, and to this square (now beneath the Wellgate Centre) the Coogate flocked, converting its south-west wing into the Baltic Coffee House.

However, by 1850, as a belief grew that Dundee's old-fashioned High Street was insufficiently impressive for the rapidly growing town, envious eyes were cast upon the town's Meadow lands given that the streets and squares planned for it in 1825 had never been realised. Predictably, no one appears to have wondered why not: namely that it was marshy – for the Scouringburn (or Mause Burn), several springs and a number of wells (including St Francis' Well and the Lady Well) all gathered there. The first step was to cut a broad new street – Panmure Street – leading from the medieval town westwards. Then, in 1852, the Coogate were persuaded to move from the Baltic Coffee House to construct a new, purpose-built, Royal Exchange on a key site in the Meadows. The Edinburgh architect David Bryce, who won the architectural competition to design it, modelled the building on the most recognised symbol of an expanding and successful cloth town – namely the medieval cloth halls of Flanders.

Dundee's Exchange would be distinguished by a three-storeyed open crown spire capping its tower. But as construction began on its tower in 1855,

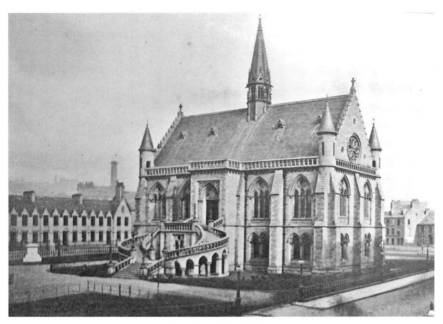

The Albert Institute.

the foundations of the Royal Exchange slipped sharply, and despite under-
pinning continued to do so. The upper storeys of the crown steeple had to be
taken down until the building stopped moving. The extent of the slippage
virtually matches that of Pisa, as can be gauged by comparing the leaning
north-east gable of the Exchange with its neighbour. The several different
angles are explained by the serial attempts to stop subsidence during con-
struction.

The remainder of the north side of the square comprised business
chambers in a matching architecture known as Royal Exchange Chambers
and terminated by a church also designed by Bryce at the western end. One
might surmise that the south side of the square was intended to be similar.
Royal Exchange Chambers were extremely successful in attracting Dundee's
prominent professionals – amongst others Thomas Thornton, the lawyer who
virtually ran Dundee single-handedly between 1863 and 1893. Consistent
with Dundee's instinctive rejection of strategic planning, the south side of
the intended square was never completed and the idea of a new centre for
Dundee's Victorian businessmen proved abortive. The space remained in
use for market gardens and greenhouses until the construction of the Albert
Institute in 1865–67 (later extended into the McManus Galleries) more or less
on the site of Dundee's ancient mill pond. (It is, therefore, no surprise that
the galleries' basement suffers from water ingress.) Meadowside, really the

'back dykes' lining the rear of the long rigs that stretched back from the High Street and Murraygate, eventually became formalised as the southern side of what was no longer a square but an irregular trapezoid open to the west. This curious aneurism became known as Albert Square.

When the ornate railings surrounding the McManus Galleries were taken down – probably during the Second World War – any sense of a smart cobbled square was lost, and Royal Exchange Chambers were demolished to make way for the Guardian Royal Exchange in 1957.

The Eastern Club

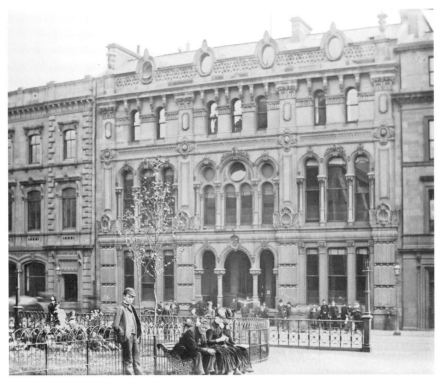

The Eastern Club was probably the finest and most elaborate élite club in Victorian Scotland outside Glasgow and Edinburgh. Funded by subscribers, its members represented the top ranks of gentlemen and businessmen from Dundee and Angus. Here, amidst the specially-commissioned silverware, regional deals were done over Medaillon d'Or champagne (these and other details are in the Wellgate Library). It was completed in 1870 and its imposing presence lent great dignity to the space now becoming Albert Square.

The subscribers had chosen the English, Edinburgh-based designer Frederick Thomas Pilkington as architect. Pilkington had a unique way of detailing stone – almost as though it were plasticene – and designed some of the finest and most idiosyncratic Gothic buildings in Scotland, including St Mark's and the McCheyne Memorial churches in Perth Road. Nineteenth-century businessmen's clubs characteristically took the form of an Italian Renaissance palazzo signifying the marriage of culture, money and authority. Not Pilkington. Although the Eastern Club was classical in form (symmetrical and well-proportioned) his dapper façade had more of the character of Venetian Gothic; if Glasgow could have a cast-iron version of Venice's Ca' d'Oro, Dundee could have its stone one, not unlike the romanesque Royal Arch down on the Shore. In a striking display of confidence, the columns of the two ground storeys were so slender that the façade was more glass than stone.

Social fashions changed and the Eastern Club was demolished in the 1960s for an unremarkable bank.

KINNAIRD HALL

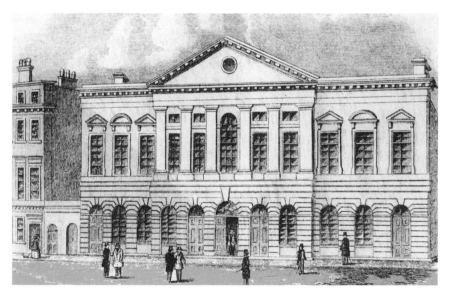

After 1833, the lands north of the High Street were opened out by the construction of Reform Street; halfway up it, an opening was left for a street to run west to Lindsay Street. In due course Bank Street emerged, thus causing the demolition of David Hunter's great lodging. Bank Street was never completed quite as originally planned, being occupied only sporadically. The

Kinnaird Hall interior.

smart terrace on the north side, later occupied by the *Dundee Advertiser*, was built over the town wall that had lined the south side of the Howff. So, when Dundee desired a new Corn Exchange in 1858, land was available in the long rigs behind the High Street that could now be reached by the new street.

The Kinnaird Hall was designed by Charles Edward on the site of St Margaret's Close (to which the Royal Mint had been relocated when it was temporarily removed from Edinburgh during a time of plague in the sixteenth century), and Edward's bluff Italianate frontispiece faced Bank Street. A corn exchange was just the kind of public building that every significant prosperous burgh thought it required, but – just as with the Royal Exchange in Edinburgh a century earlier – it failed. The merchants and farmers still preferred to conduct their business in the open air.

So, after only a few years, it metamorphosed into the public hall called the Kinnaird Hall, after Lord Kinnaird, who donated the ground it was built on. The hall could seat 1,476 people and became Dundee's principal public hall and the preferred location for political meetings (Winston Churchill addressed several election meetings here when he was MP for Dundee), civic functions, auctions, concerts and shows. Prior to the opening of the Caird Hall, it was also Dundee's principal ceremonial arena. It was here that the

freedom of the city was awarded to Sir William Arrol, builder of the second Tay Bridge. Behind the hall's grandiose façade was a broad iron-framed space, with stepped seating and an organ at one end. Once the Caird Hall was in place the Kinnaird Hall was transformed into the Kinnaird Cinema. It was demolished in 1966 after being severely damaged in a fire.

The North Lindsay Street Fair

School Wynd, a lane that had run in front of St Mary's ceremonial western portal between the Nethergate and Overgate, was widened into Lindsay Street in 1824 and extended northwards. Focusing axially upon the Sheriff Court, it opened up the Ward lands to the north, as had been the ambition of the Council for at least 20 years. However, Windmill Hill ran along the back of the Overgate and the Overgate's medieval closes, wynds and courts clambered right up it (as can be seen to the right of this drawing) and lay in the way. The hill needed to be removed. Once a sufficiently wide track had been cut through, the Newtyle Railway was routed down past St Mary's to the Nethergate, and on to the Shore. For much of the nineteenth century the quarried part of Windmill Hill, known as the North Lindsay Street Quarry, was used as a principal location for visiting fairs. Recently built tenements formed the east side of Lindsay Street next to St Mary's tower. Once levelled,

The North Lindsay Street Fair by Charles Lawson.

the site was replaced by Ward Mills, and the fairs were relocated down to the Greenmarket by the Shore. Most of this scene now lies beneath the Overgate Centre. If the figure standing proclaiming on the left, tormented by urchins, is the poet William McGonagall (as seems likely) the drawing on the previous page cannot predate 1876.

As the highest point of the burgh and commanding all the northern approaches to the town, Windmill Hill had always been significant in Dundee's history and had been fortified by John Mylne during the civil wars. In 1757, William Robertson, the architect from Leven who had constructed new packhouses on the Shore, invented a new type of windmill that he proposed to erect on the hilltop (and from which it derived its later name). The Council agreed – provided that Robertson paid for it himself. The windmill, visible in all later eighteenth-century drawings of Dundee, was thus described by Bishop Pococke when he visited in 1760:

> Extraordinary . . . The Diameter of the room is 30 feet, the wall is 6 feet thick, and I believe about 20 high. On this, by triangular Machinery, is fixed a Wheel with three radii 56 feet and 8 inches in diameter. There are 24 radii more, which are strengthened by a piece of timber fixed at one end and to the axle of the wheel: to each of which is fixed a vane of wood of half its length, and

another between them, 48 in all according as the Wind requires
. . . The grand wheel is moved round to the wind properly by a
cogwheel, which turns in a hoop of iron fixed horizontally all
around the top of the tower: on which the whole machinery
belonging to the wheel turns and moves the wheel with it . . . It
turns four mills for barley, oats, wheat and is of power to move
a much greater number . . . The question is how it will stand
stormy nights when the wind often veers about and may take it
every way in a very short time.

THE DOOMED TAY RAIL BRIDGE, 1879

The first completed railway bridge across the Tay was the ninth attempt to
bridge the Tay estuary with a railway line, and the culmination of 25 years of
pressure by Dundee's entrepreneurs to ensure that the town was connected
to the national rail network. The project was dogged by difficulty. The first
contractor died, the second contractor went mad and the third contractor
was based in Middlesbrough and remote from the site. He left the work to
be managed by the 32-year-old German engineer Albert Grothe. By all ac-
counts, Grothe was a poor man-manager who failed to exercise adequate
quality control.

Problems were exacerbated by the foundations. The engineer, Thomas
Bouch, had relied on a survey (probably for a slightly different site) that had

concluded that the riverbed was continuously solid all the way across at 10 metres below high tide level. The survey was wrong. When the contractors reached pier 15 from the south, they discovered that the river was virtually bottomless from this pier northwards, and so Bouch had to redesign the entire bridge very hastily, whilst the contract was still running. He altered the structure from twin solid brick columns to a single slender column of lightweight cast iron. His design engineer, Allan Stewart, was at the forefront of such structural design (he later went on to direct the drawing office on the Forth Bridge) but its stability depended on good and careful construction. The foundrymen, however, had craftily found ways of avoiding any quality control by the supervising engineers. Bouch himself was rarely on site.

The construction programme had fallen so far behind, and the costs had risen so much – double the original estimate in both cases – that both railway company and contractor were in financial difficulties. Corners were cut. The last part of the bridge to be completed were the central 13 high girders above the navigation channel. For reasons of speed, Grothe ordered that the raking columns intended to stabilise the high girders should be added subsequently, rather than erected at the same time as the girders were put in place. The risks of this approach were demonstrated one night in February 1877, when the first two high girders were blown over by a gale before their raking columns were put in place. The second girder was damaged beyond repair, blown up and replaced. The first high girder, however, was salvaged, shipped down to Middlesbrough, patched up and beaten back into shape. It was then re-erected as High Girder No. 1, coming from the south. But it had been badly weakened, and probably began to deform as soon as lumbering coal wagons began to trundle across the bridge in autumn 1877. As the girder deformed, a kink developed in the track, and passengers found the journey northwards distinctly uncomfortable, as train and carriages bounced into the air – to the extent that season-ticket holders began to return their tickets. At 7.15 on Sunday evening, 27 December 1879, the kink in the rail of High Girder No. 1 threw up the lightweight, oversprung and empty second-class carriage, and a gusting gale blew it off the track. Minutes later, that wayward carriage snagged the side of High Girder No. 4, and the heavy brake van shattered it from behind. The impact fractured the bridge's cast-iron structure. All 13 high girders collapsed into the Tay, taking somewhere between 63 and 75 souls with them.

The chairman of the ensuing public enquiry had prior instructions from the government. The enquiry never heard the full evidence, and never really worked out why the bridge had come down – and indeed never came to a

unanimous conclusion. The engineer, Sir Thomas Bouch provided rambling and incoherent evidence and was a suitable scapegoat: so in a minority report, the chairman blamed it all on him. That is what history has believed ever since. However, given that it never heard the evidence that the carriage came off the track, the verdict cannot be trusted.

The railway company was running trains with carriages rented from another company, over a bridge built by another different company, whose maintenance had been contracted out to yet another company. Despite its structural imperfections, the bridge might never have collapsed had it been subject to a more professional maintenance and inspection regime.

This view from the north bank shows the high girders in the middle distance and the remains of Dundee's celebrated Magdalen Yard beaches marooned high and dry in the foreground.

East Station

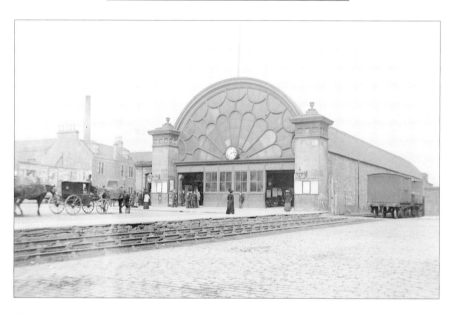

The Dundee to Arbroath railway formed the second part of Dundee's railway strategy, after Newtyle. Its construction had been made much easier by the Earl of Panmure's decision to make over the necessary land at low cost, in a reverse of the norm during this period of railway speculation. It was opened in 1838. The intent was that the railway should create a new industrial axis, with mills and factories running all the way from Dundee to Arbroath. Luckily, that forecast proved wrong.

The first terminus lay out by East Craigie then extended to Carolina Port – but once Dundee's dockyards had been extended eastwards through the tidal flats and Dock Street had been opened, the Arbroath railway was gradually extended westwards through the mud flats to terminate by Trades Lane close to the Customs House. In doing so, it marooned all those industries, such as the whaling companies, that had had their own piers and depended upon direct access to the sea. Those that could not adapt went bankrupt.

Being the terminus of only a single line, the final Dundee East Station, constructed in 1854, was an inconspicuous shed-like structure, principally notable for the ornate ironwork of its gable.

CITY IMPROVEMENT, 1871

In 1871, Dundee probably had the most extensive intact medieval town centre surviving in Scotland. Much of it, particularly in the maritime quarter between High Street and Shore, had become overcrowded, because it provided the cheapest accommodation and had become the haunt of the

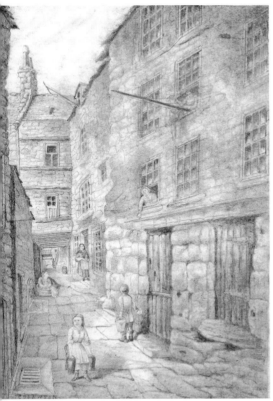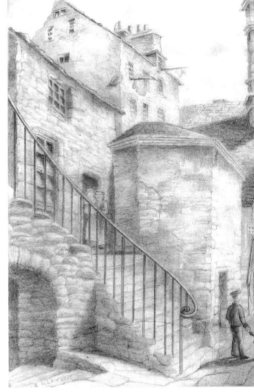

Two views of Scott's Close in the Maritime Quarter.

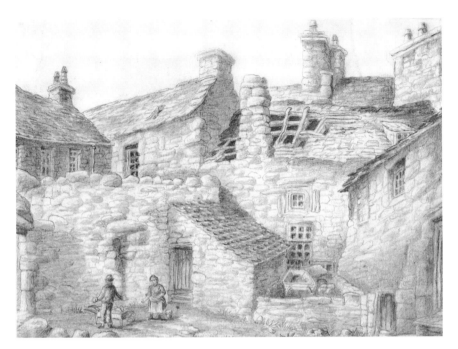

Drawing of St Margaret's Close by Charles Lawson.

destitute. The reputation of the Maritime Quarter around Fish Street had become anathema.

In 1869, James Cox of the Camperdown Works had been persuaded to stand for the Council and by 1871 was elected provost. By this time his colleague, the lawyer Thomas Thornton, controlled most of the boards and trusts that ran the burgh. Between them, Cox and Thornton transformed Dundee. As one might expect from the chairman of the largest jute mill in the world, Cox brought a managerial and businesslike approach to Dundee's problems. Seeking appropriate professional expertise, he brought William Mackison in from Stirling to the new post of Burgh Engineer. That same year the Dundee City Improvement Act went through parliament. Cox became chairman of the City Improvement Trust and Thornton its legal agent.

The Improvement Trust's objectives were less social welfare or reform than the efficiency, cleanliness, good order and appearance of the town. The narrows of the Murraygate, just 12 feet wide, constrained the principal land route from the town to Aberdeen and Inverness. The narrows of the Seagate inhibited access to the downstream docks, whereas there was no adequate cross route from Perth to Forfar. Traffic jams were customary. The Improvement Trust decided therefore to reformat the entire city centre. Between 1873 and 1963, the ancient port of Dundee was systematically removed.

Charles Lawson's drawings show just how high the quality of those ship-masters' apartments in the maritime quarter had been, which goes a long way to explain why the burgh had seen no need to build a 'New Town' when all other Scots burghs were doing so.

The Narrows of the Murraygate, 1870s

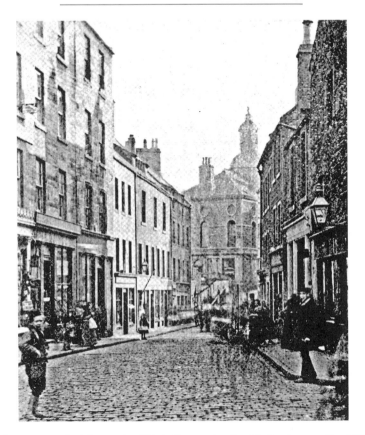

The Murraygate led from the High Street to the Wellgate, up the Hilltown and north along the King's Highway to Forfar and Aberdeen. It was possibly Dundee's busiest street during the eighteenth century. Most of the town's staple export of low-grade brown linen or osnaburgs was manufactured out of Ratziger flax imported from Danzig, Riga and St Petersburg and distributed along this route to weavers in the vicinity of Forfar. The finished product was brought back again through the Murraygate for export to America and the West Indies.

Perhaps as a consequence, many of the agents, shipowners and insur-ers congregated in the 'broad' of the Murraygate, which duly became the

burgh's primary commercial centre and was almost entirely rebuilt during the eighteenth century. The narrows of the Murraygate were occasioned by the Scouringburn running beneath it at this point, making the street a form of 'inhabited bridge' and protecting the High Street from the north-easterly wind. Although modernised, the buildings were essentially seventeenth-century or earlier in form, save the great mass of the 1776 Trades Hall, which can be seen on the left. Proposals to widen the Murraygate Narrows had first been put forward in the 1790s, repeated frequently thereafter but never acted upon. By the 1870s, the narrows of the Murraygate now blocked all land traffic between Edinburgh and Aberdeen, and were a principal stimulus of the 1871 City Improvement Act.

That may explain why the first action of the Improvement Trustees was to take the narrows of the Murraygate and Seagate out, creating the opportunity to construct a splendid new boulevard on the Parisian model. Thus was Commercial Street conceived: in place of myriad closes, wynds, the Mauchline Tower and the winding, overcrowded and narrow Fenton Street, arose smart shops and apartments.

This photograph, taken from a volume of similar photographs in the University Archives recording those parts of old Dundee about to be lost to the City Improvement Act, shows that the demolition of buildings to the rear of the Trades Hall to make way for the Clydesdale Bank had already begun. At the far end of this vista the High Street was still closed by the 1782 Union Chapel – but not for long (see p. 19).

THE NARROWS OF THE SEAGATE, 1870S

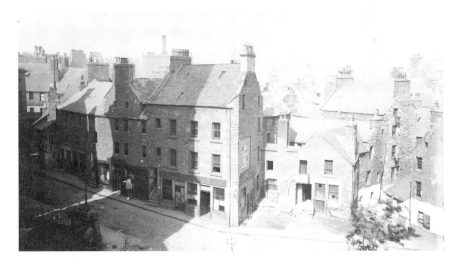

The location of this photograph (previous page) can be anchored by the shadow of St Paul's Cathedral on the Castle Hill, which can be made out on the left.

The Scouringburn passed from the narrows of the Murraygate southwards directly underneath the Burnhead (hence its name) that narrowed the Seagate to under two metres. One of the most ancient quarters of Dundee, the gardens between the Seagate and the Murraygate had become progressively built up and very dense. It was through the right-hand side of this dense mass that Commercial Street would be driven northwards to the Meadows. The buildings on the left-hand side would be replaced by the Clydesdale Bank after the road had been suitably widened. The alley on the right, leading into St Paul's Close, can still be accessed from Seagate, and retains ancient relics such as blocked-up windows and outside stairs.

BLACKSCROFT

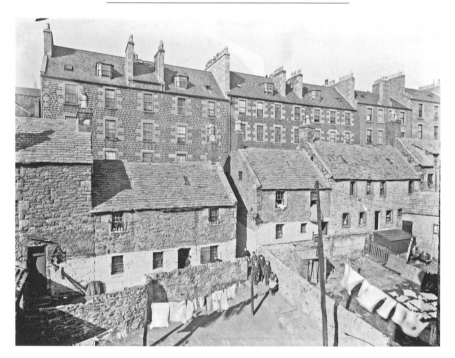

Blackscroft lay on the high ground immediately outside the eastern burgh boundary. It probably occupied the lands which, during the Renaissance, had been reserved for those who had been exiled there on the grounds of their potential contamination during time of plague. Because of its proximity to the foot of the Dens Burn, it early became an industrial suburb – and

a substantial one at that, to judge from the sturdy but substantial cottages that lined its principal street. It had been feued out in 1759 and had become 'like a village & contains as many Inhabitants as is in some parishes' by 1775. Nonetheless, it lay inconveniently on the principal route between the burgh and Broughty Ferry and so these old houses stood in the way of development, to be replaced by new roads, tenements and mills.

THE HILLTOWN

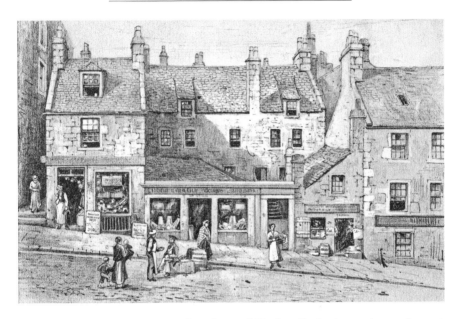

The King's Highway between Dundee and Forfar climbed steeply north-west through the suburb of the Hilltown, also known as Rottenrow or Bonnet-Hill. The Hilltown became a 'burgh of barony' of Viscount Dudhope in September 1643, and duly set up a normal burgh apparatus – with its own bailie and tolbooth, and deacons for its various crafts. That led to the typical misunderstandings and grievances between a royal burgh and a neighbouring burgh of barony until the Hilltown's absorption into Dundee in 1697 – although some of its burgh functions remained.

The name Bonnet-Hill derived from Dundee's bonnet-makers. They used to sit outside the gable of their thatched cottages knitting the typical Dundee blue bonnet from worsted (the only survivor now is the one used by the chancellor of the University of Dundee to confer degrees at graduation) while watching cart-borne trade drag uphill to Forfar and Angus. Although that was the principal craft it was not the only one, for bucklemakers and

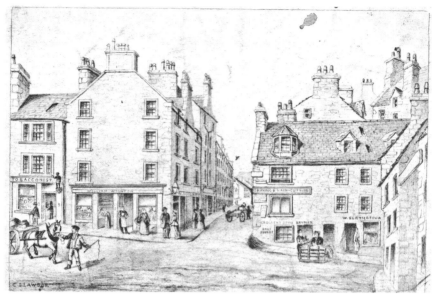

The crossing of the Wellgate (right) with Bucklemaker Wynd (ahead).

armourers congregated around Bucklemaker Wynd. The Ladywell lay on the Hilltown's south-western fringe downhill, more or less opposite Buckle-maker Wynd, which led off opposite along the lower slopes of Forebank just at the point where the Wellgate and the Hilltown met. Bucklemakers were a branch of the hammermen, whose tasks probably also included gunsmith-ing and armour- and harness-making. But Dundee had long been promi-nent in shoemaking and during the late eighteenth century this became one of the town's principal industries. Buffalo-hide was imported through Charleston to Dundee, tanned in the tanneries that clustered around the Wellgate, then crafted into shoes for export to London. In return, Dundee exported to Charlestown cheap brown cloth (osnaburgs) and brightly col-oured thread.

By the later nineteenth century Dundee's ancient route north to Forfar up Bonnet-Hill had become unsuitable for the increasing number of vehicles – and wholly impossible for trams. So the Improvement Trustees decided to construct a gentler, more efficient route that could take trams along the line of Bucklemaker Wynd. Christened Victoria Road, it was to become one of the most successful new streets in Dundee – a grand urban parade of shops and flats on the south side, with mills, churches and industrial premises on the north. However, to achieve the required gradient for vehicles the new road level of Victoria Road had to be higher than that of the Wellgate at the point that the two crossed each other. So the Wellgate, the ancient entrance

to Dundee from the north, became a vehicular cul-de-sac ending in the flight of stone Wellgate Steps.

The Wellgate was demolished in the 1970s for the Wellgate Centre. At the same time, the opportunity was taken to demolish the south side of Victoria Road and replace confident Victorian urbanism with small groups of inappropriate harled cottages in the manner of Pittenweem. This type of 'regeneration' symbolised the extent to which post-war Dundee had lost all sense of its identity.

GILFILLAN MEMORIAL CHURCH, C. 1886

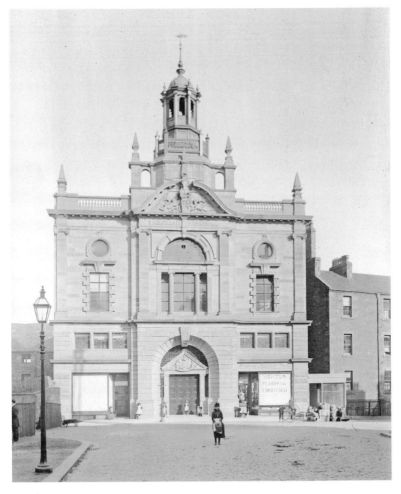

It is always easier to demolish than to build. The second phase of city improve-ment, which began c. 1886, demolished the Maritime Quarter faster than the

new Dundee could replace it. Its dense closes and wynds between Fish Street and the Nethergate, so well recorded by Charles Lawson, were pulled down for the new urban parade of Whitehall Street and Crescent. Together, they provided an opulent Victorian entrance into the city centre for those arriving by train or sea. When this photograph was taken, the street was paved, and the pavements laid with the street lamps – but that is all. The packhouses and the cholera hospital have not yet been entirely replaced by Whitehall Crescent. The keystone of this phase of improvement, however, stands proudly in place at the foot of the as yet unbuilt Whitehall Street – namely Malcolm Stark's Gilfillan Memorial Church, completed in 1888. It looked very much more imposing then, when it dominated all around it, than it looks now. It became diminished when Whitehall Crescent was built up alongside to the same scale, and shrank even more when it lost its cupola.

George Gilfillan (1813–78) was a Victorian celebrity preacher who ministered in a radical manner for 42 years from the School Wynd Church (see p. 71). At his death (his funeral was a national ecumenical event accompanied by furious outpourings of verse in the newspapers) he had been supporting the liberal/radical views of the Rev. David Macrae against the concept of eternal damnation. Macrae held that salvation was open even to unbaptised heathens. That affronted the United Presbyterian synod who, just at the point that Macrae had been elected to Gilfillan's vacant pulpit, expelled him. A majority of the congregation got up a subscription to build an independent church, holding services in the Kinnaird Hall in the meantime. The first sermon in the Gilfillan Memorial Church was preached in May 1888.

THE NETHERGATE

THE BROAD OF THE NETHERGATE

Before it finally narrowed at the Barrass Port (the inner timber gate) at the foot of Long Wynd, the west end of the Nethergate had widened from the narrows into the broad of the Nethergate, where it ran alongside the nave of St Mary's. This space was originally used for the Greenmarket (for herbs and vegetables). It was the élite end of seventeenth-century Dundee. The substantial villas lining its south side had gardens and rigs extending down southwards to the new and west shores. It was open and sunny, and therefore no surprise that the Earl of Crawford's town house was located there. Most of the timber galleries that had once lined the façades of the tenements had been removed in the 1760s, and various sections rebuilt as smart Georgian

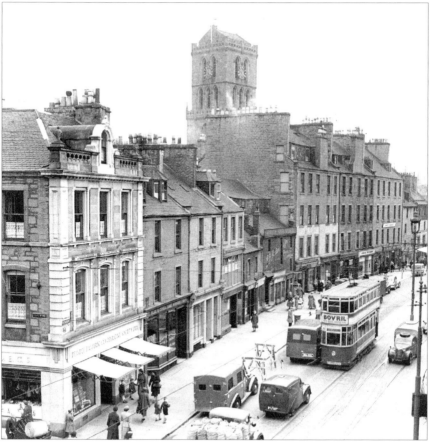

Top: the Broad of the Nethergate. Bottom: the Nethergate looking east.

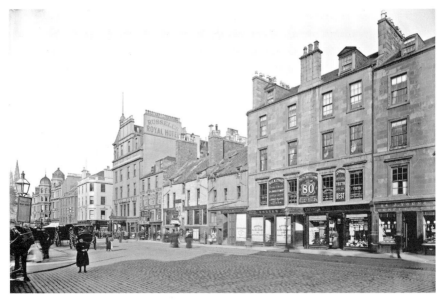

The Nethergate, south side.

and Regency apartments. In the top picture on the previous page, the road opening to the right, originally Kirk Wynd, then School Wynd and finally Lindsay Street, joined the Overgate to the Nethergate, and the elegant classical building on the right was the School Wynd Church (see p. 71). The buildings on the north side (see picture previous page), including St Enoch's Church, were demolished in the 1960s for the Inner Ring Road on the line of Long Wynd (misleadingly called Marketgate) and the western wing of the Overgate Centre. Nothing of this view survives.

Although most buildings on the south side were re-fronted in the eighteenth and nineteenth centuries, like their fellows across the street they retained much earlier fabric behind their structures. The small houses fourth and fifth from the left in the bottom picture on the previous page, probably the oldest, were probably fairly typical of original properties on the edge of the town centre. The original tenement must have stood some way back from the street line, with a timber gallery projecting to the front which, as often happened, was replaced by a stone façade in the seventeenth century.

St David's

When modernising, Dundee would take only what it needed and leave the rest behind. It is thus in the backlands that pre-modern Dundee can still mostly be found. Some older properties behind the south side of the broad of the Neth-

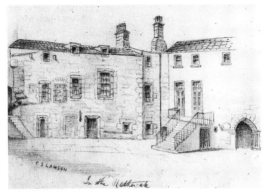

St David's.

ergate that escaped modernisation included several long, ancient closes and
the truncated remains of Renaissance town houses between Malthouse Close
and the Newtyle Railway. Some of these ancient structures were demolished
in the 1930s for a garage, which was in turn demolished for the Nethergate
Centre in the late 1970s. All, however, was not lost. What the modernisers did
not need to rebuild, they left. Lying behind MacMillan's Buildings, there are
buildings around two courtyards, three gardens and framed by four closes in
a decaying condition that comprise the largest single relic of ancient Dundee
as a seaport.

Behind the street front, St David's comprises a courtyard bounded by an
internally elegant Regency villa, probably designed by David Neave, perched
in and upon massive medieval masonry. An early seventeenth-century carved
arched entry leads beneath that villa to the garden and shore. The courtyard
is lined by equally ancient structures, including three enormous vaulted cel-
lars, a Victorian wash-house, and a splendid Renaissance doorway, together
with the lower flights of a gracious seventeenth-century staircase. To the
west, entirely separate from the buildings facing Nethergate, is a free-stand-
ing seventeenth-century house attached to the Auld Steeple Guest House.
This extensive survival of pre-improvement Dundee awaits rescue.

WEST PORT

The West Port of Dundee formed the town boundary on the road north-west
from Dundee up the Scouringburn to Coupar Angus. Immediately outside,
to its south-west, lay the convent of the Grey Sisters, on land later called the
Witches' Knowe; to its south lay the Blackfriars, and immediately inside
clustered the burgh's shoemakers. On the sunny slopes to the north, running
down to the Scouringburn, Dr Patrick Blair set up his Cabinet of Curiosities

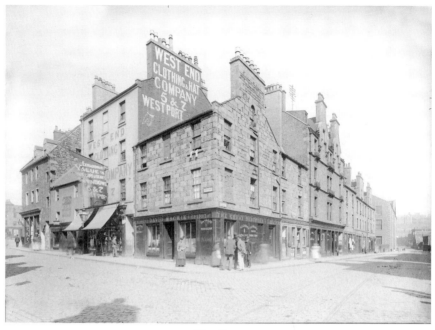

West Port.

(museum) in the late seventeenth century and created Dundee's first Botanic Garden in his orchard. The fertile slopes of the Witches' Knowe became the principal market gardens of Georgian Dundee. Once the Overgate Port had been demolished in 1757, this area became an extraordinarily busy junction. The arrival of the new turnpike road from Dundee to Coupar Angus in 1793 changed everything. In order to bypass both the narrow and winding street of the Scouringburn and the steepness of the Pleasance, a new, gentler route was selected, running along the south edge of the Dudhope estate through the swan ponds of Dudhope. It then curved south through the Kirklands to the Town's Hospital on Perth Road, to join the other new turnpike road. North of the West Port, this new street became North Tay Street, and south of it, South Tay Street.

North Tay Street became the eastern boundary of the Blackness industrial district, as the gable of the enormous Tay Mills, in the distance on the right, indicates. All else of this ancient site has been replaced by cars.

THE HARBOUR IN THE 1880s

A good way of testing the licence taken by a painter is to juxtapose a painting with a photograph. Both of the images opposite were taken at approximately

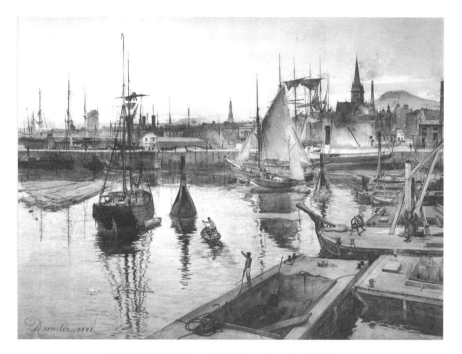

Top: a view of Dundee Harbour by James Douglas, 1888.
Bottom: a photograph of the Harbour at the same period.

the same time from approximately the same location in the harbour – more or less in line with the foot of the recently extended and greatly smartened Commercial Street. It is now the view from the Tay Road Bridge. The spire of St Paul's Episcopal Cathedral on Castle Hill, completed some 30 years earlier by Sir George Gilbert Scott, dominates. The steeple to its left is that of William Adam's Town House, followed by the pinnacles of the Royal Arch, and the iconic tower of St Mary's frames the view on the left. When painting this wide panorama in 1888 the artist, James Douglas, had to flatten and compress the buildings. A different reality can be seen from the photograph. The buildings on the burgh's shoreline, far from being a backdrop, loom over the masts and sails of Dundee's herring fleet. The painter reduced the scale of the buildings the more to emphasise an industrial harbour where coal and timber barges were interspersed with stacks of timber being seasoned in the dock. The integration of harbour, port and town, so vividly emphasised in these images, was destroyed in the 1960s.

UNIVERSITY CITY 1900–2008

INTRODUCTION

This period of Dundee's history starts in depression and decline and closes in renewal and optimism. Dundee entered the twentieth century having survived the recession caused by the Boer War and buoyed by the subsequent demand generated by the First World War for jute to make sandbags for the trenches and heavy linen for military tents and tarpaulins. The prosperity brought by the war was, however, to be fleeting, and Dundee's failure to diversify its economy in the expanding years of the jute trade left it vulnerable to both downturns in the economy and to increasing foreign competition.

By 1911, 48 per cent of Dundee's employed workers were in the textile industry, compared with 5.5 per cent in Glasgow, and almost two thirds of the

Dundee from the sea, 1953.

Dens Works, c. 1950. Feeding the hackling machine.

population were involved in the manufacturing industries, compared with half in Glasgow. It was also a city in which a higher proportion of women worked; in 1911, 43 per cent of the total working population was female, compared with a Scottish average of just under 30 per cent. There was also a disparity in the distribution of female employment within the different industries and sectors. Whereas 85 per cent of women in Dundee worked in the manufacturing industries (29 per cent and 47 per cent in Edinburgh and Glasgow respectively), only 21 per cent worked in the service industries, compared with 66 per cent in Edinburgh and 48 per cent in Glasgow. The high proportion of women in the jute industry gave rise to the image of Dundee as a town of strong and determined women and unemployed, downtrodden men, reinforced throughout the period in popular culture by songs and poems, including those of Mary Brooksbank, the evocative 'The Jute Mill Song' reflecting low wages and long hours in the mills.

As imports of raw jute reached their peak in 1902 – when over 400 tons were brought from India into the city – expansion of the Calcutta mills and

Oh Dear Me
(A mill song)

11

Oh Dear Me, The mills gane fest
The puir wee shifters canna get a rest
Shiftin' Bobbins coorse and fine
They fairly mak ye work for yer ten and nine

Oh Dear Me, I wish the day was done
Rinnin, in and oot the pass is no nae fun
shiftin' peecin' spinnin' Warp, Weft and Twine
Tae feed and cled my Bawnie, aften ten and nine

Oh Dear Me, The World's ill-divided
Them that work the Hardest, are wi the least Provided
But I maun bide Contented, dark days or fine
But theres no much Pleasure livin aften ten . Nine

Original manuscript page from a Mary Brooksbank notebook.

factories, primarily alongside the Hooghly River, was increasing. Paradoxically, this was achieved using skills and technology exported from Dundee. By 1919, 89 jute mills in Calcutta were employing 330,000 workers: Dundee employed 41,000. Imports of Indian cloth continued to increase till the late 1930s, by which time only 32 textile companies were still in business in Dundee. Of course, the city was not totally dependent on the production of cloth. Shipbuilding, engineering, whaling and the food and drinks trades employed

Workers at Titaghur No. 1 Mill, West Bengal.

substantial numbers, though those involved in public administration and the professions made up only 3 per cent of the employed (Edinburgh having 11 per cent). The buoyancy of the industry at its height was, throughout the first half of the twentieth century, replaced by depression, with almost half its workforce unemployed. On the eve of the Second World War only 28,000 men and women were employed in the jute industry. However, despite the encroaching competition of the Bengal jute mills, a small number of Dundee jute mills managed to survive, assisted after the war by Jute Control, a quasi-protectionist measure which remained in place until 1969. Nevertheless, survival was only possible by diversification of the product range and by moving to the production of polypropylene (a by-product from the refinement of crude oil), which replaced jute backing for carpets. A consequence of this process was the gradual incorporation of jute companies into petroleum and chemical companies. The dismal state of much of Dundee's industry was reflected in the stagnation of its population. Growth of 7 per cent within the city was achieved solely through boundary changes, with less than 0.1 per cent actual increase. Unemployment ensued, leading to protest and riots, as Dundee faced the cold wind of recession.

Within the context of industrial decline in the period between the wars, the fabric and form of Dundee's urban landscape was changing, influenced

in no small part by city architect and engineer, James Thomson. Having worked for the municipal authority since 1873 in the department of William Mackison, the burgh engineer, he was appointed as city architect in 1904 and two years later also took over as the city engineer. On appointment, his first big projects were the outstanding Renaissance libraries at Blackness and Coldside in 1906–07 (though the Coldside design has been attributed to his son Frank), followed by others in St Roque's (1910) and Barrack Street (1911), which later became the Natural History Museum. During this period he built up his staffing complement to enable him to develop the planning projects where his interests really lay.

In 1907 the Council established a Housing and Town Planning Committee, in anticipation of the Housing and Town Planning Act of 1909. By 1910 Thomson had unveiled his magnificent scheme for transforming the central area of Dundee and its harbour. The plan proposed the infilling of the Earl Grey docks, grand new municipal buildings on a scale unparalleled in Dundee and a new railway station complex. The plan was remarkable in its vision and in its optimism, reflecting an innate confidence that the worst of the

St Roque's Library.

Coldside Library.

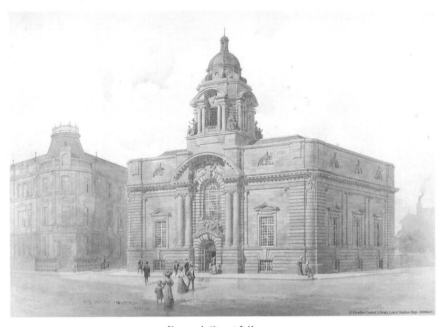

Barrack Street Library.

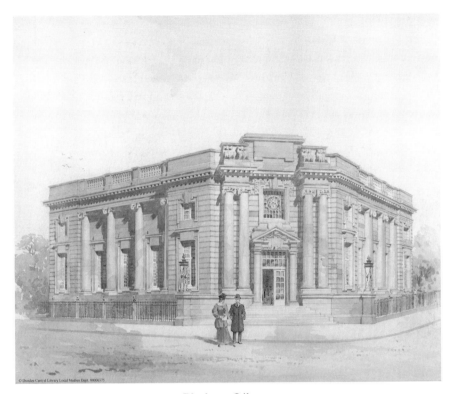

Blackness Library.

nineteenth-century crowded, unhealthy city could be transformed into an economic and aesthetically viable cityscape. His plan was hindered by Sir James Caird's insistence on a scheme according to his own ideas. Caird, a jute manufacturer – owner of the Ashton and Craigie Works – and philanthropist, did not favour Thomson's grand plans, and promoted the building of a new city hall built according to his personal vision. Though designed with Thomson's attention to detail and quality, Caird Hall, when completed in 1922, was forbidding and austere. The construction was funded by Caird's donation of £100,000 and a further donation from his sister, Mrs Marryat (after whom the Marryat Hall was named) provided the colonnade. The building of Caird Hall sealed the fate of 'The Pillars', William Adam's distinctive Town House, which was demolished during 1931–32.

At the end of the First World War Thomson had produced another report showing considerable urban vision, as in his 1910 report, but which concentrated on urban housing and transport. Benefiting from government subsidies available under the terms of the 1919 Addison Act, municipal house building began at Logie in 1919 and by 1922 674 houses had been built, the

first post-war council-housing estate in Scotland. Influenced by the Garden City movement, it was spaciously laid out, with wide tree-lined streets, which were in sharp contrast with the remaining slum areas in the city centre. Over 16,000 council houses were built in the inter-war period, though severe inner-city problems of overcrowded and unsanitary houses remained. It was impossible to rebuild the whole of Dundee at the same density as Logie. Furthermore, many of the new housing areas, such as Mid-Craigie, were isolated from the city centre.

These criticisms became levelled at the planners and architects of the post-1945 new towns and in the new council estates in other Scottish cities. Rent of over £30 a year was beyond the means of many in slum areas, representing almost half the average wage. Consequently, the homes were occupied by white-collar or skilled workers and not those living in the overcrowded city dwellings. By 1931, 15,000 families were still living in overcrowded inner-city dwellings and it was not until the 1940s that the new housing schemes in Douglas and Angus, Kirkton, Charleston, Fintry and later at Menzieshill, Ardler and Whitfield were developed.

Casualties of the post-war development included the Royal Arch, symbol of the affluent days of the port and city, which was demolished in 1964 to make way for the Tay Road Bridge. Prior to the construction of the £6 million bridge, opened by the Queen Mother in 1966, the Tay ferries (under the

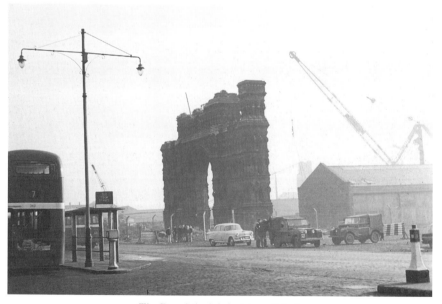

The Royal Arch being demolished.

The Tay Ferry.

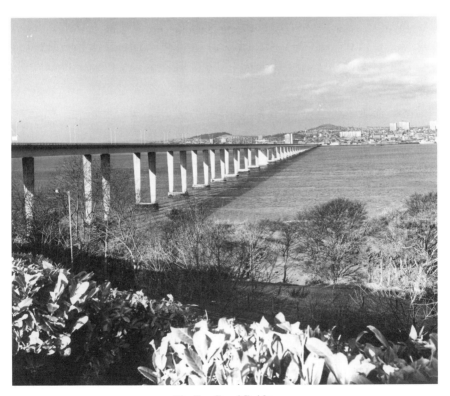

The Tay Road Bridge.

The Angus Hotel.

control of the Dundee Harbour Trust) transported vehicles, commuters and day trippers from the foot of South Union Street to Newport. By 1947 over 2,000 vehicles a year used the ferry, rising to 80,000 in the 1960s. The bridge removed the need for the ferry and to an extent cut off the direct contact of Dundee's people with the river. Nevertheless, the economic advantages outweighed other factors as the bridge integrated Dundee into the national road network, in a way hitherto impossible with ferry crossings over the river.

The Overgate, location of some of the city's worst slums, was knocked down and replaced in 1963 by a shopping centre and the Angus Hotel, designed by architects Ian Burke and Hugh Martin. The development was not a shining example of inner-city planning and was demolished in the 1990s, to be replaced with a modern shopping precinct which frames the steeple of St Mary's Church. Further redevelopment occurred in the Wellgate, which became the site of another shopping centre, by James Parr and Partners, in the late 1970s. The only survivor of Dundee's medieval grandeur that still remains, apart from some of the ancient closes and wynds, is Gardyne's Land, in the High Street, which has been conserved and converted into an impressive five-star hostel.

Despite the high levels of unemployment it experienced in the 1930s, Dundee had not been considered eligible for assistance under the 1934 Scottish Special Areas Act. Following the end of the war, however, it was

designated as a development area, which facilitated loans and grants to firms who chose to locate in Dundee. Of great importance was the establishment of new industrial estates on which were built factories designed to house new methods of production, replacing the old and obsolete factories in the centre. Between 1948 and 1966 those employed by firms situated in Dundee's industrial estates rose from 1,075 to 11,407. This amounted to almost 12 per cent of the working population, the majority of whom were men, in sharp contrast to the high numbers of women that had been employed in Dundee's traditional industries.

Foreign inward investment brought new industries to Dundee, with four out of the seven biggest companies coming from the United States: National Cash Register (NCR); the United States Time Corporation (now called Timex); Holo-Krome, manufacturing socket screws, and Veeder-Root. Both NCR and Timex came to the city in 1946, housed in buildings designed by Beard and Bennett of London. By the mid 1960s NCR, founded in Dayton, Ohio, and principally located at Camperdown, off the Kingsway, employed almost 3,500 workers, producing cash registers, accounting machines and electronic data processing equipment. Later, in 1979, NCR endowed a Chair of Electronics and Microcomputer systems at the University of Dundee, reflecting the company's position in the local economy and community. In 1948 Veeder-Root Ltd arrived, producing counters and recording and mechanical computing equipment for the petrol-pump industry. The Scottish company Ferranti Limited opened a factory in Dundee in 1952, increasing the highly skilled Dundee workforce engaged in research, design, development and production in a range of electronic and mechanical-engineering factories.

Although the industrial landscape of Dundee changed throughout the twentieth century, some companies were able to survive the city's economic peaks and troughs. One notable example was James Valentine, the publisher. Based in Dundee from the early nineteenth century, the company diversified in 1897 and began publishing postcards which have since become highly collectable. The company was bought by Hallmark Cards Inc. in 1980, and the Dundee works closed in 1994. Its surviving archives are held by the University of St Andrews.

Alongside the municipal and industrial changes which occurred in Dundee, developments in education were growing to the extent that the sector is now one of the largest employers in the city. Over 30,000 students contribute to the local economy. Again, the jute industry was crucial to the beginning of this process, notably in the form of a bequest of £120,000 by Mary Ann Baxter, of the Baxter jute dynasty, to found University College,

Copy

School Registered
Deed of Endowment & Trust

— of —

University College, Dundee

— by —

Miss Mary Ann Baxter
of Balgavies

and

John Boyd Baxter Esq. LL.D. Dundee

dated 30 & 31st December 1881
& 26th April 1882
Forfar

At Edinburgh the twenty sixth day of April One thousand eight hundred and eighty two between the hours of three and four afternoon the Deed with Warrant of Registration thereon hereafter engrossed was presented by Donald Stewart Campbell Maker Edinburgh for Registration in the General Register of Business for Publication and also in the Books of the Lords of Council and Session for Preservation and is, with said Warrant of Registration, recorded in the Register of Business as follows:—

We, MISS MARY ANN BAXTER, of BALGAVIES, in the COUNTY of FORFAR, and JOHN BOYD BAXTER, LL.D., of CRAIGTAY, DUNDEE: **Whereas** we sometime ago resolved to establish a College in Dundee for the purposes and objects hereinafter particularly set forth, and with that view agreed the one with the other to provide a sum of £140,000 in the proportions following, viz.: the sum of £130,000 to be paid by me, the said MARY ANN BAXTER, and the sum of £10,000 to be paid by me, the said JOHN BOYD BAXTER, said sums to be held invested and applied in manner hereinafter provided: **And whereas** we, the said MARY ANN BAXTER and JOHN BOYD BAXTER, have acquired, at the price of £35,000, certain subjects situated in Dundee, with the buildings thereon, being the subjects hereinafter disponed to be used for the purposes of the College, of which price I, the said JOHN BOYD BAXTER, have advanced and paid the foresaid sum of £10,000 agreed to be contributed by me, and I, the said MARY ANN BAXTER, have advanced and paid the sum of £25,000 to account of the sum agreed to be contributed by me; which subjects are held by us in trust to be applied for the purposes of the said College under an obligation to denude of and dispone the same to or for behoof of the College when established: **And whereas** it is necessary, for the purposes foresaid,

Inductive and Narrative Clauses.

The Deed of Endowment of University College, Dundee.

Mary Ann Baxter.

The Professors of University College. Standing, far left, John Edward Aloysius Steggall; second from left, Patrick Geddes; front left, D'Arcy Thompson.

Dundee (UCD). The college was one of the first in the UK to offer equal entry to both sexes, and was secular from its establishment. Among the early appointments were D'Arcy Wentworth Thompson, professor of Biology, and Patrick Geddes, professor of Botany and the founder of town planning. University College affiliated to the University of St Andrews in 1890 and was incorporated as a college of St Andrews in 1897. It became Queen's College of the University of St Andrews in 1954. The University of Dundee was granted independent status and a charter in 1967, with the Queen Mother installed as the first chancellor. One year later the actor, Peter Ustinov, was elected as its first rector. From 3,000 students in 1981, the University of Dundee now has over 18,000 students, and during the first decade of the new millennium embarked on an ambitious £200 million building programme to expand the campus, following a master plan drawn up by Page and Park and Sir Terry Farrell. Iconic buildings such as the Sir James Black Centre (Nobel laureate and a former chancellor of the university), the Queen Mother Building

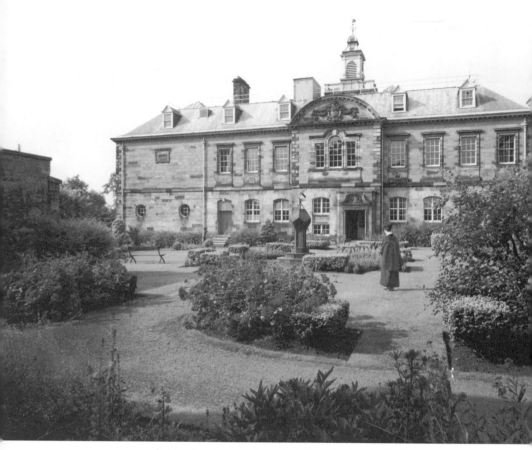

Geddes Quadrangle, Queen's College, during the 1960s.

and the Dalhousie Building created the Campus Green as the focus of the university.

In the early days, educational provision in Dundee expanded rapidly following the founding of University College. The campus grew to include the Technical Institute, located in Small's Wynd, designed by J. Murray Robertson in 1888. This again was funded by the Baxter family, this time by the estate of Sir David Baxter. It provided teacher-training in 1906, independent of the university, and moved in 1911 to new premises in Bell Street, as the Technical College and School of Art. It subsequently developed into the College of Technology and is now the University of Abertay, Dundee. Other notable additions to the campus included the School of Medicine, the Geddes Quadrangle, laid out by Patrick Geddes, the Physics Building – designed

by Rowand Anderson in 1909 – and the Dental School, which was opened in 1918.

The Duncan of Jordanstone College of Art, originally part of the Technical Institute, moved to the Crawford Building on Perth Road in 1950. The building was designed by James Wallace in 1937 but was built to a slightly different design after the Second World War. Joined by the Matthew Building in 1974, the Art College merged with the University of Dundee in 1994. The University Tower Building was designed by Robert Matthew Johnson-Marshall and Partners, and built in 1961. The building and its later extension house the university's arts, social sciences and administrative functions. It remains one of the most distinctive buildings on the Nethergate.

University College was also involved in the movement to improve Dundee's appalling record of slum housing, overcrowding and high mortality rates. D'Arcy Thompson, John Steggall (Professor of Mathematics), James A. Ewing (Professor of Engineering) and Mary Lily Walker (1863-1913, daughter of a Dundonian solicitor, and a prize-winning student at University College, Dundee), established the Dundee Social Union (DSU). The approach of the DSU differed from the Charity Organisation Society (COS), which advocated the need for self-help, sobriety and thrift. Help from the COS was reserved only for the 'deserving poor' (those whose circumstances of poverty were beyond their control, caused for example, by unemployment, sickness, old age and which did not arise as a result of their own faults of character and behaviour) ignoring the liberal movement which grew from the 1880s and advocated collective action against poverty and ill-health. The views of the COS were similar to those of the philanthropist Charles Booth, who sought to contain and control the poor. The leading figure in the DSU, Mary Lily Walker, introduced far-reaching social services into Dundee and supported new social welfare legislation. From modest beginnings, the DSU developed wider social welfare programmes informed by the liberal tenets of collective responsibility.

Following a year in the Grey Lodge religious settlement house in London, Walker founded the Grey Lodge house in Dundee in Wellington Street. She proceeded to undertake a large-scale social investigation of Dundee, culminating in a meticulously researched and comprehensive report, published in 1905. Her report on 'Housing and Industrial Conditions and the Medical Inspection of Schoolchildren', detailed graphically the poor housing and working conditions in which many women and children were living and working. In particular, the report revealed high levels of infant mortality in parts of Dundee. Walker embarked on a programme to reduce those rates,

Report of the Dundee Social Union.

establishing restaurants for nursing mothers, baby clinics and home visit-
ing and became a recognised authority on social conditions in Dundee. Her
passage was made easier throughout by the relationship of the DSU with
University College and by the continued support of D'Arcy Thompson and
Steggall. The establishment of public baths and wash-houses, nurseries and
night refuges in Dundee also assisted in the fight against unsanitary living
conditions, which were only resolved when affordable housing was made
available after the Second World War.

The main large-scale charitable institutions from the late eighteenth
century were the voluntary hospitals, reliant on charitable donations. The
Dundee Royal Infirmary (DRI) was granted a royal charter by George III
in 1819, establishing it into a Body Corporate and Politic, called the Dundee
Royal Infirmary and Asylum. By the mid nineteenth century the King Street
premises were no longer adequate and in 1852 building started on a new site
in Barrack Road, near Dudhope Castle. Designed by Messrs Coe & Goodwin
of London, it was completed and opened in February 1855, when patients
were transferred from King Street. Originally constructed to accommodate
220 patients, later additions were made and the hospital began to diversify

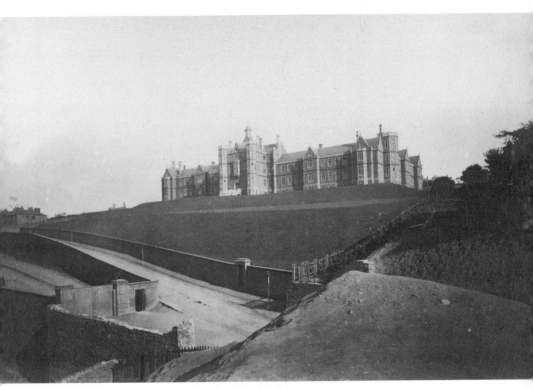

Dundee Royal Infirmary.

its services with new children's, eye, ear, nose and throat wards and an out-patient clinic.

The Infirmary was granted further royal charters in 1877 and 1898 – the former on the occasion of the opening of a convalescent home at Barnhill and the latter providing for the addition of a maternity hospital. In July 1948 the running of the Infirmary was transferred to the National Health Service in accordance with the 1947 National Health Service (Scotland) Act. Dundee Royal Infirmary closed in 1998 with its remaining functions moved to Ninewells Hospital (opened by the Queen Mother in 1974) and the buildings converted into flats. Designed by Robert Matthew Johnson-Marshall and partners, on the site of the stables of Invergowrie House, the protracted construction of Ninewells began in August 1964. Phase I of the building was completed in 1973, although some sections were not finished until 1975.

The Dundee Lunatic Asylum was established in 1813 (see page 68) supported by voluntary contributions, in Albert Street, Dundee, and opened in April 1820, when three patients were admitted. In 1875 it received a royal charter from Queen Victoria to become the Dundee Royal Lunatic Asylum. In 1874 the directors purchased land near the parish of Liff and Benvie for

No. 3756.

Madeline Flora Wilson ÆT. 35.

DATE.		Disease—with Detailed Symptoms.
1884. Statement		Chronic mania. Married. wife of Presbyterian Minister. For years insane. third attack. not epileptic, nor suicidal, but dangerous. n.q. her husband. Rev Geo Wilson. The manse. 60 Church Road, Canonbury London.
Med Cert I .1.		Bodily health good. mentally excited incoherent violent & idde LS Clouston. MD. Edinburgh 23 June 1884. Sanction of Board. Arthur Mitchell 24/6/84. Date of Sheriffs order. 12ᵗ June 1879.
History		Patient has been an inmate of the Royal Edinburgh Asylum for the last 5 years. for a year previous to this she was in the Private Asylum at Saughton hall. For the last four years she has been very excitable at times habits occasionally dirty. very noisy at intervals & is dangerous. is healthy. Kept fairly quiet during journey.
Pres Cond.		medium height, dark hair, fair complexion, nourishment of body good, has a wild restless look & seems very excitable

Oct 1896

Case notes from Dundee Royal Lunatic Asylum, 1884.

Edwin (Neddy) Scrymgeour.

the purpose of building a new asylum and the original one was demolished. Operations of the Royal Asylum were transferred to the National Health Service in 1948. In 1992 Royal Dundee Liff Hospital (RDLH) became part of the Dundee Health Care (NHS) Trust and when a new psychiatric unit was opened in 2001 in the grounds of Ninewells Hospital, the RDLH lost many of its services. Indeed, other hospitals, such as Maryfield and Strathmartine, have closed down completely since Ninewells was built.

Dundee always had a strong trade union culture and politically, the twentieth century was a period of flux. Prior to 1906, Dundee (a two-member seat since 1868) had elected only Liberal MPs since the 1832 Reform Act. In 1906 Dundee became one of two seats in Scotland to elect a Labour MP, namely Alex Wilkie, who would represent the city until his retirement in 1922. For most of his career Wilkie sat with the Liberal Winston Churchill, who considered himself to have a seat for life in Dundee. However, during his period there, Churchill managed to incur the wrath of the suffragettes (Ethel Moorhead, a Women's Social and Political Union activist, threw an egg at Churchill in Dundee) and alienated many of his constituents and the local press. In 1922 Churchill and the Liberals were routed in Dundee, with the city choosing to send the Prohibitionist Edwin Scrymgeour to parliament along with the noted Socialist writer E. D. Morel. In 1931 Dundee's electors

produced another surprise, electing the Unionist Florence Horsbrugh (the city's only ever female MP) and the Liberal Dingle Foot. Both would remain MPs until 1945, when Dundee returned two Labour MPs. For much of the subsequent 60 years Dundee appeared to be safe territory for the Labour Party, but at the 1974 General Election Gordon Wilson of the SNP captured Dundee East. Wilson held on until 1987, when Labour's John McAllion was successful. In 2003 the SNP gained the Dundee East Scottish parliament seat and two years later held the same seat at the Westminster elections. The SNP won both seats at the Scottish parliament elections in 2007, suggesting that Labour's days as the dominant political party in Dundee had come to an end.

While Council candidates in Dundee did not originally stand on party tickets, the Council had become more party-political by the start of the twentieth century, with the election of Labour and Prohibitionist candidates. In 1919 the non-party councillors (who in reality were mainly Liberals and Tories) grouped together to form the Municipal Electors Association and sought election to the Council as Moderates. Apart from two brief periods of Labour control in 1936–37 and again in 1945–47, the Moderates (later known as Progressives) would run Dundee until 1954. Thereafter it would usually be Labour that was the majority party until local government reorganisation in 1975 which established regional authorities. In the later 1970s and early 1980s the elections to the new District and Regional authorities tended to produce a situation where the Conservatives ran the Region, but Labour had a majority on the District Council. Since 1999 no party has had an overall majority on the City Council.

After the Second World War the increasing functions of local government meant that the existing system, dating from the 1929 Local Government Act, was no longer seen as effective. The Wheatley Commission, reporting in 1969, recommended a two-tier structure. Regional councils were given responsibility for the main functions of local government (including planning, water services, housing, roads, transport and the emergency services), whilst district councils were charged with administering local matters (such as building control, libraries, museums, environmental health and local courts). The intention to establish a Tayside region, including Angus and North Fife, underestimated the sheer strength of local loyalties and was met with such opposition that the proposal was abandoned in its original form. It was not until local government reorganisation in 1975 that Tayside Regional Council (wholly based north of the Tay, with northern Fife excluded) and Dundee City Council were established. The system stayed in place until the reorganisation

of 1996 removed the two-tier system of local government, and established the unitary authorities that exist today.

The inter- and post-war eras experienced a growth of consumerism, with an expansion of department stores, tea rooms, restaurants, cinemas and other leisure facilities such as public swimming baths. Film footage of the 1930s, held by Scottish Screen Archives, shows a city coping with depressed circumstances: ships in the city's docks, a parade in Baxter Park, boxing matches at Forfar, skating at Claypotts, Dundee FC playing at Dens Park, and the flight of the Maia and Mercury aircraft. Department stores, including D. M. Brown, McGill Bros, G. L. Wilson and Draffen's with its gracious coffee bar, and later Arnott's, were a feature of city life. Arnott's was the only one of the city's traditional department stores to see out the twentieth century, closing its doors shortly thereafter. Today, Debenhams is the sole remaining department store in Dundee, having taken over the Draffen's building in the 1980s, then moving to the rebuilt Overgate Centre in the early years of the new millennium.

By the mid 1960s, Dundee had many cinemas, including the Tivoli, in Bonnybank Road, which specialised in continental films and contained a coffee bar and licensed lounge bar. It advertised itself as 'The Cinema with the Club Atmosphere'. The ability to see art-house cinema in the city continued with the Steps Theatre behind the Wellgate Centre and the film theatres in Dundee Centre for Contemporary Arts (DCA). The DCA itself, built and opened in the late 1990s, provides evidence of the thriving cultural scene present in the city today.

Dundee did not have many beat cafés, but those it did have were popular. Between 1962 and 1965 the Haparanda Café, which opened in 1957, organised around 20 dances, known as 'the Hap Dances', usually with between 600 and 800 people attending. Over these years they were held in the Continental Ballroom, the Palais and the Chalet Road House, Broughty Ferry, and would feature local bands and musicians including The Paladians, Erle Blue Stars and Prohibition Pete. Dundee also had six bingo halls and two dance halls. The Dundee Ice Rink and another cinema were built off the Kingsway in the west of the city. Dundee Repertory Theatre (Dundee Rep), founded in 1939, was originally located in Nicoll Street in the city centre before moving to Dudhope Church in Lochee, and finally arriving in its current home in Tay Square in the 1970s. Throughout its history many famous names appeared at the Rep, including Virginia McKenna, Tom Conti, Michael York, Joanna Lumley, Arthur Lowe, Gregor Fisher (Rab C. Nesbitt) and local star, Brian Cox. From 1999 Dundee Rep received unprecedented Arts Council funding

to form Scotland's only resident ensemble company of actors, one of the most ambitious experiments in Scottish theatre for many years.

From the late 1980s Dundee underwent a regeneration during which the city centre was pedestrianised and former jute mills were converted into flats (including Upper Dens and Tay Works). The Cox Camperdown Works in Lochee, once the most extensive textile mill in the world, with the distinctive Cox's Stack, was developed into a leisure park containing a cinema, bowling alley, residential flats and a supermarket. For a time this development was a success, with packed car parks and crowded venues. Unfortunately the success proved fleeting and the final years of the century saw the area degenerate, with the closure of a number of the venues.

However, the stagnation of the developments at the former Camperdown works should not be characterised as typical. The rejuvenation that the city underwent from the late 1980s has transformed Dundee. The rebuilt Overgate Centre, the pedestrianised streets, the notable Public Arts Programme, and an influx of shops into the Murraygate has provided a positive sense of optimism within the city. The establishment of the Discovery Visitors' Centre alongside Captain Scott's ship and the renovation of Riverside Drive, have begun to draw Dundonians back to the waterfront. Upmarket hotels and apartments have been built alongside the frigate *Unicorn*, in the former docklands to the east of the road bridge. The area between the University of Dundee and the University of Abertay has been rebranded as the city's cultural quarter and encompasses the theatre, the DCA and various smart independent restaurants and shops. At the end of the first decade of the twenty-first century, Dundee is a rejuvenated and vibrant city; looking forward whilst retaining a sense of history and the past.

PART THREE

UNIVERSITY CITY 1900–2008
THE ARCHITECTURAL HERITAGE

AERIAL VIEW FROM THE RIVER, c. 1960

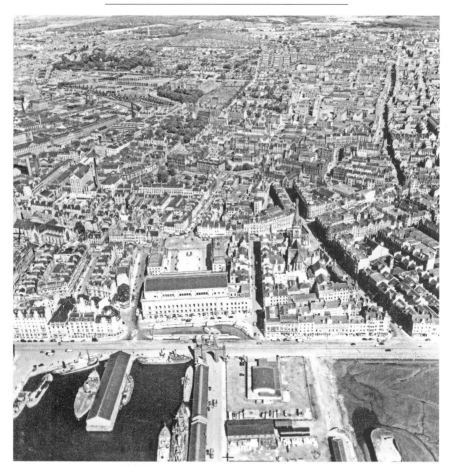

This photograph shows Dundee shortly before the removal of much of its innate character as a seaport. The King William IV and Earl Grey docks are prominent in the foreground, with the Victoria Arch serving as an ornate entrance to the harbour. The docks were soon filled in to provide the approach

roads for the Tay Road Bridge, opened in 1966 by the Queen Mother. The Arch was demolished as part of this process, and the rubble used as landfill. The inglorious spectre of Tayside House, designed by James Parr and Partners and built by Bett Brothers, now dominates the area.

Within the city itself much of the old medieval outline can still be seen at this point; the Overgate is clearly visible behind the city churches, although it was shortly to be demolished and replaced by a concrete complex – itself to be short-lived and which had vanished by the end of the twentieth century. To the middle right of the city panorama is the Wellgate, leading to the dense alleys of the Hilltown, both of which are virtually unrecognisable today, replaced by a modern, successful shopping mall and high-rise flats respectively. The Adam Town House has already vanished, demolished in 1931–32 and replaced by City Square. The centre of the town would also be greatly changed by the construction of the inner ring road, originally proposed by James Thomson in 1919, but not begun until the early 1960s, and not finally completed until late 1992.

The jute industry still had a heavy presence, as can be seen by the dense volume of mills towards the left. Within 30 years they would all be closed and the textile industry virtually dead. To the north of the city can be seen the rural hinterland of Dundee, which over the next four decades would experience increasing encroachment of the new housing schemes of Ardler, Kirkton and St Mary's, and the expanding suburbs of Downfield and Strathmartine.

JAMES THOMSON, CITY ENGINEER AND ARCHITECT

James Thomson (1852–1927) was the principal architectural visionary of twentieth-century Dundee. He had been working on city improvement under William Mackison since 1873, and once he became City Architect in 1904 and City Engineer in 1906, he took the opportunity to devise a much more strategic vision for the city along the lines of the 'city beautiful'. In 1910, he designed an enormously ambitious Civic Centre on the Earl Grey Dock and adjacent foreshore, with a central railway station and an enormous riverside park, together with significant improvements to the town centre. Of all this, only the City Square and the Caird Hall, begun in 1914 and completed in 1922, were completed.

With his assistants William Carless and his son Frank, he designed the St Roque's, Blackness and Coldside Libraries, and Barrack Street Natural History Museum. He also pioneered garden city housing with Logie and Craigiebank suburbs in 1919. Logie, the first council-housing estate in Britain, had an experimental district heating system. Thomson's interests in broader planning led to a structure plan that included a Tay road bridge (using the foundations of Bouch's ill-fated railway bridge), the provision of housing settlements to the north and east, and an orbital tram route running along the centre of an outer ring road – constructed as the Kingsway. In 1919, he persuaded the council to invest in 'the specimen house' to test the applicability of using electricity in household appliances. Its cost, however, took it above the level that could attract subsidy, so he moved into the house himself, to some consternation. His sons, Harry and Frank, were also talented architects.

JAMES THOMSON'S PLAN FOR THE SHORE

The palette for Thomson's ambition to create a 'city beautiful' in Dundee lay between the High Street and the harbour. He planned to give Dundee an urban quality worthy of a city of its size, and his plans went through several incarnations. This first plan, in 1910 (see next page), proposed the demolition of the area directly behind the Town House – namely the Vault and its surrounding dense housing and medieval closes – in favour of a new public market, topped by a roof garden, between Crichton Street and Castle Street.

The Town House being demolished by this scheme, Thomson proposed the construction of a majestic domed civic centre on the Earl Grey dock, which would have given Dundee one of the finest municipal buildings in Britain, in some ways comparable to what was then being built in Cardiff. Crichton Street was to be widened and straightened to provide an axial vista of the Civic Centre from the High Street, in the approved Beaux Arts manner. The competing railway stations and yards on the west were to have been amalgamated into a single *Hauptbahnhof*. The Tay Ferry terminal was to be moved from Craig Pier (which would have disappeared) to beside the new civic centre, and replaced by a formal landscape of an enormously expanded 68-acre esplanade parkland, which would have provided Dundee with perhaps

183

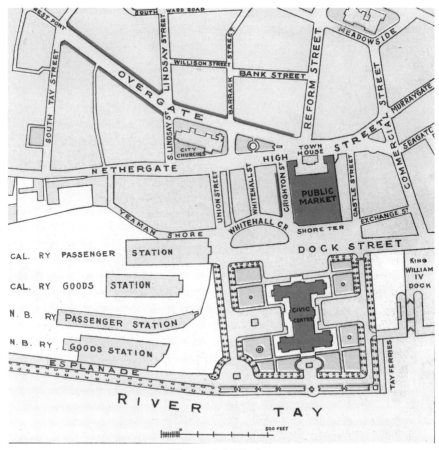

Thomson's 1910 plan.

Britain's largest Edwardian riverside park. Union Street was to be axially fo-
cused upon a tall statue near the Shore in the Esplanade, which would have
acted as the pivot between the vistas west and north. Later plans added a
concert hall. It was all very much in the mode of the plans for restructuring
Chicago designed by Daniel Burnham, whom Thomson had met in London
in 1910.

However, the Harbour Authority refused to release the Earl Grey dock,
so the proposed market gave way to the Caird Hall in 1914, following Sir
James Caird's gift of £100,000 for a new city hall to replace Kinnaird Hall.
The plans to transform Dundee into 'the Venice or Nice of Scotland' had been
opposed by the strengthening Labour faction, and once Thomson's chief
political ally, Rev. Walter Walsh, had left for London in 1913, the political
momentum slackened. When James Caird offered to pay for a new city hall,
(or for most of it), the Town Council proceeded with that and abandoned the

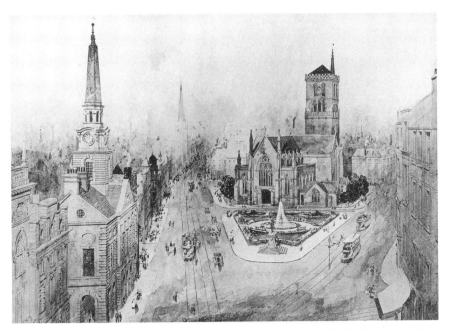

James Thomson's vision for the centre of Dundee with the removal of the Luckenbooths.

rest. So the only part of Thomson's plan to be carried out was the removal of the Vault district and the Town House, and its replacement by City Square and the Caird Hall.

JAMES THOMSON'S CIVIC CENTRE

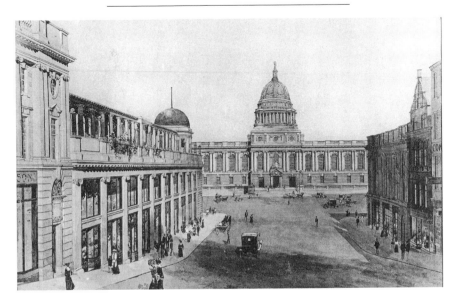

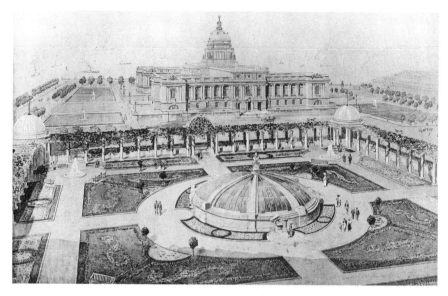

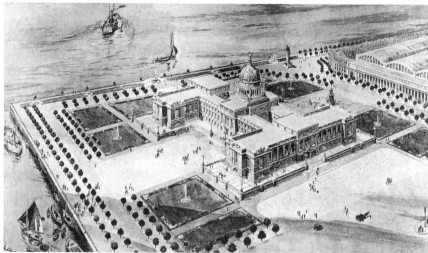

Top: James Thomson's Civic Centre. Bottom: Thomson's plan for the shore.

The centrepiece of James Thomson's vision for Dundee was the grandiose domed civic centre located on the Earl Grey Dock. By 1910, William Adam's Town House was considered to be too shabby and unbecoming for a city of Dundee's size and importance, and Thomson's design, strongly influenced by Burnham's for Chicago, was the perfect replacement. Its enormous scale and classical dignity were intended to give visitors arriving by sea or by rail a powerful first impression of Dundee. Its setting, with tree-lined walks and fountains, was intended to enhance its solemnity. The main route from High

Street to civic centre was to be a widened and realigned Crichton Street with, on its east side, a three-storeyed public market, somewhat in echo of Edinburgh's Waverley Market, capped by a beautiful roof garden, all in Thomson's ponderous classical manner.

Thomson also planned a rebuilt Overgate, a smartened High Street, and the removal of the Luckenbooths from the junction between the Overgate and High Street, thus clearing the view west to the city churches, and giving them a suitably Edwardian setting. He would later propose removing the Town House to this site.

Thomson's vision for Dundee would have given the city a formal urban dignity that it had failed to achieve a century earlier, when the other important Scottish towns acquired their polish.

Demolition of the Strathmartine's Lodging, the Vault and The Town House 1910–32

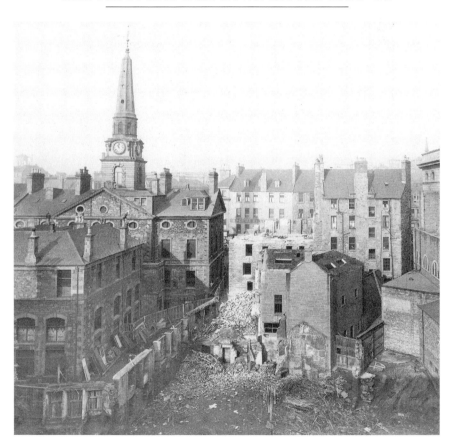

One of the few parts of James Thomson's 1910 scheme to be promptly enacted was his plan to remove the Vault – the warren of streets and buildings between the rear of the Town House and the Greenmarket.

Thomson had intended that this area would be occupied by his public market with its rooftop garden, but in the end it was an entirely different structure (albeit one designed by Thomson) that would arise like a phoenix from these ruins. The building was the classical Caird Hall, named for Sir James Key Caird, one of Dundee's greatest benefactors. Begun in 1914, when

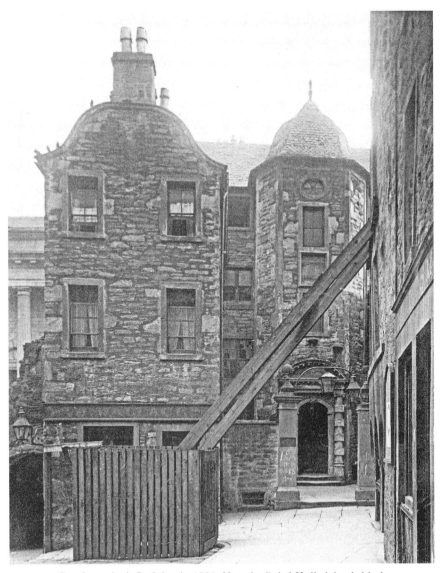

Strathmartine's Lodging in 1930. Note the Caird Hall rising behind.

King George V and Queen Mary travelled to the city to lay its foundation stone, it was not completed until 1922, mainly as a result of the intervention of the First World War.

Unfortunately Caird's building came at a cost, for he presumed that it should replace the Town House which would then be demolished. Additionally, it was decided that the new hall should be fronted by a new city square, which necessitated the removal of the Town House itself (although for a while it was considered possible that it might be rebuilt elsewhere). This was a highly controversial decision, as the 200-year-old building was popular with the citizens of Dundee.

Prior to Sir James Caird's death in 1917 the local historian Dr A. H. Millar tried to persuade him that the Town House should be saved. According to Millar, Caird finally decided that this was desirable, but died a few days later without communicating his wishes to the Council. Consequently plans went ahead. For a few years Millar and others strived to save the Town House. However, by 1931 the Town Council (which had abandoned the building for a new council chamber in the basement of the Caird Hall some years earlier and would move to new chambers later in the decade) argued that it was unsafe, had the spire removed and claimed the remaining building was dangerous. It was claimed that the removal work would create work at what was a time of severe unemployment in the city. The world looked on with disbelief at what was widely considered an act of desecration and architectural vandalism. The *Scotsman* was one of several newspapers which was very critical of the plans, and even the government was not entirely happy. In January 1932 the First Commissioner of Works, William Ormsby-Gore MP (Conservative) went so far as to have his department draw up a letter to the Town Council, which he ordered be reprinted in the press, making it clear the department did not approve of the demolition of the Town House. Doubt was also cast on the Council's argument that the building was dangerous and a threat to public safety.

Yet the Council stood firm and in 1932 it was demolished. Within a few years a new square had been laid out, with the Caird Hall being flanked by new buildings including a new city chambers.

LOGIE HOUSING SCHEME, 1920

Many of the major building developments in Dundee between the end of the First World War and the 1960s were council-housing schemes. Begun in 1919, before the passage of the Addison Act, Logie was not only the first council-house

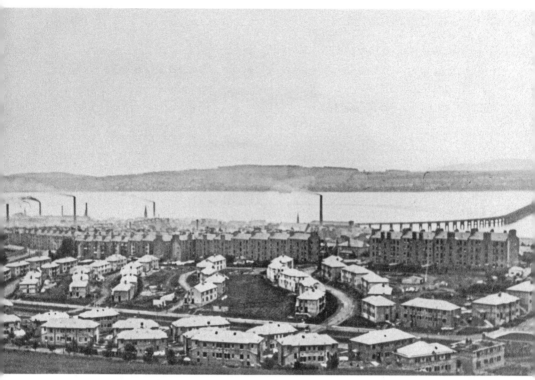

Logie Housing Scheme, 1920.

scheme in Dundee, but also the first such development in Britain. Designed by James Thomson in his role as city architect, the scheme was built in what was then a semi-rural area, although building expansion has meant that this element has been lost. In contrast with the tenements which dominated the background, the four-in-a-block flats were well spaced out and had reasonably sized gardens, giving the area the feel of a leafy green suburb.

This aura was reflected in the names of the streets in the development, which were called after trees and included Sycamore Avenue, Elm Street and Lime Street. Interestingly, this was not the original plan. The streets were to have had names like Haig Street, Kitchener Street and Beatty Street to commemorate British heroes and the First World War. This was opposed by Councillor John Reid, a leading member of the Labour group on Dundee Council, and after further consideration the Council's Works Committee decided to opt for less controversial themes.

The problem with Logie and other early council-housing developments in Dundee (including Taybank and Craigiebank) was that while they were intended to provide better housing for the city's working classes, they were expensive to build. Consequently their rents ended up being much higher

than those of the tenements. Thus these houses were simply too expensive for ordinary workers to afford. As a result, they came to be inhabited by tenants who were employed in skilled or clerical work or who were employed in industry at a supervisory level. As a result Logie, Craigiebank and Taybank all had an almost middle-class feel to them, which would persist until late in the twentieth century.

KINGSWAY C. 1950

What became the Kingsway was devised by James Thomson in his 1919 plan for Dundee. It was an outer, dual-carriageway ring road looping round the north of the city, with trams running on the central reservation, like the Boulevard in Glasgow. The pioneering feature of the Kingsway was that it formed a circular bypass, which led to Thomson being consulted on similar bypasses elsewhere in Britain.

The trams, however, which would have provided Dundee with an excellent public transport system, were never developed along the Kingsway, probably because it was too far away from the then centres of population. The two trams that can be seen in the background crossing the Kingsway (over a roundabout) were travelling along Strathmartine Road en route from Downfield to the city centre. By 1950, trams in Dundee were dying.

The tramway network had shrunk for the previous two decades, and the fleet of tramcars was ageing and in need of replacement. Since buses were proving a more flexible alternative, the last tram in Dundee ran on **20** October **1956**.

Work on the Kingsway had begun shortly after the end of the First World War, and the final section, from King's Cross to Invergowrie, begun in **1930**, finally connected the main roads to Arbroath and Perth, enabling motorists to bypass the city centre.

Other than the suburb of Downfield, which had grown around Baldovan Railway Station in the nineteenth century, there were few houses to the north of the Kingsway when it was begun. Although many of the houses then built facing the Kingsway itself were middle-class villas, Thomson's strategic plan for the city had proposed major urban settlements to its north, and large council-housing schemes – such as Kirkton (traces of which are visible in the background of this picture), Fintry and, later, Ardler – began soon thereafter.

Watson's Bond Fire

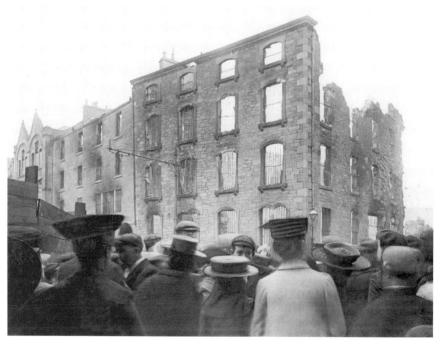

The premises of James Watson and Co., Wholesale Whisky Merchants, occupied a spacious site corner of Trades Lane and Seagate, with a 60-foot frontage and covering 'a large acreage'. In 1906 the firm employed around 300

people. On the evening of 19 July 1906 an employee of the company who was passing the building noticed smoke emerging from its roof. By the time the fire brigade arrived the building was ablaze. The situation was made worse when large vats of whisky caught fire and exploded, causing flaming alcohol to rain down on the surrounding streets. The inside of the building was soon gutted, and the walls were left standing precariously.

Fanned by extraordinarily high winds, the blaze was so bad that firemen were called in from as far away as Edinburgh in a desperate attempt to stop the fires spreading to other buildings. Despite the firefighters' best efforts, the fires raged all the next day and spread to other buildings. The flames destroyed the Candle Lane premises of another whisky merchant, John Robertson and Son Ltd, before burning two jute warehouses in Trades Lane. At the time it was estimated that at least £450,000 of damage had been caused by the fire.

People came from across the city to witness the blaze and its aftermath. Workmen from the city engineer's department began urgent work to remove the dangerous ruins of 'the Bond' on 20 July, even as the fire continued to burn in neighbouring buildings.

HAWKHILL

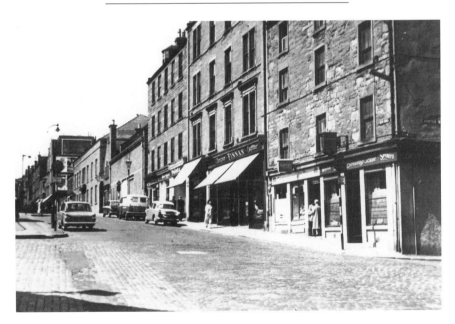

Under the 1952 City and Royal Burgh of Dundee Survey and Plan, Hawkhill was proposed for complete eradication. Until the late 1960s it had been a

relatively densely populated and thriving part of Dundee, dominated by old tenements, many of which had small, family-run shops occupying their bottom floor. The shops at this section of Hawkhill included the butcher's shop owned by William K. Fitzgerald, who became Lord Provost of the city in 1970. The Hawkhill ran into the Overgate, providing a practically unbroken series of little shops leading all the way to the city centre itself.

Hawkhill was effectively isolated from the town centre by the creation of the 1960s Overgate centre and the inner ring road. Its ultimate fate was sealed, however, when it was sundered at its junction with Bellfield Street – from here the eastern half became a cul-de-sac and its name was changed to Old Hawkhill. The name 'Hawkhill' was appropriated by the new dual carriageway which extended from the western half and curved to the north of the Old Hawkhill, eventually meeting the inner ring road beside the West Port.

Today only two small sections of the old Victorian Hawkhill remain – the apartments at the western end that run down towards Blackness Library, and the area around the West Port. All the rest – the tenements and factories – has been demolished to make way for industrial units or university buildings. Indeed, the whole area between the 'old' and 'new' Hawkhills has been colonised by the University of Dundee. The buildings housing the university's life sciences college and schools – which have been so important in the reinvention of Dundee – are located along the end of Old Hawkhill; and with the large-scale post-2003 expansion of the university campus, Old Hawkhill leads to a number of the new showcase buildings, including the Dalhousie Building, the Queen Mother Building and the Sports Centre Extension. Further down, the new shops, galleries and delicatessen/restaurant beside the West Port have changed the character of the area and themselves owe their existence in part to the expansion of the campus.

G. L. Wilson's Department Store

Until the 1970s Dundee had a number of locally owned, successful department stores in its city centre. Notably three of the four corners of the intersection of Murraygate and Commercial Street were occupied by three major family concerns: D. M. Brown's, Smith Brothers' and G. L. Wilson's. The last of these three, known locally as 'the Corner', was founded in 1894 by the Fife draper Gavin L. Wilson. After his death the business passed to his sons, including Sir Garnet D. Wilson, who served as Lord Provost of Dundee from 1940 to 1946 and was one of the most prominent figures in public life in Dundee in the

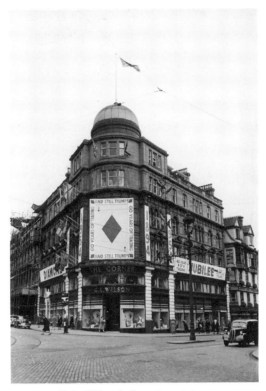

G. L. Wilson's department store.

mid twentieth century. Wilson was a prominent figure in the Liberal Party in Dundee and played a significant part in the decision to run an Independent Liberal against Winston Churchill in 1922, a key factor in Churchill's defeat. As Lord Provost, Sir Garnet played a part in securing an airport for the city and a key role in persuading the National Cash Register Company to move to Dundee. He also served as a popular wartime civic leader.

'The Corner', in common with its contemporaries, extended over several floors. In its heyday, like the other major department stores in the city, it would also feature elaborate displays on its frontage such as the one above to mark the diamond jubilee of the firm in 1954. However, the firm and its contemporaries were increasingly being challenged by national chains such as Woolworths, which opened a store in Dundee in 1924. This competition eventually killed the local department stores. Some, such as Draffen's and D. M. Brown's, would be absorbed by bigger firms, but most, like G. L. Wilson's, simply ceased trading as retailers. The buildings these grand firms occupied generally still stand, but have undergone radical alterations and subdivisions which leave visitors to Dundee with little clue as to their original purpose.

ALHAMBRA CINEMA

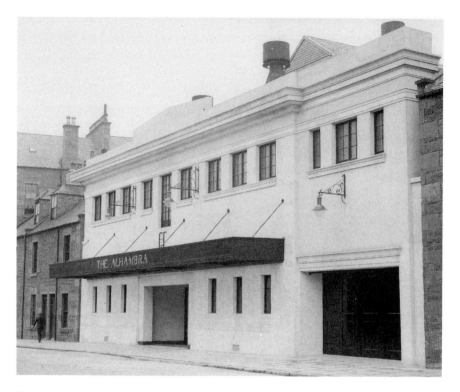

Between 1900 and 1960 more than 60 different establishments of various sizes that showed films sprang up across the city. Some, like the massive Green's Playhouse in the Nethergate, or the elegant La Scala in the Murraygate, were located in the city centre, but many others were located in the suburbs, particularly in the Perth Road, Blackness and Hawkhill areas. Among these was the Alhambra, opened at 12 Bellfield Street in 1929 on the site of the Queen's Cinema (which had closed in 1928) designed by Frank Thomson, the son of former city architect James Thomson. The Alhambra could seat 1,039 and from 1937 onwards was also used as a venue for live theatre.

By the late 1950s the arrival of television affected attendance and a number of cinemas closed. While many were demolished or converted into bingo halls, the former Alhambra had a different fate. In the 1960s Dundee had been left with virtually no theatres and a movement for a new public theatre to be opened in the city developed. One of the leading backers of this movement was Bailie Alexander Mackenzie, who was leader of the Progressive group on Dundee Council and who in 1967 became Lord Provost. Under Mackenzie's influence, the Council purchased the former cinema and

converted the building into the new Whitehall Theatre, opened in 1969 and still a major entertainment venue in the city.

The front of the Alhambra as seen in this picture is still recognisable as the Whitehall of today, but the surrounding buildings have long since been demolished.

GREEN'S PLAYHOUSE

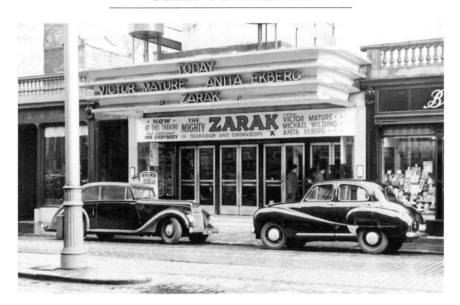

Of the 30 active cinemas of Dundee in the 1930s, Green's Playhouse in the Nethergate was by far the most impressive. George Green had moved from fairground showmanship to cinemas and, in the Glasgow Playhouse, had built the largest cinema in Europe. It was designed by the Glasgow cinema architect, John Fairweather. Green then moved with Fairweather on to Dundee, and the Dundee Playhouse opened its doors to customers in 1936. This iconic building sat an incredible 4,126 people, making it the second-largest cinema in Europe and testimony to Dundee's particular fondness for films. The screen measured 30 feet 3 inches by 22 feet.

Obsessed with showmanship and carnival, Green encouraged the use of neon to create a magical atmosphere by day and night. From the street, the Playhouse was identified by its tall 'fin' or advertising tower, which at 90 feet was thought to be the tallest in Europe, whose colours would change at night. The 'U' of 'Playhouse' was always at a rakish angle.

The tower and the front of house – much more distinctive than Glasgow's – were probably designed by Fairweather's nephew George, originally from

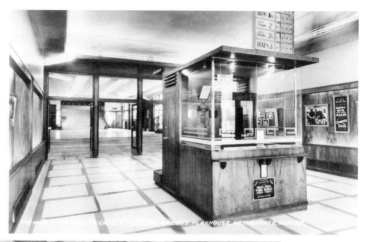

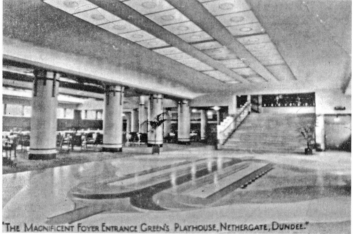

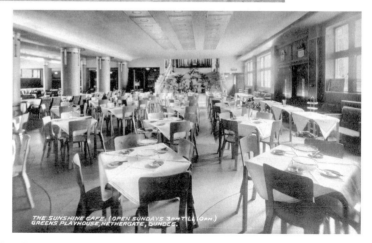

Interior of Green's Playhouse. From top: the box office, the entrance foyer and the Sunshine Cafe.

GREEN'S PLAYHOUSE, Nethergate, DUNDEE		POST CARD
Monday Sept. 7th 6 days	**GIVE US THIS NIGHT** (U) Jan Kiepura and Alan Mowbray. NEVADA (U) From the Novel by Zane Grey Larry (Buster) Crabbe and Kathleen Burke. Colour Cartoon: Spark Plug	FOR ADDRESS ONLY
Monday Sept. 14th 6 days	**DANCING FEET** (U) Ben Lyon and Eddie Nugent and Joan Marsh. MAN HUNT (A) Ricardo Cortez and Margaret Churchill. and Full Supporting Programme	
Monday Sept. 21st 6 days	All the way from Erin's Isle **LAUGHING IRISH EYES** (U) Phil Regan and Evelyn Knapp. Irish Songs, Irish Music and Irish Dances, etc. MURDER ON A BRIDAL PATH (A) James Gleason and Helen Broderick and Full Supporting Programme	
Monday Sept. 28th 6 days	**Happy Days are Here Again** (U) The Famous Houston Sisters and Violet Compson and Herbert Cameron. I CONQUER THE SEAS (A) A Drama of Newfoundland Stanley Morner and Steffi Dunn and Full Supporting Programme	
Playhouse Cafe Open Daily—10 a.m. till 10 p.m. Sundays— 3 p.m. till 10 p.m.		

Programme of shows at Green's Playhouse.

Montrose but by then working with Joseph Emberton on the most advanced leisure buildings in Britain – the Blackpool pavilion. Notable interior features included a splendid marble staircase which led up to the balcony, the balustrade lit by neon as though it were a Busby Berkeley film set. As well as showing films, the cinema had a popular tearoom with its own dance floor, and a restaurant open on Sundays, when the cinema was closed. Like its Glaswegian counterpart (which was burnt after a boxing match), it was also used as a venue for live entertainment, and latterly as a bingo hall. By the early 1960s, the cinema was used more often for bingo than for films, and ultimately it was turned into a bingo hall permanently. The tower lost most of its character when it was encased in ribbed grey metal in the 1970s, and any hope that the Playhouse might be restored to its former glory ended on 26 August 1995, when it was completely destroyed by a massive fire. The new bingo hall in its place has little of the quality of its predecessor.

THE PRINCESS CINEMA

The Princess is one of several Dundee cinemas of which no trace now remains. Located in the Hawkhill, it was opened in 1918 on the site of an earlier cinema, the New Hippodrome. Its frontage was fairly attractive, with its name spelt out in large letters and some vaguely classical decoration. Although from the outside it appeared fairly small, it was designed to be capable of seating

199

The Princess Cinema.

1,000 persons. This number eventually had to be reduced to 650 for safety reasons and to comply with new fire regulations. Cinema safety was a big issue in Scotland following the deaths of 70 children who were crushed and suffocated in an attempt to escape from a suspected fire at the Glen Cinema, Paisley, on 31 December 1929.

The Princess was cited by former film censor Audrey Field as a typical example of a 'family' picture house. From 1928 until it closed the Princess was run by Miss Minnie McIntosh, who pioneered children's club showings on Saturdays. Her father, W. D. McIntosh, had bought the New Hippodrome in 1917. He was a strict teetotaller and wanted to own a cinema so as to offer locals an alternative to drink. With audience numbers falling, closure came in 1959 and the building, like much of the Hawkhill, was demolished to make way for the expansion of the University of Dundee's Campus.

While Dundee had once had a preponderance of cinemas like the Princess, when the Victoria cinema in Victoria Road closed in 1990, the Cannon Film Centre (built on the site of Her Majesty's Theatre and Opera House and formerly known as the ABC Capitol) was left as the only traditional cinema in Dundee. The Cannon itself closed its doors for the last time in 1998, leaving Dundee with only the new multiplex cinemas which have opened on the outskirts of the city since the late 1980s, and the two theatres in Dundee Contemporary Arts.

BUSTER STALL

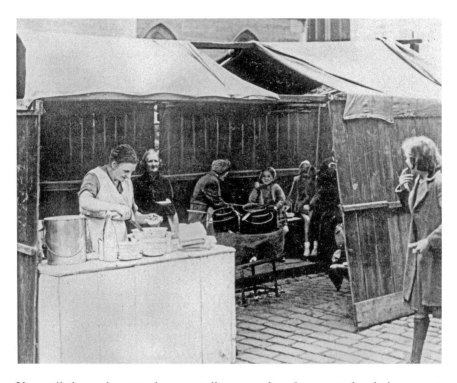

Up until the early 1960s buster stalls were taken for granted as being a part of life in Dundee, yet within a few years they had completely vanished from the city, and have been largely forgotten. Indeed, many Dundonians today would have no idea what a buster stall was, let alone what it looked like. They were effectively Dundee's first fast food outlets. The delicacy that they sold was a 'buster' –a dish that consisted of chips accompanied by semi-mushy peas (which had been boiled in vinegar and water).

The success of these stalls lay in the fact that they provided a nourishing but relatively cheap source of food for customers, making them attractive to those with a limited budget. Their demise can be said to reflect changing tastes and the emergence of modern cafés and restaurants that sold reasonably priced meals. Arguably, their legacy can be felt in the vast number of cafes, food courts and fast food outlets that are to be found in the centre of Dundee today. This part of the Overgate, in front of the city churches, was always thriving with people until it was removed in the 1960s to make way for the Overgate Shopping Centre.

Ardler High-rise Flats

Perhaps no 1960s housing scheme better exemplifies the brief success but ultimate failure of the attempt to create accessible modern housing for all than Dundee's Ardler housing scheme. The scheme consisted of multi-storey blocks, four-storey apartment blocks (or 'walk-ups') and maisonettes. Building began on land acquired from Camperdown Golf Club in 1964 and the estate was opened to its first residents from 1967. The centre of the scheme had shops, a community centre and library, and a church created from the old Chalmers Church, which was uprooted from its Hunter Street location beside the university campus.

The scheme was dominated by the six multi-storey blocks, each of which contained three connected blocks. There were thus eighteen courts, all of which were named after a British golf course, beginning with Baberton and ending with Wentworth. The total number of dwellings in the multi-storey blocks was 1,788. Located on the high north-west corner of Dundee, they were an imposing sight and at night became an impressive symbol of Dundee's modernisation. For the majority of the first-time occupants the flats were an improvement on their previous dwelling, with bigger rooms and a new luxury, an inside toilet!

Ultimately, high-rise flats, the utopian vision for housing in the 1960s, were seen, towards the end of the century, as a social and domestic disaster. There were various reasons for this – poor planning and design, inadequate

maintenance, inferior quality of the building material, insufficient community facilities and the anonymity and alienation that resulted from such a concentration of people were all factors – but the most important by far was the change in society during the latter half of the century. As incomes and families grew, the flats were seen as no longer adequate, and the new emphasis on home ownership during the post-1979 Conservative government resulted in a greater societal polarisation. Those who could, bought houses, while the Ardler flats increasingly became inhabited by poorer Dundonians. Isolation from the centre, high levels of unemployment and a rise in the number of single-parent families led to a breakdown of any semblance of community and in particular the multi-storey blocks were affected by vandalism and anti-social behaviour. Installing security guards in each court during the mid 1980s and later building high fences around all the blocks did not prevent the decline. Instead they added to the image of an urban ghetto. By the 1990s Ardler was seen as one of the worst areas of Dundee.

The City Council had no option but to demolish the scheme and the multi-storey blocks were spectacularly destroyed by controlled explosions, the last being demolished in 2007. A scheme to create a new Ardler Village was conceived by Dundee City Council in partnership with Sanctuary Scotland Housing Association, George Wimpey Homes and HTA architects, and work commenced in 2000. The area has now been transformed beyond recognition.

WHITFIELD

Started in the late 1960s and developed further in the 1970s, Whitfield, to the north-west of Broughty Ferry, was one of the last council-housing schemes to be built in Dundee. The distinctive hexagonal design of its first phase concealed potential problems caused by the lack of shops and other social amenities, compounded by a lack of public transport. Most of the original hexagonal blocks of elongated walk-up flats were demolished or renovated from the late 1980s onwards, though some remnants can still be seen today from aerial photography and high-resolution satellite images. Those that survived became part of the pioneering Dunbar Park development, the transformation of nearly 400 houses into new accommodation for sale, rent or housing association use. These buildings have pitched roofs, colourful new elevations and improved security. The area was further improved by creative landscaping and the development of recreational areas for children. Between 1944 and 1971 approximately 37,000 council houses were built in Dundee,

Whitfield.

with a further 3,000 built in the early 1970s. With the census recording a population of c. 180,000 in 1971, this indicated that a significant proportion of Dundonians lived in council housing at that time. Following demolition programmes and the introduction of the 'right to buy' scheme, only around 15,000 houses are now available to let by the Council.

CLAYPOTTS

The lands of Claypotts were first mentioned in a 1365 charter of liberties by King David II, and once extended over a sizable area of land that stretched from where the wind turbines now spin in Douglas through what is now West Ferry to the shores of the Tay. The name 'Claypotts' today tends to refer to the castle and to a small area immediately around it.

Claypotts was a fourth-rank seat, extended for the Strachans in the most contemporary 'Marian' (i.e. French) manner c. 1566. It consisted of a circular tower for public use with a chapel and a public staircase in one corner, and another for family use in the opposite corner, with a smaller stair for household use. Both stairs led up to a small gallery in the roof, once adorned with splendid dormer windows and a viewing platform at each end. It would have been surrounded by an inner court. However, c. 1587 (for Pont sketched it with its towers decapitated) it was 'Scottified' by the imposition of two elegant, rectangular studies on top of the round towers. It appears to have fallen into farm use by the eighteenth century, when the inner court buildings were converted accordingly, and the house was no longer occupied. The farm buildings beside the castle have since been demolished, private houses and apartments have spread around the castle almost right up to its front door, and the crossroads

has disappeared to be replaced, first by a large roundabout, then during the 1990s by a large and rather complicated junction. Indeed at their present junctions with the A92, Baldovie Road and Claypotts Road are no longer directly opposite each other. Across the road from the castle we can make out the corner of what is now an open green area in a slight depression that until the 1960s was flooded during each winter to provide a free community skating rink. The petrol pumps belong to Claypots (*sic*) Garage, which disappeared during the redevelopment of the junction. The east side of Baldovie Road has been developed as an area of commercial and industrial units. More recent additions to the area near the Arbroath Road (A92) corner are a major supermarket (Sainsbury's) and a fast food restaurant.

The Docks, 1954

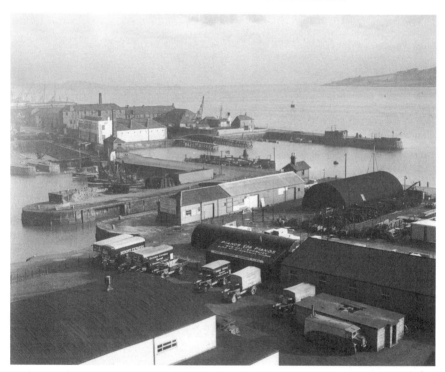

The main structural weakness of the King William IV and Earl Grey docks was that they were too small for modern shipping, having been designed for early nineteenth-century ships. By the 1950s the once-thriving harbour in this photograph of William IV dock was in decline. Dundee's fortunes as a port floundered after the Second World War, as coastal shipping was no longer financially viable or able to compete with the freight services of the

roads and railways. Dundee's main shipping company, the Dundee, Perth & London, would end all coastal traffic around 1960, briefly chartering a goods train to offer a freight service to London. Ultimately, DP&L was able to survive by diversifying its interests into other sectors, including travel agencies. The other reason for the harbour under-utilisation was the continuing slow decline of the jute industry, now entering its dying throes. There simply was no longer the volume of raw jute from Bengal to sustain a large harbour. The freight generated by the new light industries arising from the US inward investment after the war was largely road- and rail-based.

This photograph shows some of the few remaining fishing vessels docked in the background and the Dundee Express Removals company in the foreground, presumably originally based there to take advantage of the space and the freight and warehouse traffic once generated by the harbour. They were therefore very vulnerable to closure and, as recommended in the 1952 Development Plan, around a decade later these docks were cleared (Earl Grey dock closed in 1963) and filled in to provide the approach to the Tay Road Bridge, opened in 1966.

Dock Street and King William IV Dock

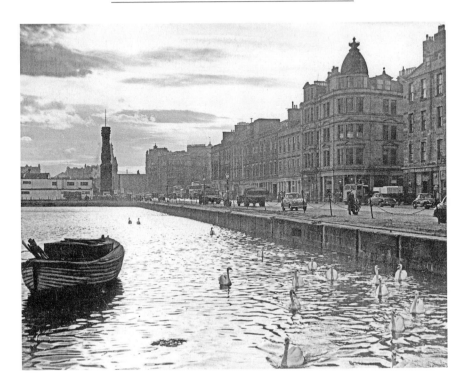

The photograph on the previous page displays the once important connection of the centre of Dundee with its harbour, which was lost when this area was extensively redeveloped in the 1960s. A lone drifting craft and settled flock of swans indicate the level to which activity had declined. A peaceful scene, but one that represented a city that was about to lose much of its character as a seaport. Also visible are two of the most significant Victorian structures in Dundee, the Royal Arch and the West Railway Station. Both were gone within a few years of this photograph being taken, along with the dock itself. They were all victims of the construction of the Tay Road Bridge and its approaches.

Another lost feature which can be seen in the background is the former Corporation Bus Terminal on Shore Terrace, from where many of the city's green-liveried bus fleet commenced their journeys. The bus fleet passed to Tayside Regional Council in 1975 and was later successfully bought out by its employees, before becoming Travel Dundee. The bus stance itself was removed in the 1970s but partially restored in more recent times.

At the end of the twentieth century this scene would be dominated by a large concrete edifice, Tayside House, built as the headquarters of Tayside Regional Council. Although some of Dundee's docks survived, by the 1990s the port generated minimal traffic and plans were made to convert much of the remaining harbour area into residential and commercial developments. This process would continue in the early years of the new millennium.

DUNDEE EAST RAILWAY STATION

Of the three main railway stations in the city, Dundee East (originally simply known as the Dundee and Arbroath Railway Station) was by far the smallest and in many ways the least important. While Tay Bridge and Dundee West Stations offered trains to Glasgow, Edinburgh and England, the East's trains consisted almost exclusively of commuter services to and from the eastern suburbs and the Angus towns of Arbroath, Forfar and Kirriemuir. However, this commuter traffic was enough to keep the station fairly busy. The East Station's original appearance was noticeably altered in the interwar period, when the original attractive ironwork gable end was replaced by a wooden façade in a vaguely art deco style, presumably to give what was a fairly basic building a more modern appearance. Nonetheless it still paled in comparison to the magnificent West Station (as the former Caledonian eventually became known).

The station did not survive in this form for long. After nationalisation of the railways a number of Dundee to Arbroath services were diverted to the

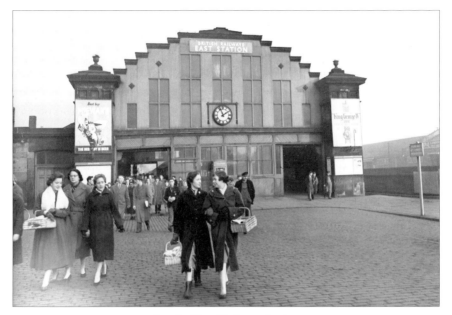

Dundee East Railway Station.

larger Tay Bridge Station. Around the same time the branch to Forfar closed
to passenger traffic, thereby slashing the number of trains which called at
the East Station. Unsurprisingly, this made it unviable and all its remaining
trains were diverted to Tay Bridge Station in January 1959. The East Station
then closed and was eventually demolished. A car showroom now stands in its
place and the only clue that there was ever a railway station in this area is a
set of disused and rusting railway tracks behind it that branch off from the
main Arbroath to Dundee line just before it enters Dock Street Tunnel.

DEMOLITION OF THE OVERGATE, 1960S

Demolition of the Overgate had probably been first envisaged in the city
improvements of the 1870s, and when it was finally demolished in the 1960s,
it was the last act of the removal of Old Dundee that had begun almost a
century earlier. James Thomson had proposed the Overgate's demolition in
1910, Thomas Adams again in 1933 and there were several other proposals
before the Second World War. The 1952 Development Plan aimed to anni-
hilate it and replace it with a pedestrianised shopping centre like Bristol's
Broadmead by Ian Burke. Although the Overgate, Tally Street, Thorter
Row, Mid Kirk Wynd and the Luckenbooths together contained Dundee's
largest surviving swathe of historic fabric, some dating back to the medieval

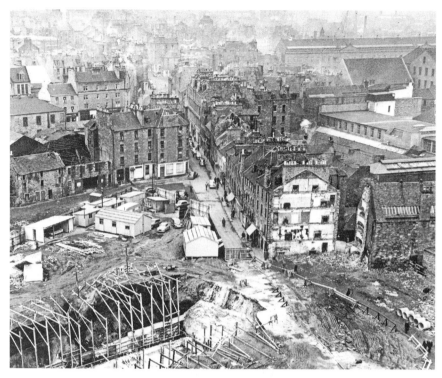

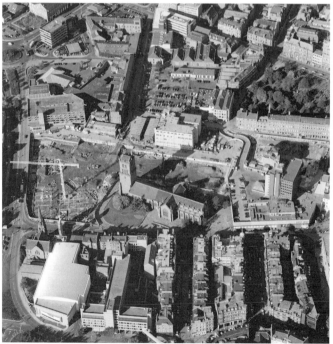

Two aerial views of the Overgate under demolition.

period and much to the sixteenth or seventeenth centuries, not a single one of its structures was identified in the Development Plan as worthy of retention. The only significant buildings to survive were the city churches.

The Overgate had had a reputation for overcrowding and slum conditions, but most of its residents had moved out to north Dundee by the 1950s, so records of dreadful conditions must be counterbalanced by the recollections of buildings in good commercial occupation with many historic features – such as tunnels running beneath the street and a barrow market in Kirk Style Wynd. Doubtless the preservation of the area would have entailed substantial work; but preservation was not the ethos of the time.

Dundee was being driven by the pursuit of modernity in the attempt to build a new city in the face of the collapse of its jute economy. There was anticipation of what promised to be a new start for the city, represented by the Angus Hotel and the Overgate Shopping Centre. This combination of enthusiasm for the future and regret for demolition of the historic buildings attracted much interest from the public and press. Unfortunately, many were to be disappointed by the poor quality of the much-vaunted new Dundee for which they had sacrificed their heritage.

The Overgate

The first town-centre redevelopment of its type in Scotland, the new Overgate was a pedestrianised area incorporating thirty-six shops and two major stores (Littlewoods and C&A, both now departed from the city), a supermarket (operated by William Low – a successful Dundee-based chain which was taken over by Tesco in the mid 1990s), a ten-storey office block and a hotel. It was designed by Ian Burke, Hugh Martin & Partners in a manner

expressive of post-war progress and modernity – spacious horizontality clad with grey concrete panels. The original tight urban structure of this district was replaced by a hard-edged vacuum, insensitive in its relation to St Mary's. The shopping centre also blocked all the ancient routes between the Ward Lands and the Nethergate, and severed traditional moving and shopping patterns. This image, looking roughly westwards towards the Angus Hotel, illustrates its concrete structure. The new Overgate was never very popular in the city, the main complaint being its lack of atmosphere, resulting from its alien scale and harsh concrete panels, and it soon became windswept and damp-stained.

Once the entirely enclosed Wellgate Centre, by James Parr & Partners, had opened on the site of the Wellgate Steps at the top of the Murraygate in the late 1970s, Dundee's shoppers moved with it. Thereafter, the only shops in the Overgate to thrive were the ones clustered nearest to the High Street, for the area towards the hotel became gradually more deserted as fewer and fewer businesses chose to occupy its units. The hotel and the majority of the shopping units were finally demolished in the late 1990s to make way for a second Overgate shopping centre in 2000. Entirely enclosed, the second Overgate centre comprises a single, mostly two-storeyed mall with a vast glass façade curving round the city churches. It is considerably more sympathetic to its historic location (though the Ward lands to the north remain blocked) and has proved popular, especially with the younger generation. This has, once again, affected the balance of shopping in the city, attracting shoppers westwards again and thereby causing problems for the Wellgate.

KING STREET AND COWGATE

Although still recognisable since the photograph opposite was taken, this area has undergone fairly radical change since the 1950s. The buildings on the north side of the foreground once backed onto Bain Square and were removed along with the Wellgate in the early 1970s to facilitate the construction of the Wellgate Shopping Centre. This was Dundee's largest shopping centre when built, and featured an ornate clock and fountains. It was adjoined by a large multi-storey car park, a relatively new feature of Scotland's shopping landscape. The centre was given a fairly expensive makeover in the early 1990s and was further altered in the early twenty-first century. Much of the housing seen in the background in King Street was demolished and replaced around the time of the Wellgate Centre's construction. To the right

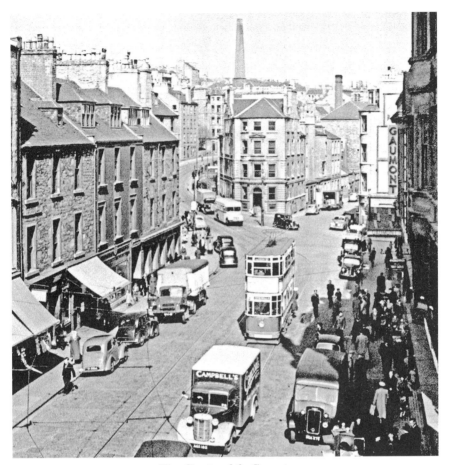

King Street and the Cowgate.

of the picture can be seen the Gaumont Cinema, formerly the King's Theatre, designed by Frank Thomson, son of James Thomson, the city architect. Like many of Dundee's former cinemas, this was converted into a bingo hall.

Two features date this scene: the large Wills Capstan advertisement and the tram heading towards the city centre from Maryfield depot.

BERNARD STREET

This small residential street of fairly modest tenements, situated between the Hawkhill and Springfield, was not particularly distinguished by its architecture, location or historical importance. It stood out in Dundee because of the character of its inhabitants, who were noted throughout Dundee for their enthusiastic celebration of events of national importance. On such occasions the drab street would be transformed by the erection of bunting and

213

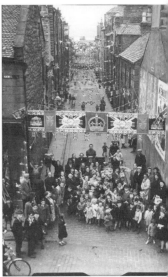

Residents of Bernard Street celebrate the coronations of 1937 (left) and 1953.

large and small Union Jacks. The photographs above depict the coronations of 1937 and 1953.

In these photographs Bernard Street can still be seen to have features from much earlier times: the very narrow street was clearly not designed to accommodate cars, the buildings are irregular in height and construction and a Victorian lamp can be seen on the left above a group of curious children. Most streets like this disappeared from Dundee during the redevelopment of the 1950s and 1960s. Many of those who lived there had grown up in a close-knit community, and when they were rehoused in the new sprawling council-house schemes on the outskirts of Dundee, that sense of community was lost.

The Tower Building under Construction, Queen's College, c. 1959

The rapid expansion of Queen's College and, after 1967, the University of Dundee, in the second half of the twentieth century, meant that many older buildings in the West End of the city were demolished to make way for larger and more practical structures. Even the four elegant Georgian villas known as Whiteley's were targeted. These had been purchased in 1882 and adapted to house the new University College Dundee (UCD). For the next three-quarters of a century they were used for teaching and

The Tower Building under construction.

administrative purposes. The buildings were also home to Professor D'Arcy Wentworth Thompson's zoology museum. However, despite renovations, these houses were never really entirely suitable for the purpose of being the principal buildings of an academic institution, and plans were periodically made either to drastically revise them, including a scheme by James Murray Robertson as early as 1892, or to replace them with an entirely new set of buildings. Lack of money meant that these schemes never got off the ground, but by 1958 the situation was critical and work finally began on a new main building.

In the photograph above the old and the new are seen side by side. Professor Sir Robert Matthew's Tower Building, which was to be the 'nerve centre' of the future university, can be seen taking shape beside the remaining two villas. The tower was designed to hold teaching and administrative departments and offices, as well as the college's library. Its construction generated considerable excitement, because it was to be the tallest modern building in Dundee (although it was slightly smaller than the Old Steeple). Sir Thomas Malcolm Knox (Principal of the University of St Andrews) commented in 1959 that he liked the design, but he was also concerned that the building might be unfairly criticised before it was completed, given its 'modern' nature and the fact that it was replacing buildings which graduates remembered with fondness. The tower was completed in 1961 and opened by the Queen Mother.

This contrast of past and future would not last for long, despite hopes that this special piece of university history could be saved. Within a decade space requirements demanded that the older buildings be taken down and replaced with an extension to the tower, which included a large new lecture theatre and increased space for teaching in what was by then the University of Dundee.

D'ARCY WENTWORTH THOMPSON'S ZOOLOGY MUSEUM

Professor Sir D'Arcy Wentworth Thompson was appointed to the Chair of Biology (renamed Natural History in 1888) at University College Dundee in 1884, and remained at the college as one of its outstanding academics and characters until 1917, when he transferred to St Andrews. On his death, *The Times* described him as 'one of the most respected and beloved figures in British university life' and 'one of the last great orators'. Thompson was an outstanding zoologist who acquired an immense collection of specimens of animals and their skeletons from around the world. To house this collection, part of the original college buildings was transformed into a zoology museum, which was tightly packed with colourful stuffed creatures, and a number of strange skulls and skeletons of all shapes and sizes. The idea was to enhance teaching and give students an opportunity to study and analyse real

specimens. The specimens also undoubtedly influenced Thompson's great work *On Growth and Form* which was published in 1917, and quickly became and remains a classic text among biologists.

The collection remained largely intact until the 1950s, but the demolition of the original buildings saw the end of the museum and the break-up of the collection, as there was no space for new museum buildings. An earlier plan, never realised, dating from around 1950, would have seen a new museum built as part of a new set of college buildings. The college was, however, able to retain a number of the original specimens, which eventually became a core part of the University of Dundee's museum collections. In 2008 the zoological collections were given a new home, with the opening of a new zoology museum in the Carnelley Building.

Biochemistry Building

Today biochemistry, as with other life sciences, is among the University of Dundee's most successful and prolific research and teaching areas. However, until the 1970s the biochemistry department was a fairly small one, with limited funding and an apparently uncertain future. After the arrival of Professor Peter Garland in 1968, the department slowly began to build up a reputation for excellent research. Principal Adam Neville (appointed

1978) recognised that biochemistry could play a major role in the university's future. By the mid-1980s the department was recognised as one of the best of its kind in Britain and the work of award-winning researchers like Garland and Professor Sir Philip Cohen began to attract significant funding awards which were crucial to the university at a time when its future was in doubt. Building on this success, by 2000 the university had a Life Sciences faculty, arguably the best in the UK and recognised by scientists as one of the best in the world.

This transformation is perhaps best symbolised by the changing nature of the building which houses the Life Science departments. In the 1960s bio-chemistry was confined to this small, run-down building, which is believed to have been converted from a former stable block. This was probably originally connected to one of the farms or houses that had occupied the lands between the Perth road and the Hawkhill until the nineteenth century. This was not untypical, as several of the college's and universities' departments use build-ings that were built with a different purpose in mind. Nowadays, the size of the College of Life Sciences and the state-of-the-art resources it needs to maintain its success require that it be housed in large, purpose-built modern buildings, notably the Sir James Black Building (completed 2007) and the Wellcome Trust Building (completed 1997), which dominates the skyline of the Hawkhill. The university has been able to build such structures thanks to the considerable research income that Dundee academics have been able to generate.

THE PHYSICS LABORATORY

From its foundation in 1881, University College Dundee had a strong focus on the teaching of the sciences. The first professor of physics, Professor Johannes Kuenen, educated at Leiden in 1884, was appointed to UCD in 1895. He specialised in thermodynamics and stayed in Dundee till 1906, retiring to Leiden in 1907. He is best known for his work on the liquification and solidification of helium. He designed many instruments for use in study and contributed numerous pieces of data.

He was replaced by Professor William Peddie, who spent his first two years overseeing a new physics laboratory. A grand plan proposed by James K. Caird, benefactor of the Caird Hall, to fund a laboratory was turned down by the College Council and it was the Carnegie Trust which eventually funded the Carnegie Laboratory of Physics, opened in 1909, which still stands in the Geddes Quadrangle. Peddie wrote on mathematics, thermodynamics and equipartition of energy. He carried out experiments on the properties

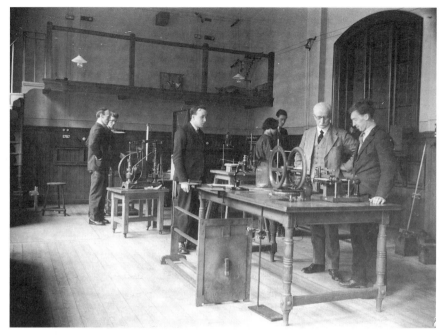

The Physics Laboratory.

of metals when twisted, colour – a subject on which he became an authority – and also wrote on magnetism.

Later in the century, during the 1970s, Dr Peter LeComber and Professor Walter Spear developed the laboratory with their pioneering research on amorphous silicon. The diverse applications they worked on, such as liquid crystal displays, electro-photography, image sensors and solar cells, were far reaching and laid the foundations for a multi-million pound industry.

DUNDEE ROYAL INFIRMARY INTERIOR

Dundee Royal Infirmary, usually referred to by Dundonians as 'the DRI', was originally constructed between 1853 and 1855 and designed to accommodate 220 patients. Its design echoed that of an Oxbridge college and, sitting on Dudhope Hill, the infirmary made a striking addition to Dundee's skyline. Over the next 100 years the hospital grew into a large complex with many interlinked buildings, but the original building remained in use throughout the hospital's life and survives today, converted into flats. Until the creation of the NHS in 1948, the hospital depended heavily on benefactors, and it was thanks to the generosity of Sir James Key Caird that it was able to construct cancer and maternity facilities.

Inside Dundee Royal Infirmary.

The infirmary also served as a major teaching hospital through its connection with the University of St Andrews and later with the University of Dundee. However, by the 1960s the cramped interiors and narrow staircases and corridors meant that it was not ideally suited to this purpose, and most of its teaching functions were transferred to Ninewells Hospital, designed by Robert Matthew Johnson-Marshall and partners and completed in 1975. The Royal Infirmary itself closed in 1998 when its functions were transferred to Ninewells Hospital.

The interiors of the hospital were fairly cutting-edge for the time, though this photograph of an operating theatre (previous page) reveals a dramatic contrast with modern medical facilities. There was very little in the way of automated equipment, including nothing that would monitor patients' well-being. Lighting was basic.

THE BATHS

Public baths and wash-houses for the use of the working classes were built as part of a reaction to the increasingly insanitary and disease-ridden housing of the later decades of the nineteenth century. They were first considered in Dundee in 1844 and funded by subscriptions from leading dignitaries.

The Baths.

Plans and estimates were submitted in 1845 by local architect David Smith from Reform Street, for a building in the Pleasance and another at Blackscroft, but the baths were ultimately built beside Earl Grey dock, where Olympia now stands.

In 1930 bathers caused some hilarity when they requested catering facilities for tea and refreshments, the Baths Committee not being sure whether the swimmers intended leaving the water to have their tea, though the committee did subsequently provide catering at the baths.

LINLATHEN AIR RAID SHELTERS

The area of housing known as Linlathen was initially developed to the north of the Kingsway in the 1930s. The image on the next page was probably taken early in its life as it shows a number of air-raid shelters as well as Linlathen's distinctive housing. The shelters were Anderson shelters, originally designed in 1938 as part of the government's preparations for the likelihood of enemy air raids in the event of a war with Germany. They were named after Sir John Anderson (later Viscount Waverley), the government minister with special responsibility for air-raid precautions, who was in charge of their development. Standard Anderson shelters were made from corrugated steel panels and were intended to accommodate up to six people. Unlike larger communal shelters, they were mainly intended for use by individual families and were

Linlathen Air Raid Shelters.

often erected in the gardens or back greens of houses. Some air-raid shelters remained standing in parts of Dundee for many years, often finding a new use as a garden shed.

Thankfully, Dundee's air-raid shelters saw much less use than those in most other British cities. Both the city, with its harbour, factories, shipyard and munitions industries, and the Tay Bridge were considered important targets by the Luftwaffe. However, Dundee was remarkably free of aerial bombardment during the war and only a handful of its inhabitants were killed or injured as a result of enemy bombing. The most serious air raid of the war came on 5 November 1940 and saw around eight explosive devices dropped on the city, resulting in the death of three people. However, things might have been much worse, as a bomb narrowly missed the packed Forest Park Cinema. The Linlathen housing estate itself suffered minor damage in an air raid in November 1941, with no serious injuries.

NATIONAL CASH REGISTER AND TIMEX

In the period following the Second World War Dundee's economy was transformed by the introduction of new manufacturing industries. Jute still employed a fifth of the working population but new industries were attracted by opportunities presented by the Distribution of Industry Acts.

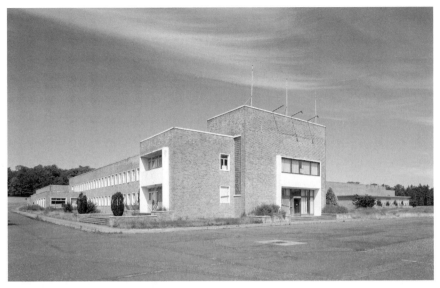

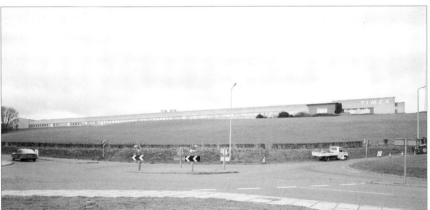

Top: the NCR factory. Bottom: the Timex factory.

The US company National Cash Register (NCR) selected Dundee as the base for its UK operations in late 1945. Production started in 1946 and by the 1960s NCR had become the principal employer of the city, producing cash registers, and later ATMs (automatic teller, or cash, machines). Sir Garnet Wilson, the Lord Provost of Dundee from 1940 to 1946, was credited as a key figure in NCR's decision to open their factory in Dundee.

The United States Time Corporation, later known as Timex, also came to Dundee, establishing, in 1946, a 200 square foot contemporary factory, designed by Beard and Bennett. Rapidly becoming a major employer in Dundee, the company's popularity was diminished in 1983 when strikers occupied the factory after management fired 1,900 workers. Members of the

British parliament, and finally Prime Minister Margaret Thatcher, inter-
vened before the six-week occupation was ended. In the same year, Timex
produced the first Sinclair ZX Spectrum home computers in Dundee. The
company broke production records, despite the sit-in by workers protesting
job cuts and plans to demolish one of the factory buildings to make way
for a supermarket. Timex finally closed its Dundee plant in 1993 following
an acrimonious six-month industrial dispute. In January 2007, NCR an-
nounced its intention to cut 650 jobs.

THE ICE RINK

Ice rinks first appeared in the 1870s; the London Glaciarium, London's first
artificial ice rink, was opened in Chelsea in 1876. It was not until the 1930s
that the ice rink in Dundee was built, designed by architect W. M. Wilson, one
of almost 40 new ice rinks, including Murrayfield, Blackpool, Liverpool and
Birmingham, which opened during that decade.

The ice rink inspired two very successful ice-hockey teams. The Dundee
Tigers (originally founded in 1938), won the Scottish National League on three
occasions before being dissolved in 1955. They were re-formed in 1987 and for
a while were known as the Tayside Tigers. The Dundee Rockets ice-hockey

team was founded in 1963 and was a founder member of the Northern League and later the British (Ice) Hockey League. The Rockets won several major competitions before they were wound up in 1987. They were one of the most successful ice-hockey teams of their era in the UK, and in 1983 became the first British ice-hockey team to enter the European Cup.

The ice rink was a favourite location for young courting couples, documented in Dundee City Council's 'Reminiscence Project'.

THE REP, LOCHEE

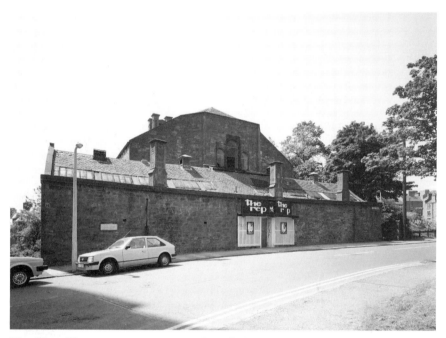

The Rep Theatre company was founded in May 1939 as a collaboration between professionals, including the actor Richard Todd, and amateurs. Its first home was in the city centre, in Nicoll Street, in 1939 and following a fire it moved to its second home, the converted Dudhope Church in Lochee, where it stayed for 18 years. It continued to attract well-known actors including Virginia McKenna, Edward Fox, Tom Conti, Glenda Jackson and Arthur Lowe, while many other familiar names progressed their early careers at the Rep during the 1960s and 1970s, including Brian Cox, Gregor Fisher (Rab C. Nesbit), Maureen Beattie and Phyllis Logan.

Following agreement between the Scottish Arts Council and Dundee District Council, a new theatre was built in Tay Square. Building work commenced but was halted due to rising prices and inflation. A public appeal

was launched which raised a massive £60,000 in under six weeks, reaching an eventual total of £200,000. In 1982 the Rep moved to the completed custom-built theatre, designed by the Nicoll Russell Studio. Containing an acclaimed 455-seater auditorium, the building won the **RIBA Architecture Award** in 1986 and since September 1999 the Rep has hosted the only permanent repertory theatre company in Scotland.

NETHERGATE GARAGE/DUNDEE CONTEMPORARY ARTS

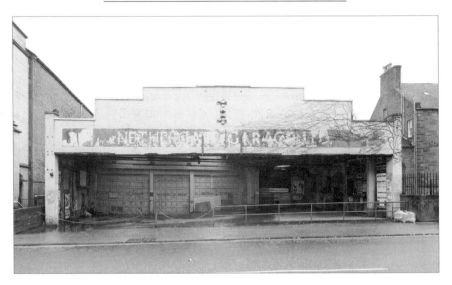

The site facing up South Tay Street was a very historic one: this had been the location of the Town's Hospital, one wing of which – with its fine ornate plasterwork – had remained in use as an academy until the end of the nineteenth century (see p. 53). It was then replaced by a garage which also occupied the brick railway sheds running along the old shoreline to the rear. The garage closed in the 1980s, and was used for some time as an informal skateboard park.

 When seeking to find new premises in 1996 for printmakers who were being relocated away from bonded warehouses in the Seagate, the City Council established a Trust to see whether disparate cultural uses could be combined in a single arts centre. Eventually, an amalgamation of the Printmakers' Studio, the Steps Cinema, the Duncan of Jordanstone Visual Arts Research Centre, and the relocation of some of the city's arts administration made a new building viable. The Council duly purchased the semi-derelict former Maclean's garage at 152 Nethergate in 1995, and an architectural competition was then held for the development of Dundee Contemporary

Arts (DCA). It opened in 1999 and has been responsible for much of the revitalisation of the city.

The 1996 architectural competition was won by the Edinburgh architectural firm Richard Murphy Architects who produced, according to the *Sunday Times* 'one of the most satisfying, sublime and stylish public buildings opened in years'. It contained the largest modern art gallery in Britain beyond the Saatchi gallery in London, and was designed with the café/restaurant as its focus. In a blend of old and new, the design also incorporated not only the rear brick sheds of the old garage and railway sheds behind, but also the stone lower walls of earlier buildings, and parts of the original sea wall. It was an immediate success, bringing, together with the Dundee Rep, enhanced cultural life to the area, and its restaurant soon stimulated the creation of several others in the immediate vicinity. It is worth remembering that when planning the architectural competition in 1996, the Trustees sought advice from economic advisers, who stated that people in Dundee were not in the habit of going out to eat, and that any catering beyond a small café would inevitably die quickly from lack of patronage. The Trustees ignored the advice. The Nethergate is now classified as Dundee's cultural quarter.

FURTHER READING

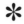

GENERAL

Primary sources

Royal Commission on the Ancient and Historical Monuments of Scotland: a major collection of plans, drawings and aerial photographs of significant architectural developments in Scotland.

National Archives of Scotland: general deposits, family papers, legal registers, court records, Church of Scotland records, maps and plans relating to Dundee.

National Library of Scotland: holds important family papers.

Secondary sources

Checkland, S. G., and Checkland, O., *Industry and Ethos: Scotland 1832–1914* (London, 1984)

Defoe, D., *A Tour through the Whole Island of Great Britain* (reprint London, 1976)

Devine, T. M., and Finlay, R. J. (eds.), *Scotland in the Twentieth Century* (Edinburgh, 1996)

Durie, A., *The Scottish Linen Industry in the Eighteenth Century* (Edinburgh, 1979)

Flinn, M. (ed.), *Scottish Population History from the Seventeenth Century to the 1930s* (Cambridge, 1977)

Fraser, W. H., and Morris, R. J. (eds.), *People and Society in Scotland, Volume II, 1830–1914* (Edinburgh, 1990)

Gazetteer of Scotland (Dundee, 1803)

Glendinning, M., MacInnes, R., and MacKechnie, A., *A History of Scottish Architecture* (Edinburgh, 1996)

Glendinning, M. (ed.), *Rebuilding Scotland: The Postwar Vision 1945–1975* (East Linton, 1997)

Gordon, E., *Women in the Labour Movement in Scotland, 1850–1914* (Oxford, 1991)

Gordon, G., and Dicks, B. (eds.), *Scottish Urban History* (Aberdeen, 1983)

Harvie, C., *No Gods and Precious Few Heroes: Scotland Since 1914* (Edinburgh, 1987)

Houston, R. A., and Whyte, I. D. (eds.), *Scottish Society 1500–1800* (Cambridge, 1989)

Knox, W. W., *Industrial Nation: Work, Culture and Society in Scotland, 1800–Present* (Edinburgh, 1999)

Lenman, B. P., *Integration and Enlightenment: Scotland 1746–1832* (London, 1981)

Loch, D., *A Tour through most of the Trading Towns and Villages of Scotland: Containing notes and Observations Concerning Trade and Manufacturers* (Edinburgh, 1778)

Lynch, M., *Scotland: A New History* (London, 1992)

Lynch, M. (ed.), *The Early Modern Town in Scotland* (London, 1987)

McKean, C., *Battle for the North* (London, 2006)

McKean, C., *The Scottish Chateau: The Country House of Renaissance Scotland* (Stroud, 2001)

McKean, C., *The Scottish Thirties: An Architectural Introduction* (Edinburgh, 1987)

Mays, D. (ed.), *The Architecture of Scottish Cities* (East Linton, 1997)

Mitchison, R., *Lordship to Patronage: Scotland 1603–1745* (Edinburgh, 1990)

Scottish Biographies (London, 1938)

Smout, T. C., *A History of the Scottish People, 1560–1830* (London, 1969)

— *A Century of the Scottish People, 1830–1950* (London, 1987)

Whatley, C. A., *Scottish Society 1707–1830* (Manchester, 2000)

— *The Industrial Revolution in Scotland* (Cambridge, 1997)

Whyte, I. D., *Scotland Before the Industrial Revolution* (Harlow, 1995)

DUNDEE

Archives

DC Thomson & Co. Ltd Photographic Collections

Dundee City Archive
Town Council Records. TC
The Minutes of the Dundee Corporation and its Committees.
The Police Commissioners Records.
Records of the Church of Scotland in Dundee.
Memoirs of James Smith, Stonemason, Dundee, 1805–c. 1869 GD/Mus 29/1.

Customs and Excise Records
Records of the Wedderburn Family of Pearsie. GD/WE
Dundee Museums and Art Galleries Maps and Plans. GB251/GD/Mus/101
'Report on the Development of the City' (Dundee Town Council, 1918)

Dundee Local History Centre
The Alexander Wilson Bequest of photographic glass negatives
The Lamb Collection (priceless antiquarian information collected by A. C. Lamb)
The Lawson Collection (approx. 600 drawings of Dundee between 1850 and 1870)

University of Dundee Archive Services
Baxter Brothers Collection. MS 11

Thornton Collection. MS 17
Ogilvie, Cowan & Co., Solicitors Collection. MS 57
Sidlaw Industries Collection. MS 66
John P. Ingram Collection. MS 73 (Shipping connected to the port of Dundee)
Joseph Johnston Lee Collection. MS 88 (Poems, notes and sketches related to Dundee)
Peter Carmichael of Arthurstone Collection. MS 102
Notebook, Mary Brooksbank Manuscript. MS 103/3/8
Shiell and Small Collection. MS 105 (Property and railways in Dundee)
James Thomson (1852–1927) Collection. MS 112 (Dundee's City Architect and City Engineer)
'Working-Class Life in Dundee for Twenty-Five Years'. MS 134
Thomas Handyside Baxter (1784–1863) Collection. MS 184
John Sturrock papers (includes diary of a wheelwright in Dundee 1864–1865). MS 234
Tayside Health Board Collection. THB
CMS Turner/McKinlay Photographic Collection.
Michael Peto Photographic Collection.
The Records of the University of Dundee and its Predecessors. Recs A/RU/UR
The Records of Brechin Diocese of the Episcopal Church of Scotland. BrMS

Newspapers, Periodicals and Directories

Copies of many of these publications may be consulted at either Archives Services, University of Dundee, or the Local History Centre, Dundee Central Library.

City Echo
Courier (and Argus)
Courier and Advertiser
Dundee (Perth and Cupar) Advertiser
Dundee (Post Office) Directory (various volumes)
Dundee Free Press
Dundee Magazine
Dundee Yearbook (various volumes)
Evening Telegraph and Post
People's Journal
Piper O' Dundee
Tocsin

PUBLISHED SOURCES

The majority of these books are contained in the Kinnear Local Book Collection, in the University of Dundee Archives, and in the collections of the Local History Centre, Dundee Central Library.

Primary sources

Beatts, J. M., *Reminiscences of a Dundonian* (Dundee, 1882)

Dundee Register of Merchants and Trades with all the offices etc., (Dundee, 1783)

Dundee Social Union Enquiry Committee (headed by Mary Lily Walker), *Report on Housing and Industrial Conditions and Medical Inspection of School Children* (Dundee, 1905)

Edward, R., *The County of Angus 1678* (reprint Edinburgh, 1883)

Forfarshire Illustrated: Being Views of Gentlemen's Seats, Antiquities and Scenery in Forfarshire, with Descriptive and Historical Notices (Dundee, 1843)

Hay, W. (ed.), *Charters, Writs, and Public Documents of the Royal Burgh of Dundee, the Hospital and Johnston's Bequest: 1292–1880* (Dundee, 1880)

Lamb A. C., *Dundee: Its Quaint and Historic Buildings* (Dundee, 1895)

— *Guide to Remarkable Monuments in the Howff, Dundee* (Dundee, c. 1892)

Mackie, C., *Historical Description of the Town of Dundee* (Glasgow, 1836)

Maxwell, A., *The History of Old Dundee Narrated out of the Town Council Register* (Dundee, 1884)

— *Old Dundee after the Reformation* (Dundee, 1884)

Millar, A. H., *Roll of the Eminent Burgesses of Dundee 1513–1886* (Dundee, 1887)

— (ed.), *The Compt Buik of David Wedderburne, Merchant of Dundee* (Edinburgh, 1898)

— (ed.), *The First History of Dundee, 1776* (Dundee, 1923)

Mudie, R., *Dundee Delineated; or, A History and Description of that Town, Its Institutions, Manufactures and Commerce* (Dundee, 1822)

Myles, J., *Chapters in the Life of a Dundee Factory Boy: An Autobiography* (Dundee, 1980)

— *Rambles in Forfarshire or, Sketches in Town and Country* (Dundee, 1850)

Norrie, W., *Dundee Celebrities* (Dundee, 1873)

Small, R., *A Statistical Account of the Parish and Town of Dundee in the Year MDCCXCII* (Dundee, 1793)

Warden, A. J., *Burgh Laws of Dundee* (London, 1872)

Whatley, C. A. (ed.), *The Diary of John Sturrock, Millwright, Dundee 1864–65* (East Linton, 1996)

Secondary sources

Black, A., *Gilfillan of Dundee 1813–1878* (Dundee, 2006)

Brooksbank, M., *No Sae Lang Syne* (Dundee c. 1969)

Buchan, G., *Dundee Harbour; Its History and Development: A Lecture Delivered to the Members of the Dundee Institute of Engineers on the 14 December 1899* (Dundee, 1899)

Dorward, D., *Dundee Names, People and Places* (Edinburgh, 1998)

Hazell, J. W., *John W. Hazell's Book of Records* (Dundee, 1977)

Jackson, G., and Kinnear, K., *The Trade and Shipping of Dundee, 1780–1850* (Dundee, 1991)

Jackson, T. M.(ed.), *The Third Statistical Account of Scotland – The City of Dundee* (Arbroath, 1971)

Jeffrey, A., *This Dangerous Menace. Dundee and the River Tay at War 1939 to 1945* (Edinburgh, 1991)

Kidd, W., *Bits of Old and New Dundee* (Dundee, 1891)
— *Dundee Past and Present* (Dundee, 1909)

McCraw, I., *The Kirks of Dundee Presbytery 1558–1999* (Dundee, 2000)

McKean, C., *Battle for the North: The Tay and Forth Railway Bridges and the Scottish Railways War* (London, 2006)

McKean C., and Walker, D. M., *Dundee: An Illustrated Architectural Guide* (Edinburgh, 1993)
— *Dundee: An Illustrated Introduction* (Edinburgh, 1984)

McKean, C., Harris, B., Whatley C. S. (eds.), *Dundee: From Renaissance to Enlightenment* (in production)

Maclaren, J., *The History of Dundee* (Dundee, 1874)

Marshall, P., *The Railways of Dundee* (Oxford, 1996)

Matthew, W. M., *Keiller's of Dundee: The Rise of the Marmalade Dynasty* (Dundee, 1998)

Meldrum, R., *The City and Royal Burgh of Dundee, Survey Report 1964* (Dundee, 1965)

Millar, A. H., *Glimpses of Old and New Dundee* (Dundee, 1925)

Miskell, L., Whatley, C. A., and Harris, B. (eds.), *Victorian Dundee: Image and Realities* (East Linton, 2000)

Naulty, D. M., *Dundee Cinemas* (Dundee 2004)

New Statistical Account of Scotland, Vol. XI (Edinburgh, 1845)

Ogilvy, G. (ed.), *Dundee: A Voyage of Discovery* (Edinburgh, 1999)

Robertson, H., *Mariners of Dundee: Their City, Their River, Their Fraternity* (Dundee, 2006)

Rollo, J. A., *The Parish and the Burgh Churches of Dundee* (Dundee, 1897)

Scott, A. M., *Discovering Dundee: The Story of a City* (Edinburgh, 1999)
— *Modern Dundee: Life in the City Since World War Two* (Derby, 2006)

Shafe, M., *University Education in Dundee 1881–1981: A Pictorial History* (Dundee, 1982)

Skinner, W. C., *The Barronie of Hilltowne of Dundee* (Dundee, 1927)

Smith, A. M., *The Guildry of Dundee: A History of the Merchant Guild of Dundee up to the Nineteenth Century* (Dundee, 2005).
— *The Nine Trades of Dundee* (Dundee, 1995)

Smith, W. A. C., and Anderson, P., *Tayside's Railways: Dundee and Perth* (Bedfordshire, 1997)

Smith, W. J., *A History of Dundee* (Dundee, 1975)

Thomson, J., *The History of Dundee from its Origin to the Present Time with a Copious Appendix* (Dundee, 1842)

Torrie, E. P. D., *Medieval Dundee: A Town and its People* (Dundee, 1990)

Town Planning in Dundee (Dundee, 1992)

Walker, B., *Architects and Architecture on Tayside* (Dundee, 1984)

Walker, D.M., *Architects and Architecture in Dundee* (Dundee, 1955)

— *Dundee Architecture & Architects, 1770–1914* (Dundee, 1977)

— *The History of Dudhope Castle* (Dundee, 1959)

— *Nineteenth Century Mansions in the Dundee Area* (Dundee, 1958)

Walker, W. M., *Juteopolis: Dundee and its Textile Workers 1885–1923* (Edinburgh, 1979)

Warden, A. J., *Angus or Forfarshire, the Land and People, Descriptive and Historical*, 5 volumes (Dundee, 1880–85)

— *The History of Old Dundee* (Dundee, 1884)

Watson, M., *Jute and Flax Mills in Dundee* (Tayport, 1990)

Watson, N., *Daughters of Dundee* (Dundee, 1997).

— *Dundee: A Short History* (Edinburgh, 2006)

Whatley, C. A. (ed.), *The Remaking of Juteopolis: Dundee circa 1891–1991* (Dundee, 1991)

Whatley, C. A., Swinfen, D. B. and Smith, A. M., *The Life and Times of Dundee* (Edinburgh, 1992).

Wilson, Sir G., *The Making of a Lord Provost* (Dundee, c. 1967)

— *Overspill* (Dundee, c.1970)

Pictorial sources

Brotchie, A. W., and Herd, J. J., *Dundee on the Move 1877–1977* (Dundee, 1977)

— *Old Broughty Ferry and Monifieth* (Dundee, 1980)

— *Old Dundee from the Tram Cars* (Dundee, 1975)

— *Old Dundee: More Scenes and Memories* (Dundee, 1980)

— *Old Lochee and round about* (Dundee, 1981)

— *Old Dundee Streets and Wynds* (Dundee, 1976)

Eunson, E., and Early, B., *Old Dundee* (Catrine, 2002)

Henderson, M, *Dundee Women: A City-Centre Trail* (Dundee, 1999)

Online resources

http://www.dundeecity.gov.uk/photodb/main.htm (Photopolis)

http://www.dundee.ac.uk/archives/source-history.htm (University of Dundee, Archive Services: Sources for local or Scottish history)

http://134.36.1.31/ (University of Dundee, Archive Services: online catalogue)

http://www.fdca.org.uk/ (Friends of Dundee City Archives)

http://www.drawnevidence.ac.uk (The Drawn Evidence: Scotland's Development Through its Architectural Archives from Industrialisation to the Millennium, 1780 – 2000)

http://www.nls.uk/digitallibrary/index.html (National Library of Scotland Digital Library)

http://www.scan.org.uk (Scottish Archive Network)

http://www.scran.ac.uk (SCRAN)

IMAGE ACKNOWLEDGEMENTS

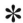

The authors gratefully acknowledge the following for the provision and use of their images:

photopolis.org (Dundee Library and Information Services): pp. xii, xv, xvi, xxviii, 22, 23, 24 (top and bottom), 26, 28, 31, 33, 34, 35, 36, 37, 38, 39, 40, 41, 42, 44, 45 (top and bottom), 46, 47, 49, 50, 51, 52, 55, 56, 57, 59 (top), 64, 65, 69, 71, 76, 84, 91, 93, 102, 105, 124, 129, 132, 136, 140, 143, 144, 145, 148, 149, 150, 151, 153, 154, 155, 156, 163, 164 (top and bottom), 165, 221.

D.C.Thomson & Co. Ltd.: pp. xxvi, 13, 27, 57, 104, 106, 107, 110, 128, 135, 137, 138, 139, 153, 157, 159, 177, 181, 187, 188, 190, 191, 192, 196, 201, 205, 206, 207, 209, 210 (top), 213, 222.

Royal Commission on the Ancient and Historical Monuments of Scotland: pp. xxiv, 56, 130, 197, 198 (top), 198 (bottom), 199, 202, 204, 210 (bottom), 223, 224, 225, 226.

Dundee Art Galleries and Museums: pp. xxii, 3, 12, 23, 30, 43, 78, 87, 103, 134.

University of Dundee Archive Services: pp. x, xviii, xxiii, 8, 15, 17, 18, 19, 48, 54, 59 (bottom), 60, 62, 63, 66, 67, 68, 70, 72, 73, 77, 81, 82, 85, 86, 89, 90, 94, 95, 96, 97, 99, 100, 108, 109, 111, 112, 113, 115, 116 (top and bottom), 117, 118, 119, 120, 121, 122, 123, 125, 126, 127, 131, 133, 141, 146, 147, 160, 161, 162, 166, 167 (top and bottom), 168, 170 (top and bottom), 171, 172, 174, 175, 176, 184, 185 (top and bottom), 186, 193, 195, 200, 211, 214 (top and bottom), 215, 216, 217, 219, 220.

University of Dundee Michael Peto Collection: p. ii.

University of Dundee Museum Services: p. 157.

National Library of Scotland: p. 14.

Professor Charles McKean: pp. 7, 30 (top), 44 (left), 198 (middle).

Professor David Walker: pp. xx, 129.

Private Collection: pp. viii, 109.

INDEX

Page numbers in italic refer to images

ABC Capitol. *See* Cannon Film Centre
Abernyte, school, 75
Adam, James 67
Adam, John, xiii
Adam, Robert, xvi, 51, 62, 67
Adam, William, xi, 6, 8, 13, 35, 55, 67, 86, 158, 165, 182, 186
Adams, Thomas, 209
Addison Act 1919, 165, 189
Airlie Place, 127
Air-Raid Shelters 221, *222*
Airport, Dundee, 195
Albert Institute, 87, 114, *135*
Albert Square, xxi, 136
Albert Street, 175
Alhambra Picture House, *196*, 197
Allason family, 2
Anderson Shelters *see* Air-Raid Shelters
Anderson, Patrick 77, 100
Anderson, Sir Robert Rowand, 173
Angus Hotel, *168*, 211, 212
Angus, George, 83, 98, 102
Annfield, 70
Arbroath Road, 206
Ardler, 166, 182, 192, *202*, 203
Arnott's Department Store, 179
Arrol, Sir William, 139
Arsenal, xi, 2, 15, 95
Ashton Works, 165
Assembly Rooms *see* Exchange Coffee House
Associated Burgher Meeting House, 101
Auld Steeple Guest House, 155

Bain Square, *8*, 25, 134, 212
Bain, Walter, 134
Baldovan Railway Station, 192
Baldovie Road, 206
Baldovie, estate, 4
Balfour Street, *127*
Balgillo Hill, 15
Balruddery House, 75
Baltic Coffee House, 25, 86, 134
Bank Street, 137, 138
Barnhill, 85, 129, 175
Barr, Thomas, 107
Barrack Road, 174

Barrack Street Library, 163, *164*
Barrack Street Natural History Museum, 163, 183
Barrack Street, 101
Barrass Port, 152
Baths, The, 220, *221*
Battery Point, 78
Baxter Brothers, xvii, xix, xxvi, 74, 87, 114, 115, *116* (tenements), 129, 169, 172
Baxter Park, 68, 179
Baxter, Edward, 129
Baxter, Mary Ann, 169, *170*
Baxter, Sir David, 172
Baxter's Half-Time School, 115, *116*
Beard and Bennett, 169, 223
Beatts, J. M., 'Reminiscences of a Dundonian', 90
Bell Street, 25, 54, 82, 99, 172
Bell, Samuel, 9, 21, 25, 32, 38, 53, 54, 58, 59, 60, 61, 62, 63, 64, 65, 66, 70, 74, 75, 112
Bellfield Street, 194, 196
Bernard Street, 213, *214*
Bett Brothers, 182
Biochemistry Building, University of Dundee, *217*
Black, James, 69
Black, Sir James (Centre, University of Dundee), 171, 218
Blackfriars, 65, 155
Blackness House, 34, *35*
Blackness Library, 163, *165*, 183, 194
Blackness Road, 70, 128
Blackness, 4, 6, 15, 34, 35, 63, 69, 80, *123*, 126, 156, 196
Blackscroft, 15, *16*, *148*, 221
Blain, William, xvii
Blair, Dr Patrick, 22, 155
Blessed Virgin Mary of Dundee. *See* St Mary's Church
Bonar Hall, 64
Bonnet-Hill *see* Hilltown.
Bonnybank Road, 179
Booth, Charles, 173
Botanic garden (Blair's), 22, 156
Bouch, Thomas, 108, 141, 142, 143, 183
Bowbridge Works, 27, 131

Boyack, W., 123
Brackenrig Fort, 15
Bradford's Land, xvi, *50*, 51
Brewster, James, 83, 99
Bridewell, 102
Brooksbank, Mary, 160, *161*
Broughty Castle, 15
Broughty Ferry, xxiv, 75, 85, 92, 129, 130, 131, 149, 179, 203
Brown, James, 100
Brown's, D. M., Department Store, 179, 194, 195
Bryce, David, 134, 135
Bucklemaker Wynd, 26, 150
Burial Wynd, 32, 42
Burke, Ian, 168, 209, 211
Burnhead, 148
Buster stalls, *201*
Butcher Row, xvi, 29, *30*, 31, 51, 90

C&A Store, 211
Cabinet of Curiosities (Patrick Blair), 22,155
Caird Hall, xxiii, 138, 139, 165, 182, 184, 185, *188*, 189, 218
Caird, Sir James Key, 165, 184, 188, 189, 218, 219
Caledonian Railway Station *see* Dundee West Station
Caledonian Railway, 106, 107, 108
Camperdown Dock, 83, *96*
Camperdown Golf Club, 202
Camperdown House, 113
Camperdown Works, xxi, 86, 117, 119, *120*, *121*, 122, 129, 145, 180
Camperdown, 169
Campus Green, University of Dundee, 172
Candle Lane, 109, 193
Cannon Film Centre, 200
Carbet Castle, 85, *130*, 131
Carlyle, Alexander, 8
Carmichael, Peter, 114, 121
Carnegie Building, University of Dundee, 172, 218, *219*
Carnelley Building, University of Dundee, 217
Carolina Port, 74, 144
Castle Hill, 13, 16, 18, 46, 71, 148, 158
Castle Street, xiv, 9, 21, 43, 53, 61, *66*, *70*, 71, 74, 78, 97, 183
Castle Wynd, 46, *90*, 133
Castleroy, *xx*, 130
Cathro, *77*
Central railway station (James Thomson's plan), xxiii
Chalet Road House, 179
Chalmers Church, 202
Chamber of Commerce, xxiv

Chapelshade Church, 74
Chapelshade, xxv, xxvii, 19, 54, 62
Charleston, 7, 64, 133, 150, 166
Cholera Hospital, 15, *94*, 95
Choristers' House, *31*, 32
Churchill, Winston, 138, 177, 195
City and Royal Burgh of Dundee Survey and Plan 1952, 193
City Chambers, xxiv
City Churches, *111*, 182, 187, 201, 211, 212, *see also* St Mary's Church
City Improvement Trust, 123, 127, 145, 147
City Improvement, ix, xiv, xxi, xxiv, 29, 48, 49, 58, 88, 91, 92, 98, 109, 127, 144, 145, 147, 151, 182, 209
City Square, xxiv, 46, 57, 58, 182, 185, 189
Civic Centre (James Thomson's plan), 182, 183, *185*, *186*, 187
Clark, George, 77
Clayhills family, 4
Claypots Garage, *205*, 206
Claypotts Castle, *205*
Claypotts Road, 206
Claypotts, 15, 179, *205*
Clayton, Thomas, 57
Clement Park, 85, 129
Clydesdale Bank, High Street, 147, 148
Clydesdale Bank, Nethergate, 54, 61
Cock Family *see* Cox Brothers
Cock, James, 121
Coe & Goodwin, 129, 174
Coffin Mill, Logie Works, 129
Cohen, Sir Philip, 218
Coldside Library, 163, *164*, 183
Commercial Street, xxi, 90, 91, 97, 147, 148, 158, 194
Constitution Road, 32, 101
Constitution Street, 42
Continental Ballroom, 179
'Coogate', 25, 80, 134
Corbie Hill, ix, xxi, 18
Corn Exchange, *137*, *138*
'Corner, The', *see* Wilson's, G.L., Department Store
Cornmarket, 9
Council (Dundee), xiii, xiv, xix, xx, xxi, 6, 10, 32, 51, 55, 57, 58, 63, 64, 65, 69, 70, 75, 77, 81, 87, 88, 95, 98, 101, 108, 112, 123, 139, 140, 145, 163, 178, 183, 184, 189, 190, 196, 203, 204, 208, 225, 226
Council Chambers, 55, 57, 58
Couttie's Wynd, 32, 42, *43*, 75
Cowgate, 5, 15, 17, 18, 21, 25, *26*, 58, 133, 134, 212, *213*
Cox Brothers, xxi, 85, 119, 121, *122*
Cox, George Addison, 121,*122*
Cox, Henry, *122*

Cox, James, xxi, 85, 88, 101, *122*, 123, 129, 145
Cox, Thomas Hunter, *122*
Cox, William, *122*
Cox's Stack, *121*,122, 123, 180
Craig Pier, 61, *93*, 94, 183
Craigie, 4, 144, 183
Craigie (House), *see* Wallace Craigie
Craigie Works, 165
Craigiebank, 183, 190, 191
Crawford Building, Duncan of Jordanstone
 College of Art, 173
Crawford, Earl of, 5, 15, 109, 152
Crawford, William, 18, *19*, 53, *54*
Crawford's plan of Dundee, 1776, 18, *19*, *20*
Crawford's plan of Dundee, 1793, 53, *54*
Crescent Street, 115
Crichton Street, xxiii, *xxviii*, 9, 21, 29, 42, 60,
 97, *132*, 133, 183, 187
Cross of the Burgh *see* Marketplace
Crown Spire, The, *see* Old Steeple
Cultural Quarter, 180, 227
Customs House, 16, 29, 95, *96*, *97*, 98, 144

Dalhousie Building, 172, 194
David Hunter's Great Lodging *see* Hunter's
 Great Lodging
David, Earl of Huntingdon, 111
de Beaugé, Jean, 1
Debenhams *see* Draffens Department Store
Defoe, Daniel, 132
Dempster, George, 38
Dens Burn, 9, 15, 114, 148
Dens Park, 179
Dens Works, *xviii*, *xix* (Calender), 27, 114,
 115, *117* (Obelisk), *118*, *119*, 121, *125*, *160*,
 180
Dental School and Hospital, 64, 173
Development Plan 1952, xxv, 120, 207, 209, 211
Discovery Point, xiv, 108, 180
Dock Street, *81*, *96*, *97*, 98, *105*, *106*, 107, 108,
 144, *207*, 209 (Tunnel)
Docks, xii, xiii, xix, xx, xxi, xxv, 14, 72, 81,
 86, 96, *97*, 98, 102, 103, 104, 108, 132, 144,
 145, 163, 179, 181, *206*, *207*, 208 *see also*
 Port and Harbour
Douglas and Angus, 166, 205
Douglas, James, 157, 158
Douglas, Lord (Castle), *49*, 51
Downfield, 182, 191, 192
Draffen's Department Store, 43, 179, 195
Drumgeich, 4
Dudhope Castle, 17, 174
Dudhope Church, 179, 225
Dudhope Terrace, 17
Dudhope, 15, 42, 100, 126, 156, 219 (Hill)
Dudhope *see* Scrymgeour, John, Third
 Viscount Dudhope

Dunbar Park, 203
Duncan of Jordanstone College of Art, 173,
 226
Duncan, George, 78
Duncans of Lundie, 48
Dundee Advertiser, 86, 138, 122
Dundee and Arbroath Railway, 82, 96, 105,
 108, 143, 144, 208, 209
Dundee and Arbroath Railway Station. *See*
 Dundee East Railway Station
Dundee and Newtyle Railway, *82* (Engine),
 101, *102* (Station), 103, 111, *121*, 139, 143,
 155
Dundee and Perth Railway, 54, 78, 96
Dundee Bank, 64
Dundee City Council *see* Council (Dundee)
Dundee College of Technology, 172
Dundee Contemporary Arts, 16, 18, 53, 54,
 132, 179, 180, 200, 226, 227
Dundee Corporation *see* Council (Dundee)
Dundee District Council *see* Council (Dundee)
Dundee East Railway Station, *143*, 144, 208,
 209
Dundee Express Removals company, 207
Dundee Football Club, 179
Dundee Health Care (NHS) Trust, 177
Dundee Heritage Trust, *97*
Dundee Improvement Trust, 88, 89, 123, 127,
 145, 147,150
Dundee Lunatic Asylum *see* Dundee Royal
 Lunatic Asylum
Dundee Project, xxvii
Dundee Repertory Theatre, 66, 179, 180, *225*,
 226, 227
Dundee Rockets ice-hockey team, 224
Dundee Royal Infirmary, 9, 64, *67*, 68, 74,
 110, 129, 174, *175*, 219, *220*
Dundee Royal Lunatic Asylum, xvii, *68*, 175,
 176
Dundee Social Union, 92, 173, *174*
Dundee Technical College and School of Art,
 172
Dundee Technical Institute, 172, 173
Dundee Tigers Ice Hockey Team, 224
Dundee Town Council *see* Council (Dundee)
Dundee West Station, *106*, *107*, 208
Dundee, Perth and London Shipping Co. Ltd,
 207
Duntrune House, 113

Earl Grey dock, 14, *96*, *97*, 163, *181*, 182, 183,
 184, 186, 206, 207, 221
East Head, x
East Port, 15, 17
Easter Powrie, 4
Eastern Club, *136*, 137
Edward family, 129

Edward, Charles, 83, 98, 99, 100, 138
Edward's Plan of Dundee, 1846, *99*
Edzell Church, 74
Elm Street, 190
English Chapel, 9, 59, 60, *72*
Euclid Crescent, 99
Ewing, James A., 173
Exchange Coffee House, 17, 74, 86, *96*, *97*, 98, 106, 132
Exchange Street, 16, 17
Exchange Walk, *97*
Exchange, The, xii, 13, 44, 97, 98, 132
'Executive, The', 76, *77*, 78

Fairweather, George, xxv, 197
Fairweather, John, xxv, 197
Falkland Palace, 33
Farington Hall, 129, 130
Farrell, Terry and Partners, 171
Fenton Street, 90, 147
Ferranti Limited, 169
Fintry, 48, 166, 192
Fish Street, xii, xxi, 2, *28*, 29, 30, 31, 42, 90, 91, 109, 145, 152
Fishmarket, 29, 98
Fitzgerald, William K., 194
Fleshmarket, 2, 9, 20, 29, 30, 59
Fletcher family, 2
Foot, Dingle, 178
Forebank, 25, 67, 75, 100, 150
Forest Park Cinema, 222
Forgan, 4
Forum Centre, 39
Fowler, Charles, 105
Franciscan Nunnery, 23
Fraternity of Masters and Seamen in Dundee, 60, 61, 64, 107
Frechou, Charles, 131
Friar's Wynd, 32, 42

Garden City movement, 166, 183
Gardyne's Land, xxvii, 1, 23, 36, *37*, *38*, 61, 168
Garland, Peter, 217, 218
Gas works, 48
Gauldie, Sinclair, xvii
Gaumont Cinema, *213*
Geddes Quadrangle, University of Dundee, *172*, 218
Geddes, Patrick, *171*, 172
Gellatly Street, 48, *51*
George III, 174
George V, 118, 189
Gilfillan Memorial Church, *151*, 152
Gilfillan, George, 72, 152
Gilroy Sons & Co Ltd, 123, 130
Gilroy, George, 130

Gilruth, Alexander, 76
Glamis Castle, 46
Glass works, 48, 74
Gothenburg, 13, 76
Grahams of Fintry, 48
Grammar school *see* High School
Gray, Patrick, 4
Gray's Close, 36, *38*, 39
Green, George, 197
Green's Playhouse, x, *xxiv*, xxv, 196, *197*, *198*, *199*
Greenmarket, 29, *90*, 98, 105, *131*, *132*, 140, 152, 188
Grey Lodge, 173
Grey Sisters Convent, 23, 155
Greyfriars, xi, 1, 18, 55, 58, 110
Grimond family, 26, 85
Grimond, Joseph, 131
Grothe, Albert, 141, 142
Guardhouse, xii, 44
Guildry, 5, 6, 13, 14, 55, 57, 58, 66
Guthrie family, 2

Hallmark Cards Inc, 169
Hallyburton family, 2
Hamburg, xi
Hamilton, David, 74, 75
Hammermen, 22, 25 (Hall), 64, 150
Hansom, J. A., 120
Haparanda Café, 179
Harbour *see* Port and Harbour
Harbour Authority, 184
Harbour Commissioners, 108
Harbour sundial, xi, 5, *13*, 14
Harbour Trust, 168
Harris Academy, 63
Harwood, Henry, 76, 77
Hawkhill, xxvii, 53, 63, 66, 83, 95, 126, 127, *193*, 194, 196, 199, 200, 213, 218
Hazel Hall, *129*
Heiton, Andrew, 130
Her Majesty's Theatre and Opera House, 200
Hie Gait *see* Market Place
High School, xii, xx, 2, 44, 74, 83, 99, 100
High Street, *x*, xiii, xxi, 1, 9, 18, 19, *20*, 22, 31, 36, 39, 41, 53, *55*, 58, *59*, 70, 78, 87, 89, 98, 104, 134, 136, 137, 138, 144, 146, 147, 168, 183, 187, 212
Hilltown, 4, 21, 26, 53, 117, 146, *149*, 150, 182
HMS *Victory*, 74, 114
Holo-Krome, 169
Holyroodhouse, 18
Hooghly River, 122, 161
Horsbrugh, Florence, 178
Hospital, Town's *see* Town's Hospital, Nethergate
Hospital Gardens, 53

Hospital Park, 63
Housing and Town Planning Act 1909, 163
Housing and Town Planning Committee, 163
Howff, 18, 30, 42, 102, 110, 138
HTA architects, 203
Hunter Street, 202
Hunter, David, 5, 22, 23, 35
Hunter's Great Lodging, 5, 23, 24, 25, 137

Ice Rink, Dundee, xxiv, 179, 224, 225
Inner Ring Road, 97, 104, 111, 154, 182, 183, 194
Inverdovat, 6
Invergowrie, 4, 15, 69, 192
Invergowrie House, 34, 36, 113, 175
Irvine Square, 54

Jacobitism, 6, 59
James IV, 111, 113
James VI, 15
Jobson family, 64, 67
Jobson, David, 64
Jobson, John, 61, 64
Jobson, Robert 'Riga Bob', xix, 8, 54, 61, 64
Johnson-Marshall, Robert Matthew and partners, 173, 175, 220
Johnston, James, 8, 54, 61, 68
Jute palaces, xx, 85, 128, 129, 130, 131
Juteopolis, xvii, xix, 80, 83, 86

Kay's Close, xvi, xxi
Keillers, 38, 39, 87
Kerbat House see Carbet Castle
Kerr, Christopher, 101
Key's Close, xvi, xxi, 109
King Street, 53, 75, 110, 174, 212, 213
King William IV dock, 93, 95, 96, 97, 181, 206, 207
King's Cross, 192
King's Highway, 15, 21, 146, 149
King's Theatre, 213
Kingennie, 4
Kingsway, xxiv, 169, 179, 183, 191, 192, 221
Kinnaird Cinema, 139
Kinnaird Hall, 101, 137, 138, 139, 152, 184
Kinnaird, Lord, 101, 138
Kirk Style Wynd, 211
Kirk Wynd, 153, 154
Kirklands, 61, 156
Kirkton, 166, 182, 192
Knox, Sir Thomas Malcolm, 215
Kuenen, Johannes, 218

La Scala (Cinema), 196
Lady Warkstairs, 39, 40, 41, 60
Ladywell, 26, 134, 150
Laing, Alexander, 89

Lamb, Alexander Crawford, xiv, 89, 91
Landale, Charles, 102
Lauderdale, Duke of, 18
Law Terrace, 17
Law, The, 15, 17, 42, 68, 73, 82, 102, 110, 114, 119, 121, 123, 129
Lawson, Charles, vii, xiv, xv, 6, 24, 25, 29, 40, 49, 50, 51, 89, 91, 119, 140, 145, 146, 152
LeComber, Peter, 219
Leng, John, 72, 122
Leslie, James, 95, 98
Liff, school, 75
Lime Street, 190
Lime Tree Walk see Exchange, The
Lindores Abbey, xi, 18, 55, 58
Lindsay Street, 19, 72, 100, 103, 124, 137, 139, 140, 153, 154
Lindsay, James Bowman, 101
Lindsay, Sir James, 51
Lindsay's Lodging, 109
Linlathen Air Raid Shelters, 221, 222
Littlewoods Store, 211
Local Government Act 1929, 178
Lochee Church, 74
Lochee, 69, 74, 85, 119, 120, 121, 126, 179, 180, 225
Locheye Burn, 119
Logie House, 69
Logie housing scheme see Logie
Logie Works, 129
Logie, xxiv, 15, 34, 69, 165, 166, 183, 189, 190, 191
Long Wynd, xxv, 104, 152, 154
Lorimer, Sir Robert, xxiii
Lovell, George, 47
Lübeck, xi
Luckenbooths, xxiii, 20, 32, 40, 57, 72, 73, 185, 187, 209
Lyon Street, 115
Lyon, Sir Patrick, 41, 42

Mackenzie, Alexander, 196
Mackenzie, William, 78
Mackison, William, xxi, 88, 145, 163, 182
Maclaren, James, 121
Maclean's garage, 226
MacMillan's Buildings, 155
Macrae, David, 152
MacSween, 38
Magdalen Green, 72, 78
Magdalen Yard, 75, 141, 143
Maitland, Lord Charles, 18
Malthouse Close, 94, 155
Marine Drive, 83
Maritime Quarter, xiv, xvi, xxi, 4, 9, 18, 29, 41, 49, 75, 86, 89, 90, 91, 104, 108, 109, 144, 145, 146, 151

Market Place, ix, x, xii, 2, 13, 18, 19, *20*, 21, 25, 32, 36, 38, 40, 44, 46, 47, 55, 58, 59, *72*, 73, 86, 133

Marketgate, 104, *123*, 124, 154

Marquis of Montrose, 5, 14, 112

Marryat Hall, 165

Marryat, Emma Grace, 165

Martin, Hugh, 168, 211

Mary I (Queen of Scots), 53, 98

Maryfield Hospital, 177

Maryfield, 213

Mason's Lodge, 32

Matthew Building, Duncan of Jordanstone College of Art, 173

Matthew, Sir Robert, 215

Matthewson, George, 78, 99, 101

Mauchline Tower, 147

Mause Burn *see* Scouringburn

McAllion, John, 178

McCheyne Memorial Church, 137

McCullough, George, *78*

McGill Bros, department store, 179

McGill, Alexander, 46

McGonagall, William, 92, 123, *139*

McIntosh, Miss Minnie, 200

McManus Galleries, 126, 135, 136

Meadow Street, 99, 102

Meadows, ix, xx, 10, 18, 25, 36, 80, 83, *86, 87*, 98, 126, 134, 148

Meadowside, 135

Mealmarket, 20, 21

Mechanics' Institution *see* Watt Institution

Menzieshill, 166

Mercat Cross, 20

Merchant's Hotel, 78

Methodist chapel, 23

Methodist Close, *23*

Mid Kirk Style, 32

Mid Kirk Wynd, 209

Mid Wynd Works, 83

Mid-Craigie, 166

Millar, Dr A. H., 189

Milne's Buildings, 51, 61

Milne's Tobacco Factory, 26

Monk, George, xxvii, 5, 73

Monk's Holm, 51

Monmouth, Duchess of, 73

Moonzie, 4

Morgan Tower, 61

Murphy, Richard, 227

Murraygate, xxi, 9, 18, 21, 25, 26, 53, 58, 77, 85, 90, 99, 126, 133, 136, 145, *146*, 147, 148, 180, 194, 196, 212

Murroes, 15, 34

Mylne family, 2

Mylne, John, 140

National Cash Register Company, 169, 195, 222, *223*

National Health Service, 175, 177

Neave, David, 53, 63, 65, 68, 69, 71, 74, 75, 76, 83, 94, 104, 120, 155

Necessary House, 19

Neish, Thomas, 80

Nethergate, xxvii, 5, 10, 15, 16, 18, 21, 32, 41, 42, 51, 53, 54, 61, 62, 64, *72*, 75, 82, 90, *91*, 94, 96, *103*, 104, 109, 111, 132, 133, 139, 152, *153*, *154*, 155, 173, 196, 197, 212, *226*, 227

Nethergate Centre, 155

Nethergate Garage, *226*

Neville, Sir Adam, 217

New Hippodrome, 199, 200

New Howff, xxv, 102, *110*, 111

New Inn, 38, 78

New Shore, xi, xii, 2, 29, *30*, 41, 95

Newburgh, 33

Newport-on-Tay, xxiv, 6, 168

Newtyle, 82, 102

Nicoll Russell Studio, 226

Nicoll Street, 179, 225

Ninewells Hospital, 175, 177, 220

Ninewells, 102

North British Railway Company, 88, 108, 123

North Lindsay Street Fair, *139*, *140*

North Lindsay Street Quarry, 139

North Tay Street, 99, 156

North Tay Street Church, 74

Old Hawkhill *see* Hawkhill

Old Steeple, x, 2, 111, *113*, 114, 215, *see also* St Mary's Church

Olympia Centre, 221

Ormsby-Gore, William, 189

Our Blessed Virgin Mary, Church of, *see* St Mary's Church

Our Lady Warkstairs *see* Lady Warkstairs

Our Lady's Well *see* Ladywell

Overgait *see* Overgate

Overgate, ix, xxiii, xxv, *xxvi*, 2, *3*, 4, 15, 18, 21, *22*, 23, 25, 29, 32, 33, *34*, 53, *72*, 73, 91, 104, 139, 140, 154, 156, 168, 179, 180, 182, 187, 194, 201, 209, *210*, *211*, 212

Packhouses and Packhouse Square, xi, xii, xiii, xvii, 2, 7, 13, 29, 30, 91, 97, 98, 106, 132, 140, 152

Page and Park, 171

Palais, The, 179

Panmure Dock, 83

Panmure Mission chapel, *109*

Panmure Street, 25, 86, 134

Panmure, Earl of, 105, 106, 143

Park Place, 63, *64*, 75

Parr, James, and Partners, 168, 182, 212
Paterson, George, 57
Paterson, John, 67
Peddie, Andrew 70
Peddie, J. Dick, 105
Peddie, William, 218
Perth Road, xxvii, 53, 58, 62, 63, 75, 78, 83,
 96, 127, 129, 137, 156, 173, 196, 218
Peter Street, 19
Physics Laboratory, University College,
 Dundee, *219*
Pilkington, Frederick Thomas, 137
'Pillars, The', *57*, 58,165
Pitkerro, 15, 34, 69
Pleasance, The, 126, 156, 221
Pococke, Richard, 140
Police Commission, 75, 91
Pont Map of Dundee, *14*
Pont, Timothy, 14, 15, 34, 205
Port and Harbour, *viii*, ix, x, xi, xii, xiii, xiv,
 xvi, xvii, xix, xx, xxi, *xxiii*, xxvii, 1, 2, 4,
 5, 6, 7, 9, 10, 11, *12*, 13, 14, 15, 16, 17, 18,
 19, 20, 29, 31, 32, 42, 43, 44, 48, 51, 53, 55,
 58, 59, 71, *73*, 75, 77, *78*, 79, 80, 81, 82, 83,
 86, *89*, 91, *93*, 94, *95, 96, 97*, 98, 103, 104,
 105, 106, 107, 121, 145, 155, 156, *157*, 158,
 159, 163, 166, *181, 206, 207*, 208, 222
Poseidon, Statue of, 13
Princes Street, 114, 117, *118*
Princess Cinema, 199, *200*
Printmakers' Studio, 226
Provost Pierson's Warehouse, xi, 16, 29, *30*,
 113, *132, 133 see also* Customs House
Public Arts Programme, 180
Puri Calcutta, ship, *84*

Quarles, Francis, 38
Queen Mother, 166, 171, 175, 182, 215
Queen Mother Building, 171, 194
Queen's Cinema, 196
Queen's College, Dundee, 171, *172*, 214, *215*
Queen's Hotel, xxiii

Ramsay family, 2
Rational Institution, 100, 101
Read family, 69
Red Friars *see* Trinitarians
Reform Street, 99, 100, 137, 221
Reis, A. L., 32
'Reminiscences of a Dundonian', 90
Replanning Act 1825, 74
Riddoch, Alexander, xix, 53, 54, 58, 61, 64,
 70, 71 (Graving Dock), 77, 78
Riverside Drive, 180
Robertson, James Murray, 172, 215
Robertson, John, and Son Ltd, 193
Robertson, T. S., 131

Robertson, William, xi, 13, 140
Rochead, James Thomas, 105, 106
Roseangle, 75, 78, 83
Ross Head, 12
Rottenrow *See* Hilltown
Rough, George, *77*
Royal Arch, *ii*, 86, *104, 105, 106*, 137, 158,
 166, 181, 182, *207*, 208
Royal Dundee Liff Hospital *see* Dundee
 Royal Lunatic Asylum
Royal Exchange, 25, 86, *87*, 114, 122, *133*,
 134, *135*, 136, 138
Royal Exchange Square, *87, 133*
Royal Hotel, 76
Royal Mint, 22, 138

Sailors' Hall, 61, *62*, 94
Sainsbury's (Supermarket), 206
Sanctuary Scotland Housing Association,
 203
School of Medicine, University of Dundee, 172
School Wynd Church, *71*, 152, *153*, 154
School Wynd, 19, 72, 139, *153*, 154
Scott, Sir George Gilbert, 71, 114, 158
Scott, Sir Walter, 68
Scott's Close, xvi, xxi, *144*
Scouringburn, 9, 15, 18, 22, 123, *126*, 134,
 147, 148, 155, 156
Scrymgeour family, 2, 29
Scrymgeour, Edwin, *177*
Scrymgeour, John, Third Viscount Dudhope,
 149
Scrymgeour, Sir John of the Myres, 111, 112
Seabraes Works, 83
Seagate, xxi, *xxii*, xxiii, 7, 9, 13, 15, 17, 18,
 19, 21, 35, *36*, 47, 48, 53, 58, 75, 77, 83, 90,
 96, 126, 145, *147*, 148, 192, 226
Seamen's Chapel, 29
Seamen's Fraternity *see* Fraternity of Masters
 and Seamen in Dundee
Seminaries, The *see* High School
Sheriff Court, 100, *102*, 111, *123*, 124, 139
Shipbuilding, *84*
Shore Terrace, *207*, 208
Shore, The, xi, xii, xiii, xxi, 16, 29, 32, 41, 59,
 60, 70, *97*, 98, 132, 137, 139, 140, 144, 184
Sidlaws, 82, 102
Sir James Black Centre, University of
 Dundee *see* Black, Sir James
Slezer, John, 15, 16, 17, 18, 35
Sliver Mill *see* Camperdown Works
Small, David, v, xiv, xv
Small, Rev. Dr Robert, 53, 67
Small's Wynd, 172
Smeaton, John, xiii, *12*, 94
Smith Brothers, department store, 194
Smith family, 39

Smith, David, 221
Soane, Sir John, 74
Song School, 112
South Tay Street, 53, 75, 156, 226
South Union Street, 61, *106*, *107*, 168
Spalding's Wynd, 42
Spear, Walter, 219
Springfield, 213
St Andrew's Church, xvii, *8*, 9, 25, 60
St Andrew's Street, 9, 53, 58, 60
St Clement's Chapel, 44, 47
St David's, 154, *155*
St Enoch's Church, xxv, 154
St Francis' Well, 134
St Margaret's Close, 138, *145*
St Mark's Church, 137
St Mary's Church, ix, 1, 2, 5, 15, 16, 18,
 19, 20, 32, 42, 59, 73, 79, 103, *109*, *111*,
 112, *113*, 114, 132, *139*, *140*, 152, *153*,
 158, 168, 182, *185*, *211*, 212 see also Old
 Steeple
St Mary's, Lochee, *120*
St Mary's Tower see St Mary's Church
St Nicholas Craig, 15, 29, 61
St Paul's Cathedral, 13, 17, 22, 59, 71, *109*,
 114, 148, *157*, 158
St Paul's Church, *93*, 94, 103
St Paul's Close, 148
St Paul's Episcopal Chapel, *70*, 71
St Roque's Library, *163*, 183
St Roque's, 35
Stack Leisure Centre, 122
Stark, Malcolm, 152
Steeple, The Old see St Mary's Church
Steeple Church, 9, 60, 112 see also St Mary's
 Church
Steggall, John Edward Aloysius, *171*, 173, 174
Stephenson, Robert, 101
Steps Theatre, 179, 226
Stewart, Allan, 142
Stewart, Dr Robert ,67
Stewart's Court, 47, *48*, 49
Strachan family, 15, 205
Strang, David, 95
Strathmartine Hospital, 177
Strathmartine Road, *191*
Strathmartine, 182
Strathmartine's Lodging, xii, xxiv, *xv*, *44*, 46,
 187, *188*
Strathmore, 21, 81, 82, 101, 102
Strathmore, Earl of, 2, 41
Stuart, James Edward, 6, 20
Suffragettes, 177
Sugar House, 7, 13, 36, 48
Sunshine Cafe (Green's Playhouse), *198*
Sycamore Avenue, 190
Symsone, James, 4

Tally Street, 32, *33*, 209
Tay Bridge Station, 108, 208, 209
Tay Ferry, The, 107, 166, *167*, 168, 183
 (terminal)
Tay Hotel, 108
Tay Mills see Tay Works
Tay Rail Bridge, xxi, 64, 82, 88, 91, 108, 123,
 139, *141*, 142, 143, 222
Tay Road Bridge, xxv, 97, 107, 158, 166, *167*,
 182, 183, 207, 208
Tay Square, 53, *65*, 66, 179, 225
Tay Street, xiv, 9, 53, 61, 65, 75, 99, 156, 226
Tay Works, *123*, 124, 130, 156, 180
Taybank, 190, 191
Tayside Historic Buildings Trust, 38
Tayside House, 106, 182, 208
Tayside Region and Council, 178, 208
Tayside Tigers Ice Hockey Team, 224
Technical College and School of Art, 172
Technical Institute, 172
Tesco, 211
Thatcher, Margaret, 224
Theatre Royal, 9, 61, *66*, 67
Theatrum Scotiae, 16
Thistle Hall, 71, 74, 75, *76*
Thistle Operative Lodge, 76
Thompson, D'Arcy Wentworth, *171*, 173,
 174, 215, *216* (Zoology Museum), 217
Thomson, Frank, 163, 183, 196, 213
Thomson, James, xxi, xxiii, 163, 165, 182,
 183, 184, *185*, 186, 187,188, 189, 190, 191,
 192, 196, 209, 213
Thomson's plan of Dundee, 1910, *184*
Thornton, Thomas, 88, 122, 135, 145
Thorter Row, 73, 209
Timex, 169, 222, *223*, 224
Tindall's Wynd, *46*, *47*, 133
Titaghur Mill, West Bengal, *162*
Tivoli Cinema, 179
Tolbooth, xi, xii, 1, 2, 6, 18, 19, 20, 21, 35, 36,
 40, 44, 47, 55, 149
Tower Building, University of Dundee, 63,
 173, 214, *215*
Town Council see Council (Dundee)
Town Guard, 55
Town House, xvii, xxiii, xxiv, 6, *7*, 8, 13, 46,
 55, *56*, *57*, 58, 66, 83, 100, 104, 133, 158,
 165, 182, 183, *185*, 186, *187*, 188, 189
Town's Academy, 53
Town's Hospital, Nethergate, 16, 18, 51, *52*,
 53, 54, 65, 156, 226
Trades Hall, xvii, 9, 18, 20, 58, *59*, 60, 64, 66,
 76, 77, 78, 98, *146*, 147
Trades Kirk see St Andrew's Church
Trades Lane, 58, 144, 192, 193
Travel Dundee, 208
Trinitarians, 51

Trinity House (Hospital) , 9, *see also* Fraternity of Masters and Seamen in Dundee
Tron, 20

Unicorn, 180
Union Chapel, 21, 147
Union Hall, 40, 59, *60*, 91
Union Street, 29, 43, 71, 74, 75, *76*, *94*, 95, 97, 98, 184
United States Time Corporation *see* Timex.
University College, Dundee, 62, *63*, 169, *170* (Deed of Endowment), *171*, 172, 173, 174, 214, 215, 216, 217, 218, *219*
University of Abertay, Dundee, xxvi, xxvii, 172, 180
University of Dundee, xxvi, xxvii, 149, 169, 171, 172, 173, 180, 194, 200, 202, 214, 216, *217*, 218, 220
University of St Andrews, 169, 171, 215, 216, 220
Ustinov, Peter, 171

Vale of Strathmore *see* Strathmore
Valentine, James, & Co, 169
Vault, The, *xii*, xxiii, xxiv, 2, 29, 44, *45*, 47, *90*, 91, 97, 132, 133, 183, 185, *187*, 188
Veeder-Root, 169
Victoria I, 104, 105, 175
Victoria Dock, *89*, *96*
Victoria Road, 26, 68, 150, 151, 200
Victoria, cinema, 200
Victory see HMS *Victory*
Vine, The, *78*
Visual Arts Research Centre, University of Dundee, 226

Walker, Mary Lily, 173
Wallace Craigie, 4, 15, 34, 35, 36, 69
Wallace, James, 173
Ward lands, ix, 10, 18, 22, 80, 83, 98, 102, 139, 212
Ward Mills, 83, 140
Ward Road, 100
Watson, James, and Co., 192
Watson's Bond, fire, *192*, 193
Watt Institution, *100*, 101
Watt, Isaac, 69

Wedderburn family, 2, 4, 29, 34, 35, 64
Wedderburn, Alexander 4, 6, 20
Wedderburn, Bessie 3
Wedderburn, David, 2, 3, 4, 22, 25
Wedderburn, James, 31
Wedderburn, Richard, 3
Wedderburn, Robert, 3
Weighhouse, The, xii, 2, 44, *45*, 47, *97*
Wellcome Trust Building, 218
Wellgate Centre, 134, 151, 179, 212
Wellgate, 4, 15, 21, 26, *27*, 86, 133, 134, 146, *150*, 151 (Steps), 168, 179, 182, 212
Wellington Street, 173
West End, xxiv, 9, 20, 83, 85, 129, 214
West Ferry, 85, *128*, 129, 205
West Port, xxv, 21, 22, 23, *63*, *72*, 126, 155, *156*, 194
West Shore, 59, 83, *94*, 152
Wester Powrie, 15, 34
Wheatley Commission, 178
Whitehall (Lyon's Residence), 42
Whitehall Close, 41, *42*
Whitehall Crescent, xii, xxi, 29, 30, 91, *106*, 132, 133, 152
Whitehall Street, xxi, 42, 43, 91, 152
Whitehall Theatre, xxv, 197
Whiteley's 62, *63*
Whitfield, *204*
Wilkie, Alex, 177
Wilson's, G.L., Department Store, 179, 194, *195*
Willison, John, 13
Wilson, Alexander, 69
Wilson, Charles, 129
Wilson, Sir Garnet, 194, 195, 223
Wilson, Gordon, 178
Wilson, W.M., 224
Wimpey Homes, 203
Windmill Hill, ix, xi, xxi
Winter's Printing Works *see* Exchange Coffee House
'Witch's Blood', xvii
Wooden Land, 33, *34*

Yeaman family, 2, 29
Yeaman Shore, 61, 103, 104